PAINTING
Nature's
LITTLE
Creatures

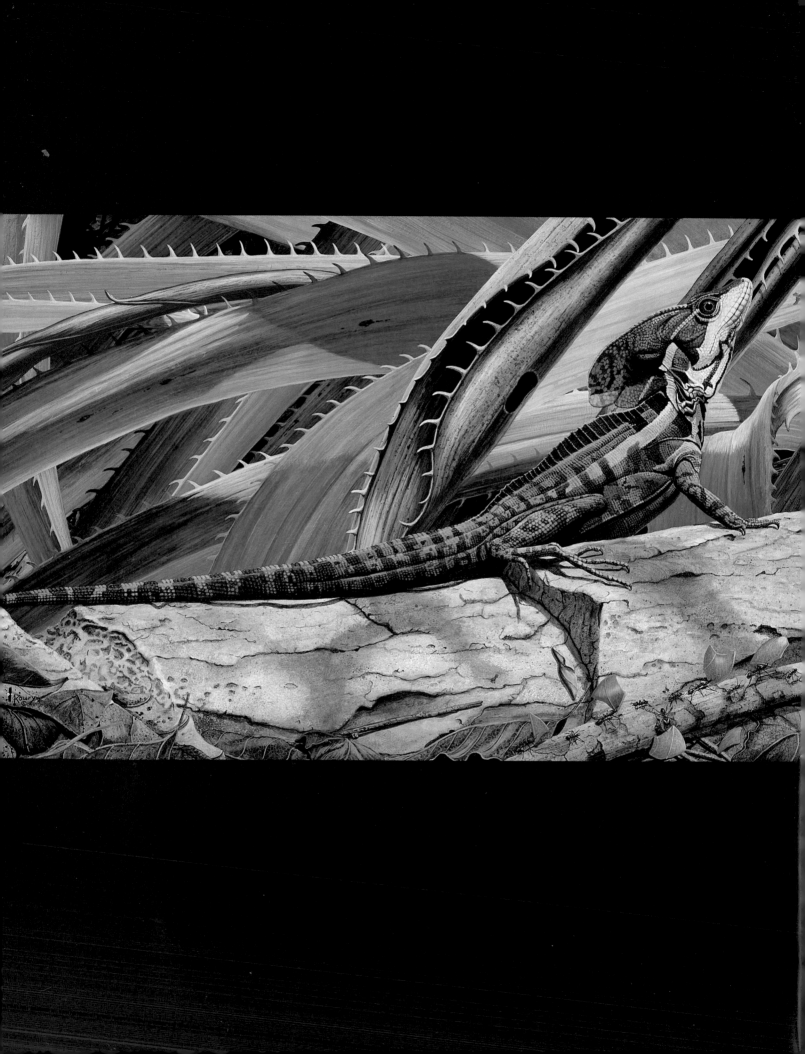

PAINTING
Nature's
LITTLE
Creatures

Stephen Koury

NORTH LIGHT BOOKS
CINCINNATI, OHIO
www.artistsnetwork.com

About the Author

On the creative cutting edge, Stephen Koury's works have earned him international acclaim as "The Painter of Little Jewels." Stephen's paintings are collected around the world and across North America. *U.S. Art* magazine named Stephen an international "Rising Star" in 1997. His paintings have appeared in *U.S. Art*, *Wildlife Art*, *Ducks Unlimited*, *Sporting Classics*, *Wildbird*, *Florida Wildlife* and *Informart* magazines. His works also have been featured in the book, *Wildlife Art: 60 Contemporary Masters and Their Work.* Stephen's works have been shown in many museums and galleries, and will be included in the prestigious Rainforest Trust Exhibition and sale in London. Stephen has led African photo safaris for the Southeastern Wildlife Expo; he has judged the state of Florida Audubon contest; he was chosen for the "top-100" in the Arts for the Parks Competition; he was named Florida Ducks Unlimited Artist of the Year and Quail Unlimited and National Forest Service Print Artist. Stephen is a member of the Society of Animal Artists and was a Featured Artist for the Florida Wildlife and Western Art Expo. He can be reached through his interactive Web site, www.skoury.com.

Painting Nature's Little Creatures. Copyright © 2002 by Stephen Koury. Manufactured in China. All rights reserved. No part of this book may be reproduced in any form or by any electronic or mechanical means including information storage and retrieval systems without permission in writing from the publisher, except by a reviewer who may quote brief passages in a review. Published by North Light Books, an imprint of F & W Publications, Inc., 1507 Dana Avenue, Cincinnati, Ohio, 45207. First Edition.

06 05 04 03 02 5 4 3 2 1

Library of Congress Cataloging-in-Publication Data

Koury, Stephen
 Painting nature's little creatures/Stephen Koury—1st ed.
 p. cm
 Includes index.
 ISBN 1-58180-162-9 (alk. paper)
 1. Wildlife painting—Technique. I. Title.

ND1380 .K68 2002
751.45'432—dc21 2001044486

Edited by Jolie Lamping Roth
Production Edited by Jennifer Lepore Kardux
Designed by Mary Barnes Clark
Cover designed by Wendy Dunning
Interior layout by Kathy Gardner
Production coordinated by Sara Dumford

Art on front cover: *Islands*, Tiger Swallowtail, 8" × 12" (20cm × 30cm); art on back cover: *Dragon Rock*, Dragonfly and Water Striders, 8½" × 12" (22cm × 30cm); art on front flap: *Emeralds and Orchids*, Wild Orchid Tree and Ruby-Throated Hummingbird, 23½" × 18½" (60cm × 47cm); art on pages 2-3: *Bad to the Bone*, Basilisk Lizard With Leaf Cutter Ants, 9" × 18" (23cm × 46cm)

Metric Conversion Chart

to convert	to	multiply by
Inches	Centimeters	2.54
Centimeters	Inches	0.4
Feet	Centimeters	30.5
Centimeters	Feet	0.03
Yards	Meters	0.9
Meters	Yards	1.1
Sq. Inches	Sq. Centimeters	6.45
Sq. Centimeters	Sq. Inches	0.16
Sq. Feet	Sq. Meters	0.09
Sq. Meters	Sq. Feet	10.8
Sq. Yards	Sq. Meters	0.8
Sq. Meters	Sq. Yards	1.2
Pounds	Kilograms	0.45
Kilograms	Pounds	2.2
Ounces	Grams	28.4
Grams	Ounces	0.04

Dedication

To Necia Koury,
a dream come true.

Acknowledgments

Thanks first and most importantly to my wife, Necia Koury, for making this book possible. She carried a huge load so I could focus on this book; it would not have happened without her.

Thanks to Rachel Rubin Wolf and North Light for giving me this chance. Thanks to Jolie Lamping Roth for somehow turning my scattered thoughts into something coherent, as well as her patience and guidance. Thanks to Frank Sisser for his friendship and sage wisdom. Thanks to Sara Gilbert and the gang at *U.S. Art*. Thanks to Robert Koenke for his advice and guidance.

We don't do many things alone in this world and a lot of people have contributed to this book over the years. Because of their support this book was made possible: Mike and Robin Kessler, Bob and Darcy Cocozza, Marty and Brenda Higgenbotham, Gus King, Jan and Ray Wood, Nancy Spencer, Chuck and Chris Anderson, Roger and Pat Mc Fadden, Ben Essenburg, John Yeackle, Brant Martin, Gary and Maybeth Davis, Bo Jackson, Andy and Debbie Bean, Hugh and Mikey Turbeville, John Valrino, Del Milligan, Dennis Ross, Frank Puissegur, David and Cathy Lanier, Dan Smith, John Banovich, Carl Brenders, Margo Bindhardt, Sonja and Kevin Vick, Susan and Louis Frampton, Jimmy and Beth Huggins, Sonny Hanckle, Judy Price, Martha Hoerner, Bob Farrelly, Rick Mitchell and Jami Herter, Leon and Nancy Capels, Mack and Sally Wilburn, Teddy and Leslie Turner, Gordon and Lois Schwenk, Harriett Gaddy, Mike and Linda Valencia, Dave and Marge Schantz. Thanks also to The Colorado Connection, Frank Mangum and Hugh Reno; and to Florida Ducks Unlimited for providing the springboard to launch this wonderful career.

A special thanks to Martha and John Walters—you're awesome. Thanks a ton to my father, Dan Koury, who somehow knew that painting was what I was destined to do long before I did. Thanks to my mother, Mary Koury, who took on a tough assignment and helped me a lot. To Grandpa Stephenson and Grandpa Koury, I thank my lucky stars to have spent time with you both. Thanks to the rest of my family whose support and love are unconditional. Thanks to all the shows, artists, collectors and friends who make this a great way to live.

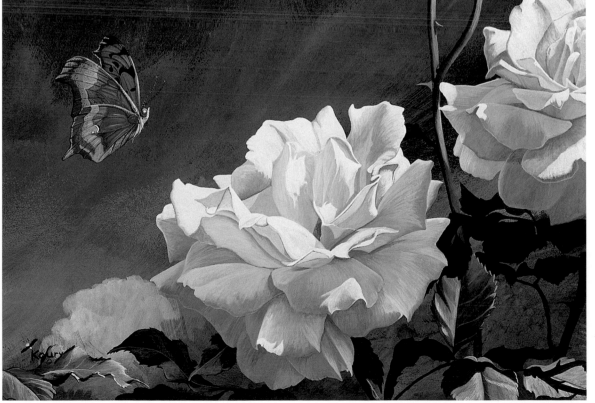

The Question
Questionmark Butterfly
and Yellow Roses
6½" × 10"
(17cm × 25cm)

Table of Contents

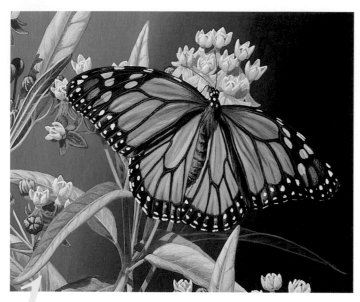

1 Butterflies

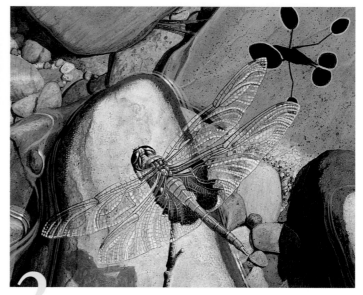

2 Dragonflies and Damselflies

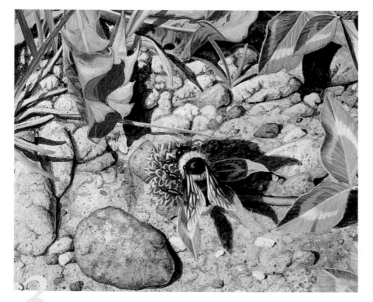

3 Bees

4 Beetles and Arachnids

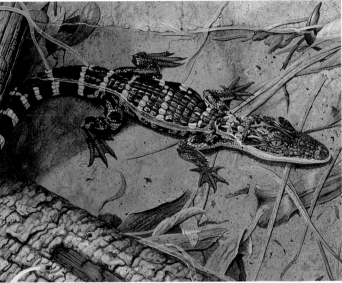

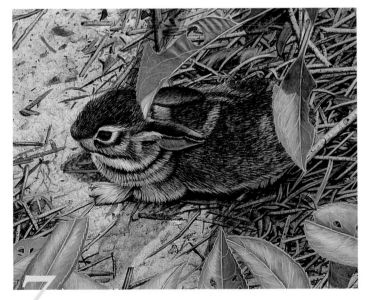

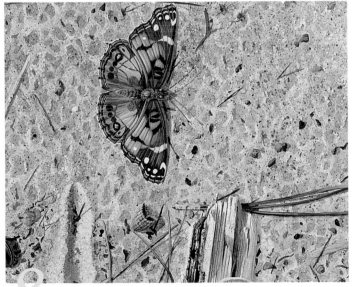

Foreword

For Stephen Koury, beauty is in the details. His attention to the little things is at the core of all he's passionate about, personally and artistically. He finds the subtle very inspiring. Like the rest of us, he doesn't go unmoved by a dramatic mountain sunset, but he's just as easily stirred by the more ethereal beauty of an Alpine meadow carpeted with delicate wildflowers. The sun-bleached African veldt is magical to him even when it isn't teeming with a menagerie of grazing species. To most of us it would be nothing more than a hot dusty wasteland. He finds equal inspiration in the delicateness of a butterfly and the power of the majestic eagle. Where most people find a towering pine tree a challenge to fully appreciate, Stephen discovers magic in the bed of pine needles that surround its base.

Through years of keen observation he has learned to see the world from an artist's unique point of view. This ability to see beyond the obvious is the foundation for the unique artistic perspective he shares with you in the pages that follow. Be prepared to take a journey of exploration. Along the way you will learn to look beyond the ordinary to see beauty you never knew existed. You'll learn to see as an artist sees. Where you once saw leaves, gravel, grasses and rock, you will learn to see a masterfully orchestrated mosaic of shapes, textures and tones. You will learn to understand and appreciate the magic of light and the way it impacts how we see color. In the process you will unlock the true source of a butterfly's beauty. You'll learn that every creature, no matter how small and seemingly ordinary, and every natural setting, even the most barren, possesses a unique beauty of its own.

Stephen Koury is the perfect guide for your journey. His passion is infectious. You'll sense it in his words and feel it through his images. Open yourself to his message. Make it your own. Your perspective of what's ordinary is about to change forever and so is your understanding and appreciation of at least one artist's way of looking at the world.

Enjoy the journey—it will lead you one step closer to seeing beauty in the details, no matter how small.

Frank J. Sisser

Frank J. Sisser is publisher of *U.S. Art*, a magazine for art collectors. He has been an active participant on the wildlife art scene nationally for the past twenty years, serving as a juror, lecturer and panelist at numerous wildlife art competitions, exhibitions and symposiums. He has judged the Federal Duck Stamp Competition, twice served as a juror for the Arts for the Parks Competition and has also been a juror for the prestigious C.M. Russell Art Auction.

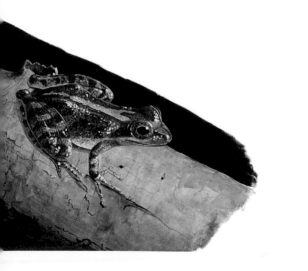

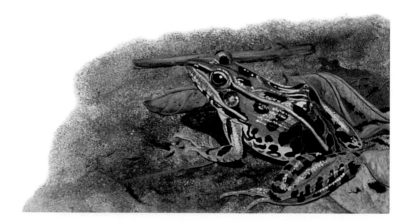

Introduction

A cheetah lounges in the early morning African sun, almost invisible in the grass below a stunted mopani tree. A group of springbok (small African antelope) graze, unknowingly moving toward the cheetah. The cheetah seems unaffected by the springbok until their grazing carries them closer. At 50 yards (45m) the cheetah silently and imperceptibly moves to its belly and crouches. As the springbok move even closer, the cheetah's body quivers with anticipation, and at 35 yards (32m) it launches! The cheetah has covered 15 yards (14m) before the springbok react—a reaction that's probably too late! Different versions of this scenario take place a million times a day on a million different levels throughout the animal and insect kingdoms, and you don't have to go to Africa to see them; they are all around you!

These natural encounters are the makings of fascinating stories. A butterfly rests with its wings toward the warming sun. A male hummingbird takes a perch to defend a nearby nectar source. A frog uses its natural coloration to blend into its environment. Countless stories abound, wondrous and beautiful. Stories happen all around us and you can re-create them with your paintings.

Throughout this book we will work on the techniques you can use to capture and portray these stories: how to portray the delicate texture of butterfly wings, the transparency of dragonfly wings, the fuzzy softness of bees, the jeweled iridescence of beetles and insects, the intricate flight pattern of a hummingbird, the skin of amphibians and reptiles, and the wonderful texture of fur on small mammals. We will cover the structure and lives of these and other little critters, and hopefully give you some fuel for the creative fires. Along with techniques, there will be several recurring themes: the use of shadows and shading; transforming these characters into works of art; the use of shape, color, texture and light; the study of nature, and the toughest concept of all—patience. Our fast-paced world tends to carry over into all aspects of our lives. We overlook the little stories below, above and around us. Slow down, take your time when observing, hiking, referencing and painting. After all, the elements of nature took a long time to get to their present state. Don't shortchange the beauty and wonder of these elements with speed. Look for stories, shapes, textures, colors and the play of light. Be a sponge; soak it up and allow your creativity to flow. Nothing is commonplace. Stay amazed and open to the stories of nature.

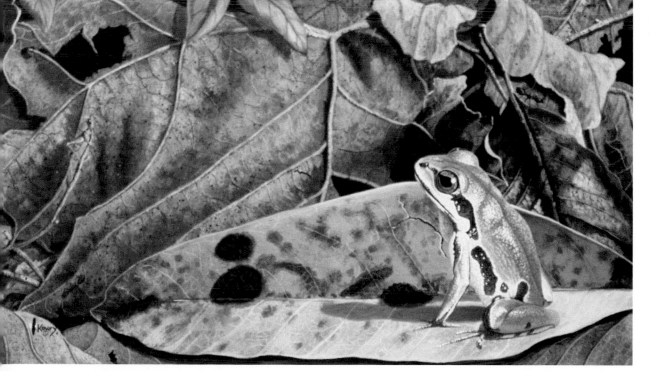

Blown Cover
Ornate Chorus Frog
4" × 8"
(10cm × 20cm)

Getting Started

PAINTING SURFACE, PAINTS AND BRUSHES

Most of my paintings are done on untreated Masonite board. I use ¼-inch (6mm) for the majority of the paintings and ⅛-inch (3mm) on the smaller paintings.

The paint I use is Artist Acrylic Gouache by Chroma Acrylics; the brand name is Jo-Sonja. This paint has all the properties of opaque watercolor while having the permanence of acrylic. It's like working with acrylic except it flows and acts like gouache. Acrylic can be used as an alternative in all of the demonstrations; the difference will be in drying time and the final finish. The acrylic gouache will dry more rapidly than the acrylic paint, and with a flat non-shiny finish.

Most of my painting requires very little paint (I paint on a small scale) and I paint with a wet palette (the lid of a small plastic container). When I do large areas such as backgrounds, I use a paper plate or other flat palette

and work quickly applying the paint. If the background is a uniform color or close to a uniform color, I mix the color I want in a little bowl and add Jo-Sonja's retarder to extend the drying time and allow more blending.

When I have finished the entire painting, I use an acrylic varnish mix, made by mixing ⅓ gloss medium, ⅓ matte medium and ⅓ water. I mix all three together and apply it with my softest fan brush. I lay down one coat, allow it to dry and follow this with at least two more coats. This not only protects the painting, it really sharpens the finished piece.

For my brushes, I prefer Loew Cornell. Some of my most-used brushes are shown below.

FIELDWORK

Immerse yourself in the environment of the creature you want to portray. The equipment needed for fieldwork is fairly simple: a pencil or pen, a sketch

pad, and sometimes a spotting scope, binoculars and a camera.

Begin by reading everything that you can get your hands on, then put yourself in the creature's environment and watch! Collect little rocks, twigs, lichen and other interesting things that you find on the ground. Start a little reference lab in your studio!

Next, study the particular pattern the creature employs and how it copes with the weather, the season and even predators! Necia and I have a wonderful butterfly garden that seems to be continuously growing. It's a wonderful reference lab not only for butterflies, but for all the other uninvited guests that come to the party! I photograph as much as I can and catalog my photos. I have several volumes on just butterflies and, most importantly, I work from these references. This building of knowledge and reference material will show through in your work and strengthen your faith in the finished piece.

Painting Materials

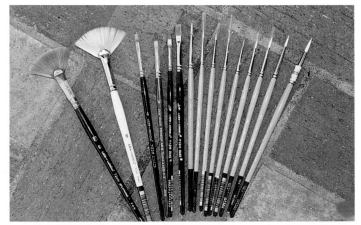

Most-Used Brushes
Brushes from left to right: no. 6 fan, Loew-Cornell 7200 series; no. 6 fan, Loew-Cornell 794 series; no. 4 shader, Loew-Cornell; no. 4 cats' tongue, Princeton Art & Brush Co.; ⅛-inch and ¼-inch (3mm and 6mm) Loew-Cornell rakes; Loew-Cornell rounds nos. 4 to 000 (no. 5 round not shown here).

I think you will find that research and gathering reference will become second nature to you, but the real beauty is that they will fuel your imagination and creativity, which will lead to creative and imaginative paintings.

Sketching

Sketch every chance you get, from fast field sketches to detailed collection sketches. Each method can help with the composition and story of your painting as well as with correctly portraying the subject.

Sometimes things happen too quickly for the camera so when I want to remember the setting and action, a quick sketch does the job. Field sketching is really being touted by many artists today as the way to go, but keep in mind that whatever you do, it needs to fit what you are doing at the moment. In other words, don't blow a great photo because you are trying to sketch. Remember, light changes rapidly; catch the moment, then sketch and make notes. Sketching can be a quick reference for colors, light, posture and unique behaviors. Most importantly, observe—I mean really look! For me, forming a mental image of what I want to do precedes any painting and is the most important part of my creative process.

BASIC PHOTOGRAPHY EQUIPMENT

Photography is an unbeatable aid in painting all types of critters from great to small. With a camera you can capture actions, poses and detail that would be impossible in the fleeting, nonstop world of critters. By combining your photos, sketches, some behavioral information and your imagination, you can come up with a wonderful composition.

I rarely use just one photograph. I usually take six or more shots at different focal distances. For example, when I find an interesting setting I will take a few background shots, a few midground shots and a few foreground shots. These photos, along with a sketch or two and some notes on light, color and possible composition, form the basis of my paintings.

Camera and Lenses

A 35mm camera is the best choice for this type of nature photography. The new cameras are easy to use. They advance the film automatically and can be used with a multitude of specialized lenses. The lenses you use will depend upon the situations and subjects. I use a 105mm macro lens, 35-70mm lens and an all-purpose 80-200mm zoom for most situations. If you can afford the larger lenses, go for it. The bonus with a larger lens is that you don't have to get too close to your subject; therefore, you relieve a little tension on both of your behalfs.

Flash and Auto Flash Systems

All the major camera brands have flash units available, either built right into the 35mm SLR body or as an attachment. I use an electronic flash unit that attaches to my camera body, because it consistently gives reliable lighting, particularly when photographing butterflies, hummingbirds and insects. Most of the time I will shoot my subject both ways—with and without a flash—because somewhere in the middle of those two exposures is where I want my painting to be. Without the flash the extremes of dark and light can really affect your photos; with the flash, the lights are softer and the darks are lighter. I want to see the details of the subject, not a dark, featureless shaded area and a washed-out light area.

Tripods, Monopods and Ball Heads

The best advice I can give you is to determine what type of photography you plan to do most often and work from there. Choose the lightest tripod and monopod that will safely support the lens you intend to use. Also look for easy adjustability, with few handles. Check for parts that move smoothly.

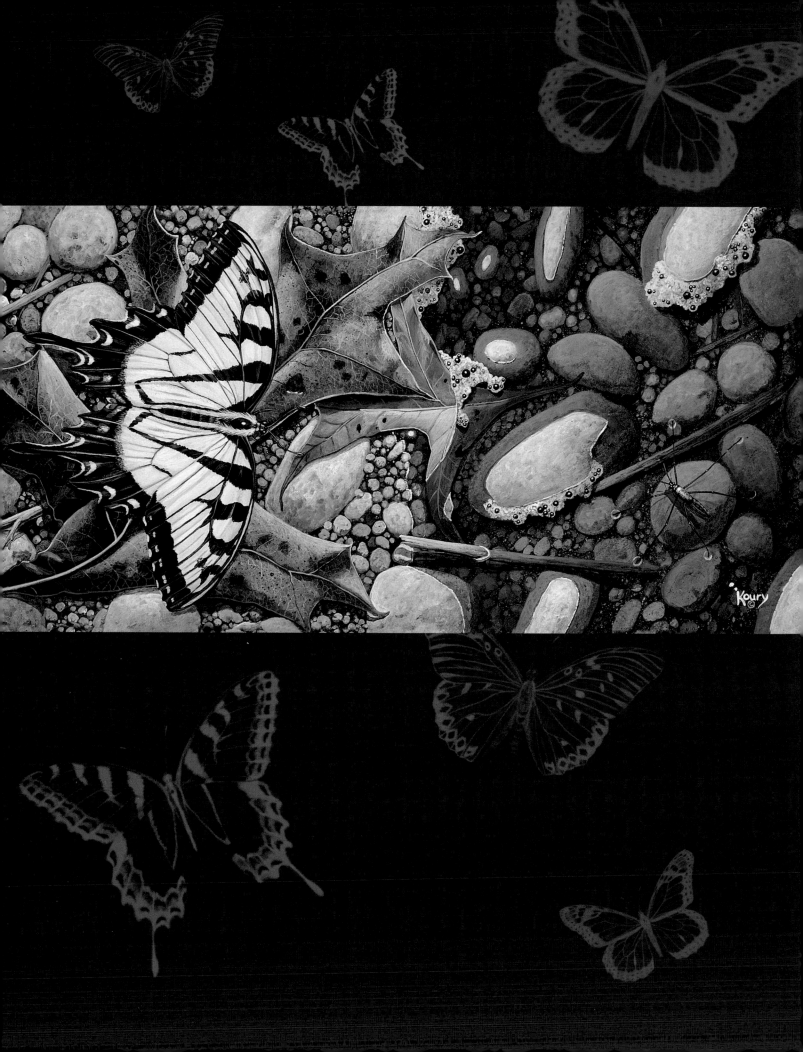

BUTTERFLIES

*T*he flight, the colors, the patterns, and the way light dances on their awesome wings is what draws me to butterflies. They come in all colors of the rainbow and more. Their wings are covered with millions of tiny shingles that reflect light in a myriad of colors, giving them a soft fuzzy look. In this chapter, I will help you bring your butterflies to life by showing you how to portray the texture, color and pattern of these captivating wings.

Yin & Yang
Tiger Swallowtail With Water Strider
5¾" × 11¼" (15cm × 29cm)

Anatomy of Butterflies

THE MONARCH

The monarch is one of the best known butterflies in the U.S., 3½ to 4 inches (9cm to 10cm) in size. The monarch is one of the milkweed butterflies and also a member of the Brushfoots, family Nymphalidae. Butterflies in this family have reduced forelegs, so when you see them, it will seem that they have four legs instead of six. The first pair is reduced and barely visible. The monarch is bright orange with black wing veins and black margins around the outer portion of the wing. The dorsal, or top side, is brighter than the ventral, or bottom side, of the wing. The female is slightly darker, and the male has a dark scent patch in the middle of the top side of the hind wing. It is believed that it is from this patch that the male gives off pheromones to attract a female. This particular butterfly is widely distributed in nearly all of North America and parts of South America. The monarch is the only butterfly that annually migrates both north and south, overwintering in California and Mexico. Both overwintering or roosting areas are currently threatened by development and/or logging.

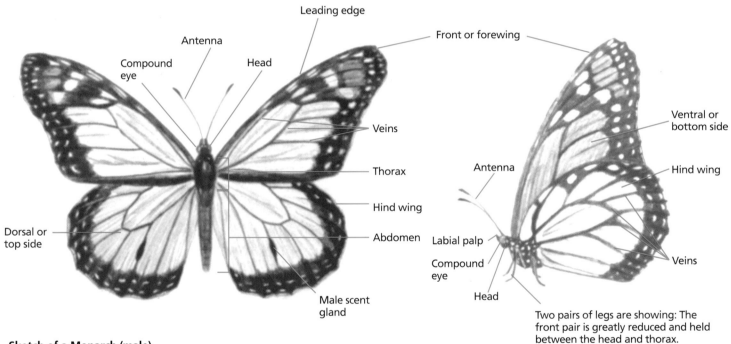

Leading edge
Antenna
Compound eye
Head
Front or forewing
Veins
Thorax
Hind wing
Abdomen
Dorsal or top side
Male scent gland
Ventral or bottom side
Hind wing
Antenna
Labial palp
Compound eye
Head
Veins

Two pairs of legs are showing: The front pair is greatly reduced and held between the head and thorax.

Sketch of a Monarch (male)

The Gulf Fritillary

The Gulf fritillary is also a fairly widespread butterfly and, like the monarch, a member of the Brushfoots, family Nymphalidae. At 2½ to 3¾ inches (6cm to 10cm), these beautiful creatures have long pointed forewings, typical of a large number of the subfamily Heliconiinae. They are bright orange with black, white and silver spots on both wings. Gulf fritillaries are relatively long-lived butterflies, living up to eight months, compared to some butterflies that live only two to four weeks. The Heliconius butterflies have a unique habit of intentionally collecting pollen on their proboscis, the extendable elongated tube used to take in nectar, sap and minerals. The protein from the pollen is absorbed through the proboscis, giving them an additional food supply. These butterflies also appear to have only four legs, again with the first pair being reduced. Gulf fritillaries fly in a steady manner with very shallow wing beats.

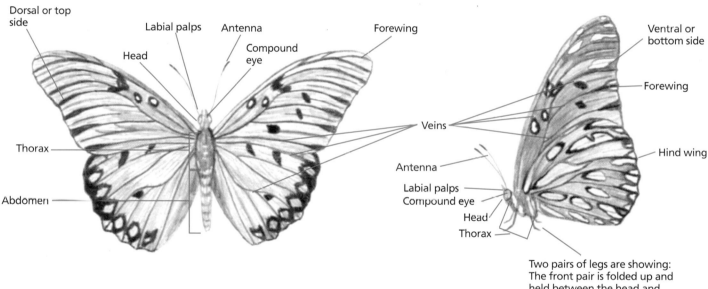

Dorsal or top side
Labial palps
Antenna
Forewing
Head
Compound eye
Thorax
Abdomen
Veins
Ventral or bottom side
Forewing
Hind wing
Antenna
Labial palps
Compound eye
Head
Thorax

Two pairs of legs are showing: The front pair is folded up and held between the head and thorax.

Sketch of a Gulf Fritillary

THE TIGER SWALLOWTAIL

Tiger swallowtails are members of the true butterflies, family Papilionidae, characterized by antennae with rounded clubs on the ends, slender bodies and larger wings. These butterflies have three pairs of walking legs and a unique trait: the forewing vein ends on the inner margin of the wing. Tiger swallowtails are 3½ to 6½ inches (9cm to 17cm), with beautiful yellow shades and black markings reminiscent of a tiger. As the name indicates, these butterflies have tails, which are elongations of the hind wing. There are two very similar tiger swallowtails within the U.S. borders: the western tiger (*Papilio rutulus*) present in the western U.S. and the eastern tiger (*Papilio glaucus*) present in most of the eastern U.S. Since both are so similar, using a field guide and the location are probably the best way to tell them apart. The eastern tiger swallowtail may be slightly larger than the western, and the female eastern tiger can be found in standard yellow or a dark form: the top side of the wing is black to dark brown and spotted with blue, orange and yellow; the bottom side is also dark with a shadow of the tiger striping. The western tiger swallowtail does not have this dark form. Each of these butterflies in its respective area is very conspicuous.

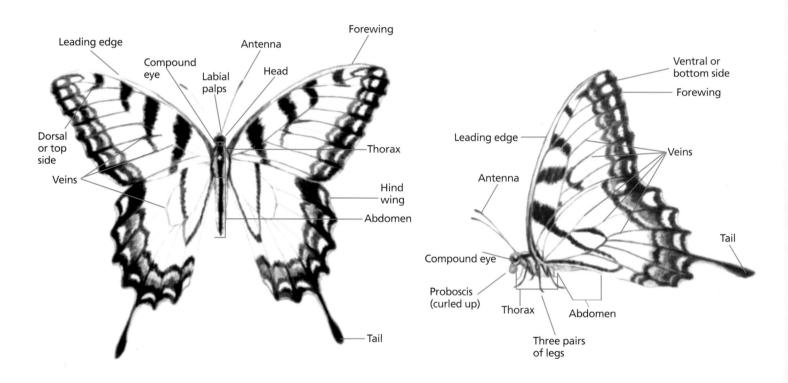

Sketch of an Eastern Tiger Swallowtail

Gathering Reference Material

OBSERVING, PHOTOGRAPHING AND SKETCHING

Prior to beginning a butterfly painting, I spend quite a bit of time photographing the subject. I have found the best time to do this is in the morning, because butterflies are like little solar gathering stations. They need the sun's warmth to heat them up prior to their daily activities. With this in mind, it is usually easier to approach and photograph them in the morning. After observing and photographing, I begin sketching and playing with composition. I always look for good light when working on a composition. While you are sketching, photographing or just observing, try to get into a position where the light plays off the wings or highlights the butterfly against the existing background. It's easy to just snap shots. Save your film and look for good composition, or shots that really show off the butterfly. You can photograph the flowers and plants after the butterfly has flown away. I look for compositions where the butterfly really stands out, without too many blooms, stems or foliage around it. Remember, if your photos have captured the butterfly lost in a bunch of flowers, you can delete these background elements when composing.

The sketch of the butterfly must be as anatomically correct as you can get it. I spend a great deal of time sketching and re-sketching until it is just right. If I make a mistake in my sketch, proportions or positioning, it is, of course, correctable during the painting, but I would rather work out the particulars now when it's less complicated. I have had to work out mistakes during the painting stage many times, so don't get upset if you have to do some correcting during the painting. Keep in mind the size of the piece and the size of the flowers and flora in your composition. You don't want a giant butterfly sitting on a tiny flower! Know the particular flower size or background that you are putting your butterfly into and keep it all in proportion.

Compositional Sketch Showing Light Source

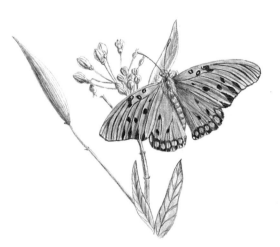

Detailed Sketch

Tips on Sketching Accuracy

Use field guides and reference books to augment your photos when working on anatomical accuracy.

Creating Texture in a Butterfly's Wings

This demonstration portrays one of the most familiar butterflies: the monarch. The rich color and striking contrast of this butterfly make it a joy to paint. Detailed veins in the wings and a fuzzy body will help this monarch come to life.

Monarch Materials List

Palette
- Burnt Sienna
- Burnt Umber
- Cadmium Yellow Mid
- Carbon Black
- Nimbus Grey
- Payne's Grey
- Vermilion
- Raw Sienna
- Warm White

Brushes
- no. 4 cats' tongue
- no. 6/0 liner
- no. 4 shader
- nos. 3, 2, 1, 0, 00, 000 rounds

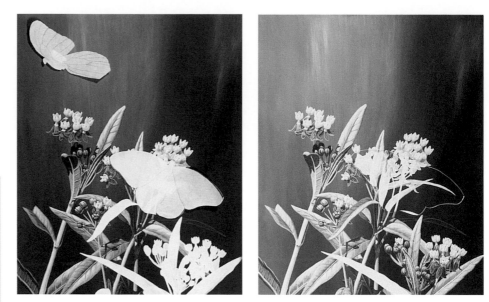

1 Position the Butterfly

After you have a good sketch that you're comfortable with, use onionskin paper to trace over it. Then cut it out and place it on the painting. Determine where you want the butterfly to be placed by moving your cutout around the painting. Once you have decided, trace around the cutout using a very watered-down mixture of Warm White and water and the no. 6/0 liner. (A small piece of rolled tape will keep the cutout in place.)

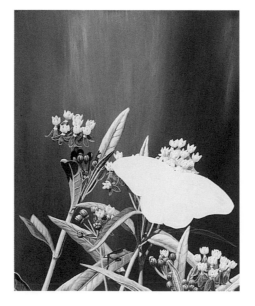

2 Fill in the Outline

This traced line needs to stand out enough for you to see it. Once outlined, use the no. 4 cats' tongue brush to paint in what will become your underpaint. Use Warm White slightly watered down. Keep applying it until the colors under the butterfly are gone or just a slight shade remains.

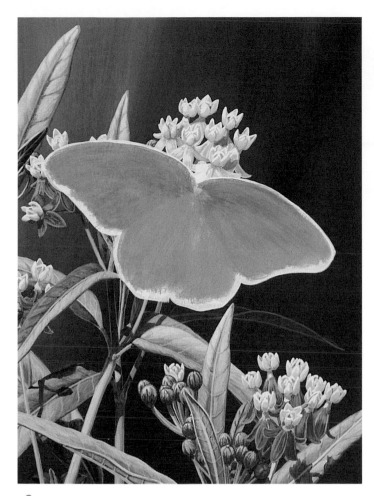

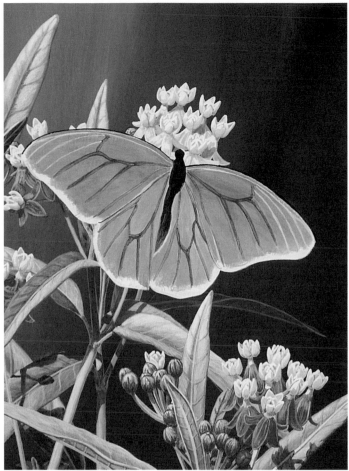

3 Fill in the Color and Blend the Values Using Layers

Use the no. 4 shader to fill in the monarch wings with a mixture of a little Burnt Sienna, Raw Sienna, Cadmium Yellow Mid, just a touch of Vermilion and water. Lay this mixture on so the color value goes from lighter at the ends to slightly darker toward the body. Give each layer of wash a minute to dry or you will just pick up the last layer. If it seems too dark, you can lighten it later.

4 Add the Wing Veins

Now this is the tricky part! First use the no. 1 round and Carbon Black to lay in the body shape. This is your landmark for the orientation of the veins. This beauty has landed sort of sideways and his body partially hides the wings on the right. Use the no. 6/0 liner and watered-down Warm White to add the wing veins and the outline that separates the wings. Do not worry if you make a mistake or do not like the way the veins were laid down. You can overpaint any mistakes with the combination of paints used in step three, making the color close to the base color. Once the veins are laid in with Warm White, use a no. 1 round to go over them with Burnt Sienna. Then use Carbon Black and the no. 6/0 liner and lay in the front edges of the forewings.

Sizing Your Subject

Sketch and paint these demos in a size that is comfortable for you. I like painting life size or sometimes a tiny bit larger, which could mean a tiny little critter and a very steady hand. Remember to keep sizes of all components of the composition in proportion.

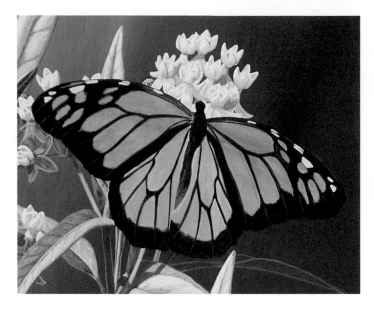

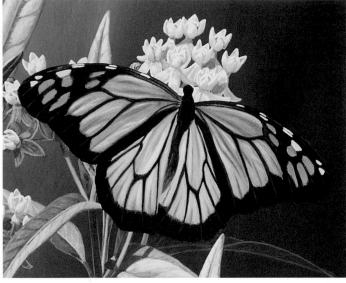

5 Lay in the Wing Markings

Using the no. 3 or 2 round, begin adding markings to the monarch's wings. Use Burnt Sienna to lay in the edges of all the markings that border orange. Then use a wash of Burnt Umber and Carbon Black to lay in the dark markings and Warm White mixed with a little Nimbus Grey for the white markings. Leave the white edges of the wings and the white dots until later. Don't worry about the markings being perfect in shape. Each butterfly is slightly different, just like we are.

6 Add Texture Around Veins and Valleys

Using a wash of Burnt Sienna and the no. 6/0 liner, add the contour valleys between the veins. Each area between the veins has these lines or valleys in the wing surface. Then using a wash of Cadmium Yellow Mid and Warm White, highlight the edges of these valleys using small short strokes with the no. 6/0 liner. As you are doing this, try to replicate the tiny scales on the butterfly's wings. Leave the edges next to the veins the original color, so that when you darken the veins there is a gradual transformation from black to Burnt Sienna. Then go over the Cadmium Yellow Mid and Warm White highlights in the valleys with just Cadmium Yellow Mid. Once this is set, highlight the contours with a Warm White wash. Work your strokes toward the wing edge.

7 Fill in the Darks

Using the no. 000 round, go over the veins with Burnt Sienna where the prior strokes were overpainted in the dark areas. Fill in the areas that were overpainted using Burnt Umber and Carbon Black. Move your brush using small strokes flowing toward the wing tips. When finished, the edges of the black areas should progress from black to Burnt Sienna to Raw Sienna as they progress toward the lighter-colored areas between the veins and valleys.

Use the no. 6/0 liner and Carbon Black to fill in the centers of the veins and the wing edges. When these are dry, use Payne's Grey and a little Warm White to go back over the veins, highlighting them to raise them above the wing surface. Be patient here!

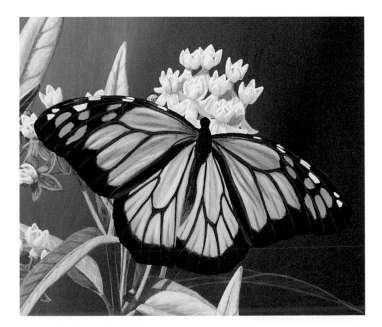

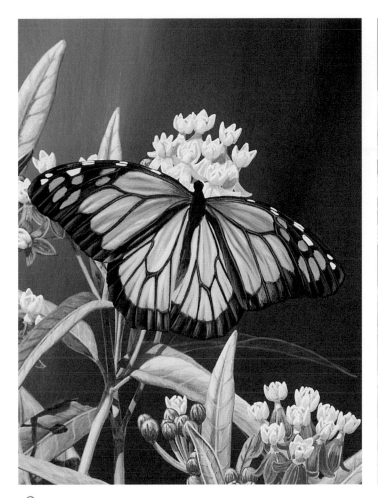

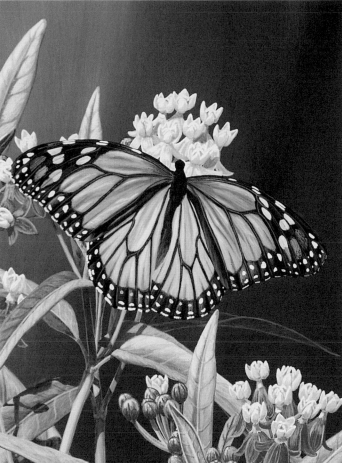

8 Soften and Deepen the Wings

To achieve depth and bring out the wing veins, use the no. 6/0 liner and a mixture of Warm White and water to go over the centers of the veins with a very thin line. Use a mixture of Carbon Black and Warm White to soften the areas of black where the light is strongest, along the wing edges (dark areas) and in between the veins and valleys. Remember, the wings are not flat; they are up and down like hills and valleys. This softening of the raised dark areas will really carry this effect. Again use short strokes moving toward the wing edges.

Use the no. 2 round and Burnt Sienna thinned with water to slightly darken the base areas of the forewings, working to the lighter base color already there. Move your loaded brush from the base of the forewing outward, applying the most color at the base.

As you are layering in the lighter values, don't worry about accidentally carrying these strokes into the black areas. You can go back and overpaint any dark areas.

9 Finish the Wing Markings

Using the no. 2 round, begin adding the white markings using a mixture of Warm White and a little Nimbus Grey. This may take a couple of layers or washes. Once they are dry, highlight the brightest areas by retouching these spots with Warm White using the no. 000 round.

Then using the no. 2 round and a mixture of Raw Sienna and a little Warm White, fill or add the markings to the forewing. Again, this may take two or three layers. Mix Burnt Sienna with Burnt Umber and, using the no. 00 round or your sharpest brush tip, darken the three orange forewing spots by stippling (using the very tip of your loaded brush to touch small color spots to your painting) while pulling your brush tip toward the end of the wing. When working this detail, keep the brush tip sharp by mixing and then pulling your brush tip through the paint on the palette, rather than by dabbing.

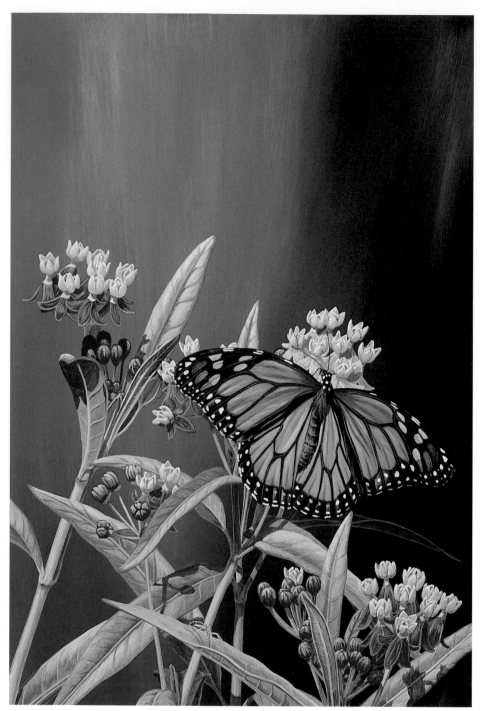

Royal Visitor
Monarch on Milkweed
12" × 9½" (30cm × 24cm)

10 Finish the Body

Start with the no. 1 round and fill in the body using Carbon Black for the head and thorax (the area just behind the head), then mix Carbon Black with Burnt Umber and fill in the abdomen. Use the no. 00 round to lay in the dividing lines of the segments of the abdomen using Carbon Black. Using the no. 6/0 liner and a mixture of Warm White and Carbon Black, create the little hairs on the body. Do this by making short strokes toward the back end of the abdomen. Leave the thorax black for now. Once these little hairs are dry, use the same brush and Burnt Umber thinned with water to go over them. This should take only one coat. Now mix a little Burnt Umber with Burnt Sienna and lay in the shadow at the end of the abdomen.

Using the no. 6/0 liner and Carbon Black with a little Warm White, start at the head and lay down the antennae and proboscis with one smooth stroke for each. Then use the no. 000 round and Carbon Black to add the rounded club at the ends of the antennae. Highlight the antennae and proboscis with a very thin mix of Warm White and Carbon Black.

Use Warm White and a little Nimbus Grey mixed together for the spots, then retouch the same spots with just Warm White. For the last touches, use Warm White to highlight the spot where light is strongest on the hard shell (the area in the center of the abdomen that is surrounded by hairs), thorax and on the tips of the antennae.

Concentrating on Light and Shadow

In this demonstration we will be working on varying intensities or degrees of light and how to achieve different effects. A butterfly on a cloudy day will have a richer, darker color than a butterfly in full sun. Keep this in mind during the composition process. A brightly lit butterfly against a shaded composition may not work right. In essence, keep your values uniform throughout the composition . Increasing the light on part of the wing will also increase the darkness on the shaded part. Balancing this effect will make the butterfly believable. Remember, the intensity of light hitting the color will dictate how rich or washed out it looks. It's like an overexposed photograph compared to an underexposed one. In this demonstration, we start with a swallowtail with the base colors added. Our light source or direction of light hitting the subject has been determined.

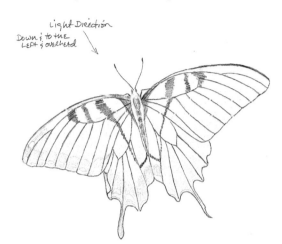

Light Direction
Down & to the
Left & overhead

Hand-sketched work showing light source direction.

<div>

Swallowtail Materials List

Palette
- Burnt Sienna
- Burnt Umber
- Cadmium Orange Mid
- Cadmium Yellow Mid
- Carbon Black
- Nimbus Grey
- Payne's Green
- Raw Sienna
- Turner's Yellow
- Ultramarine Blue Deep
- Ultramarine Blue
- Warm White
- Yellow Light

Brushes
- no. 6/0 liner
- no. 4 shader
- nos. 2, 0, 000 rounds

</div>

Cutout of Swallowtail
The same sketching process followed by a cutout of onionskin paper was used here as in the previous monarch demonstration (see page 18).

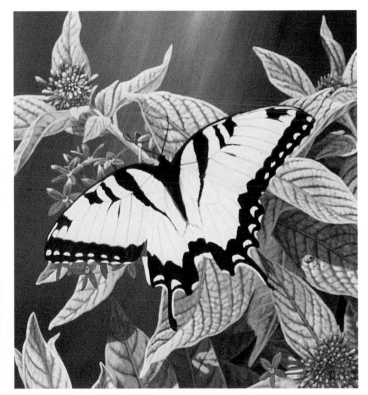

1 Add Base Values and Patterns
Add base values to the swallowtail using a mixture of Cadmium Yellow Mid, Warm White, Raw Sienna and Yellow Light. Add the dark markings using a Carbon Black, Burnt Umber and water mixture.

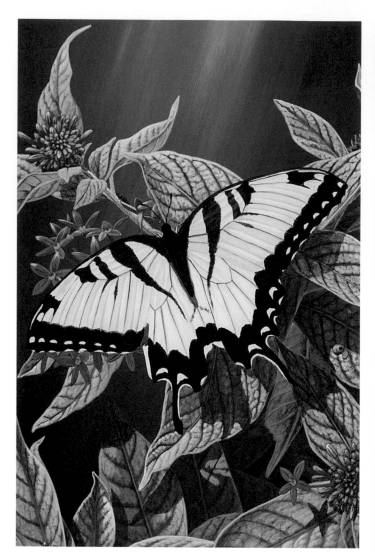

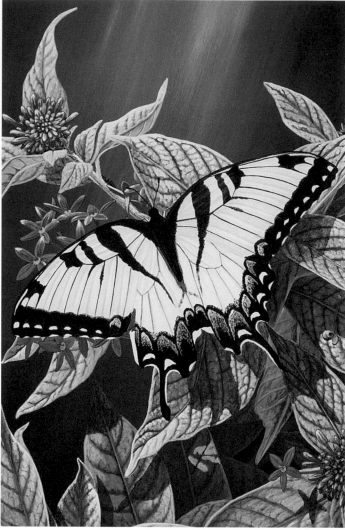

2 Deepen the Color

First we will work on a low-light situation and really try to turn up the color. In this example the day is not dark but partly cloudy, just slightly subdued. The shadows soften and the colors get richer. Use the no. 2 round and Turner's Yellow to lay in the valleys and creases in the wing surface and also the edge of the forewing where it overlaps the hind wing. You want to create a slight rounding at the edge of the forewing, so the value should be dark to light working from the edge in. Using the same mixture, shade the areas of the wings just next to the veins using short strokes moving toward the wing tips. Now you can use Carbon Black to overpaint all the dark areas that have overstrokes from the prior steps, while leaving a slight edge of the underpainting around the areas that touch yellow.

3 Create the Metallic Look on the Markings

Using the no. 0 round and Warm White, underpaint where the blue spots at the base of the hind wing will be by just touching the painting with the tip of the brush with almost a stippling effect. You will come back later and add the correct colors. Now using the no. 000 round and Carbon Black use the same stippling method around the edges of the black markings, starting with a loaded tip near the black and moving out into the yellow. With the same mixture, trace over the veins, a procedure that will lift them above the wing surface.

Underpainting

By underpainting with white, you allow the next layer or color to be cleaner and richer, which can really make it jump.

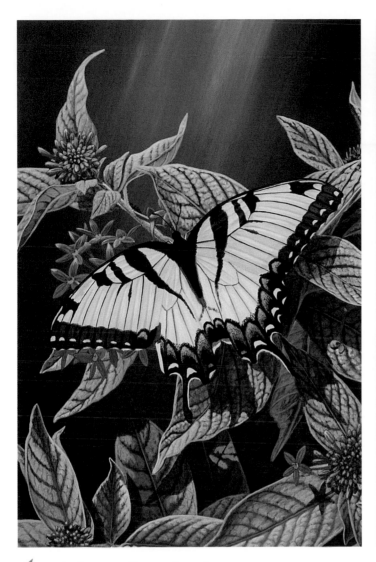

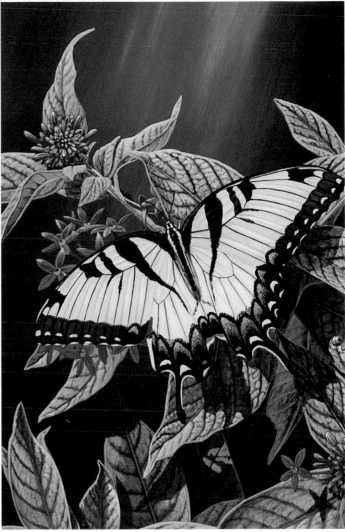

4 Finish the Metallic Look and Highlight the Darks

With the no. 0 round, apply Ultramarine Blue Deep to the white spot area on the hind wing. Then mix Ultramarine Blue with just a little Warm White, and using the brush tip, dot over the Ultramarine Blue Deep. This creates the metallic look to the spots. Use the same brush loaded now with Cadmium Orange Mid and lay down the orange areas at the back of the hind wing. When this is dry, use Cadmium Yellow Mid to lightly stipple the Cadmium Orange areas. Now use your sharpest brush tip and a mixture of Burnt Umber, Burnt Sienna and Warm White to highlight the back edges of the two forewings. Work this in thin washes, moving your brush toward the edge of the wing. Then use the same brush and Carbon Black to lay in the veins and valleys. Stay with the same brush and a mix of Warm White and Carbon Black to highlight the valleys and peaks on the two hind wings. Once this is dry, mix Burnt Sienna with just a little Burnt Umber and put a wash over the highlights that you just laid down.

5 Fill in the Body

Moving to the body, which is underpainted with Carbon Black, use the no. 6/0 liner and Warm White to lay in the hairs moving out and away from the body edge. Overpaint this white with a mixture of Cadmium Yellow Mid and a little Yellow Light. Keep in mind that this is subdued light so do not brighten these hairs too much. Now using the same brush, highlight these hairs by adding lines of Raw Sienna.

Use the no. 000 round and Payne's Grey to highlight the eyes, thorax and antennae, and add the wing veins in the dark areas. By now, you should have a pretty good representation of a butterfly in low-contrast/low-shadow lighting.

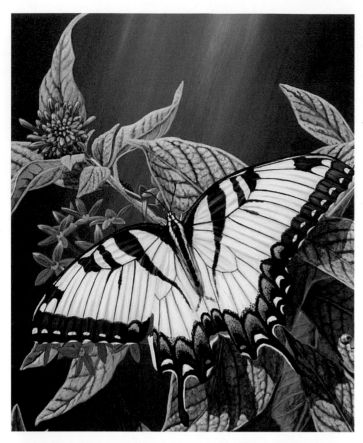

6 Turn Up the Light

Using the same butterfly from the low-contrast position, we can now turn from the impact on the amount of light hitting the subject. Using the no. 2 round and a mixture of Warm White and Yellow Light, go over the peaks and ridges above the valleys and creases of the front two wings. It will take two or three coats to brighten up these areas. Follow this with a thin wash of Warm White and water, going over the same areas and the hind wings. Stipple the yellow spots along the edges of the wings and the bright sides of the veins on the forewings using Warm White and your finest brush tip.

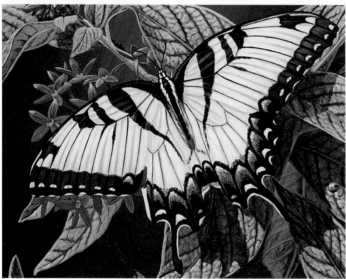

7 Tone Up the Body

Now use the no. 6/0 liner and Yellow Light to go over the little hairs on the body, moving from the body outward. When this has dried, lay in a few hairs using Warm White. What we are doing is toning everything with highlights. Using the same brush or a no. 000 round and Warm White, stipple the blue dots. Then mix Yellow Light with Warm White and stipple the orange dots. Just a few little stipples is all that these areas will need.

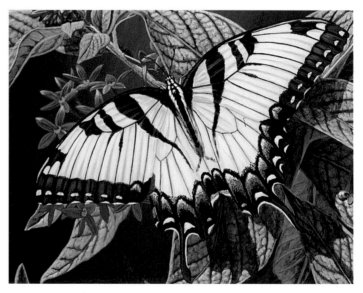

8 Highlight the Contours and Veins

Where the wing is shadowed by its contours, use a mixture of Turner's Yellow and Nimbus Grey to darken these areas. Using the no. 000 round and a mixture of Carbon Black and a little Warm White, highlight the dark areas and the veins. Remember your light source and leave the shadow areas darker than the corresponding features. Now use a mixture of Payne's Grey and Warm White to highlight the thorax, eyes and antennae. Go over these areas with Warm White, leaving the edges of the underpainting showing.

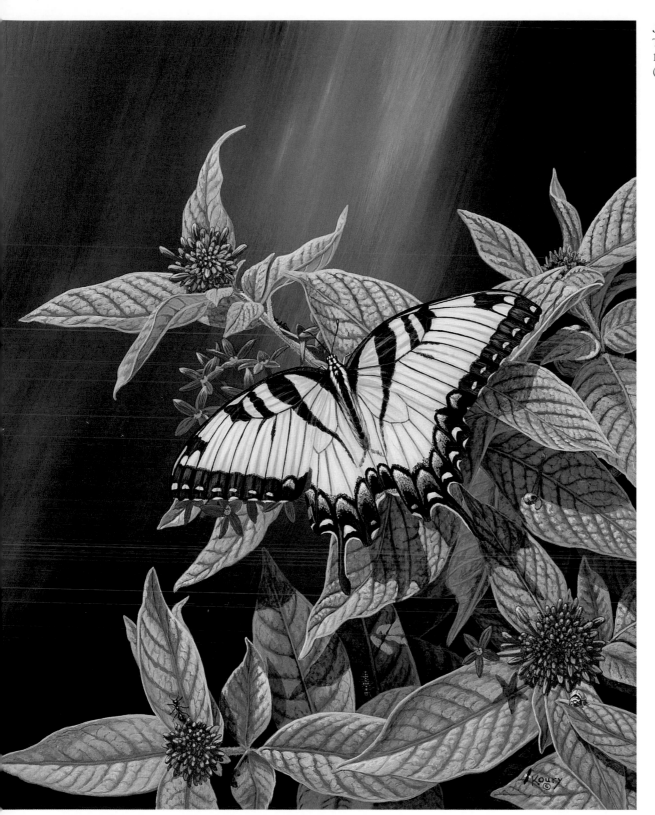

Summer's Best
Tiger Swallowtail
11⅞" × 9⅜"
(30cm × 24cm)

We have taken the same butterfly from a basic color to a richer color and then to a brighter higher-contrast color by overpainting richer and then lighter values. This method can be applied in many situations as long as the color values are close to each other. Be aware of your light source and be sure your shadows and values follow that source.

Wing Topography

As you are working on the values of the wing, think of its topography, its ups and downs—and use your values to highlight these peaks and valleys.

27

Achieving the Effect of Light Through the Wings

In this demonstration we will work on establishing and conveying the effect of light through the wings of the Gulf fritillary and the tiger swallowtail. Butterflies with lighter-colored wings lend themselves to this very well. Darker butterflies that are backlit tend to exhibit a sort of corona effect around the edges while the wings stay fairly dark.

Gulf Fritillary Materials List

Palette
- Burnt Sienna
- Carbon Black
- Burnt Umber
- Napthol Red Light
- Cadmium Orange
- Raw Umber
- Warm White
- Cadmium Yellow
- Cadmium Yellow Mid

Brushes
- no. 6/0 liner
- nos. 1, 0, 00, 000 rounds

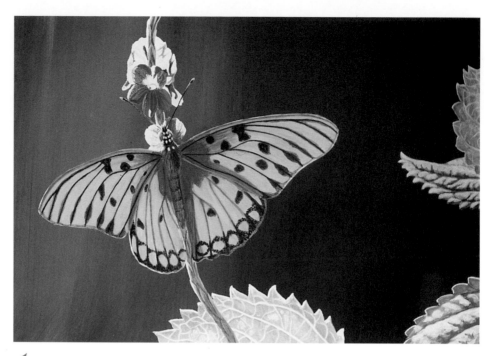

1 Increase the Value

This step was preceded by painting in the background and sketching in the butterfly. The lightest value in the wings was established with Cadmium Orange, Cadmium Yellow and a little Burnt Sienna for the wings and the same mixture plus a little more Burnt Sienna for the inside portion of the wings. The dark areas and the veins were filled in with Burnt Umber. The back edges of the hind wings were laid in with Raw Umber.

Using the no. 0 round and a mixture of Burnt Sienna and Napthol Red Light, lay in the shadow at the base of the wing working your strokes outward toward the tip of the wing and to the shadow line that I have laid in. On the portion of the wing where the backlight is hitting, use the no. 0 round and a mixture of Cadmium Yellow Mid and a little Cadmium Orange to fill in the wing surface until there is a strong value change between the two areas. Do not worry about overlap; you can go back and work the line where the shadows meet the light using the Burnt Sienna and Napthol Red Light to cover.

Using the no. 1 round and Carbon Black, darken in the areas of Burnt Umber by stippling, again leaving the very edges Burnt Umber. Also use the same Carbon Black and the no. 6/0 liner to lay down the veins of only the two front wings, overpainting the Burnt Umber, but leaving the edges Burnt Umber. Then use Burnt Sienna for the veins of the hind wings. Remember, these markings will not be too dark because of the light coming through the wings, except in the valleys toward the back edge where you will use a mixture of Carbon Black and Burnt Sienna and your sharpest brush to lay in these fine lines.

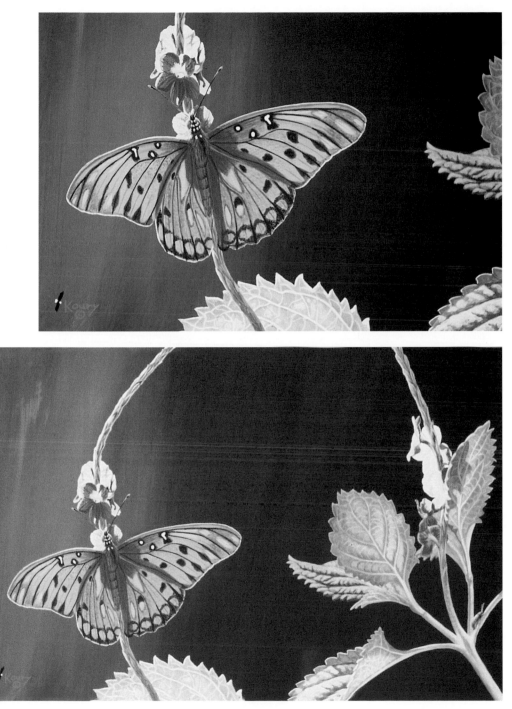

2 Turn Up the Light and Harden the Shadows

With the no. 1 round and Cadmium Orange with a little Cadmium Yellow Mid, use small strokes originating from the shadow line and moving outward to the wing tip. This will darken the shadow values while really lighting up the wing. Now use the no. 00 round and Burnt Sienna mixed with Raw Umber to fill in the front of the wing markings that are showing through. These are lighter areas on the other side of the wing and are bordered by a darker color. Now use Burnt Sienna mixed thinly with water to shadow the hind wings and tips of the forewings using the same brush. Using the no. 000 round, fill in the white markings on the wings using a mixture of Warm White and water. Once these are dry, go over the wing edges—just the very edges—with Warm White, and be patient. This may take two layers to get the glow or corona that we want.

In the Spotlight
Gulf Fritillary
6" × 9" (15cm × 23cm)

Enhancing Light Effects

In the following swallowtail example, we are working with a much lighter wing surface so the effects of light through this wing will be even more enhanced. The trick here is to convey light through the wing without washing out the color and making it seem like a reflective surface. Again we will start with the lightest values already established.

Swallowtail Materials List

Palette
- Burnt Umber
- Carbon Black
- Cadmium Orange
- Cadmium Yellow Mid
- Nimbus Grey
- Payne's Grey
- Raw Sienna
- Turner's Yellow
- Ultramarine Blue Deep
- Yellow Light
- Warm White

Brushes
- no. 4 shader
- nos. 5, 2, 0, 00, 000 rounds

1 Establish the Base Values

Use the no. 4 shader and a Burnt Umber and Carbon Black mixture for the dark areas and Yellow Light, Cadmium Yellow Mid and Warm White for the light areas. For the wing that light is passing through, use the same combination plus Warm White and a little less Cadmium Yellow Mid. Use the same mixture plus Raw Sienna and Turner's Yellow for the shaded areas.

2 Darken the Shadows

Use a mixture of Cadmium Yellow and Nimbus Grey and the no. 6/0 liner to lay in the valleys between the veins, the edge of the forewing separating it from the hind wing and the shadowed edges of the veins. Mix Cadmium Yellow Mid and Nimbus Grey with just a little Turner's Yellow and using the no. 5 round, fill in the shaded portion using small strokes, overlapping slightly and moving toward the wing tip. There should be a slight color value change from the valleys, the edge of the forewing, and the rest of the shaded wing surface.

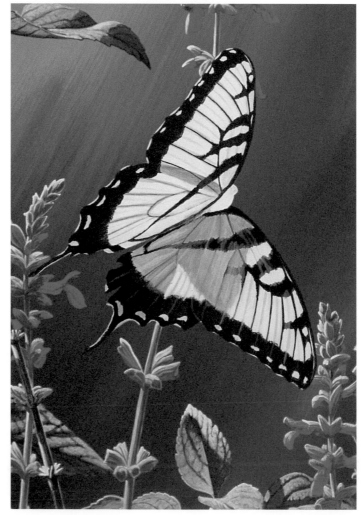

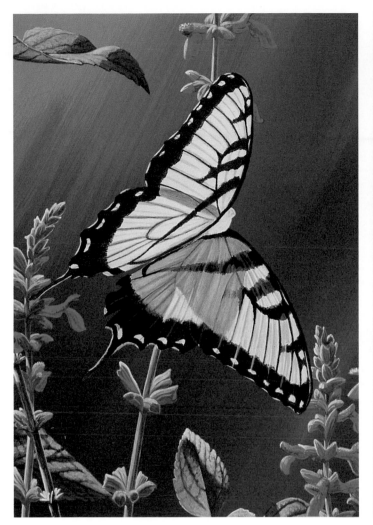

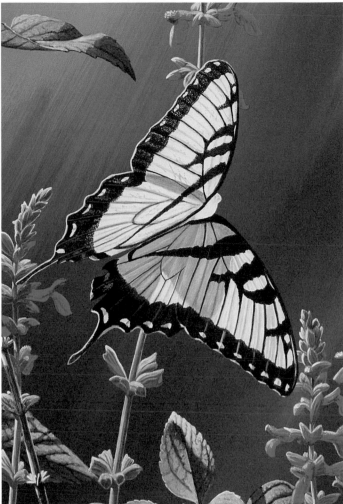

3 Turn Up the Warmth

On the shadowed wing, begin by using the no. 2 round and Yellow Light. Lay the paint down where the light meets the shadow and work toward the wing tip. Leave the valleys and edges next to the veins the original undercolor. This may take several layers. Keep going until it glows yellow, not white. Then using the no. 2 round go back to where the shadow meets the light and use a mixture of Turner's Yellow and a little Cadmium Yellow Mid to define the line. This application needs to be very wet. Use more water than paint so that it's a wash and apply evenly over the whole shadow. This also may take a few coats. Work it until its value is uniform in the shadows. Allow each wash or glaze to dry before applying the next or it will lift off. Then use the no. 00 round and a mixture of Warm White and Cadmium Yellow Mid to define the contours in the shadow on the wing that the light is passing through. Use the no. 00 round and Warm White to lay in the highlights between the veins and the valleys. It will take several washes to get these areas to almost white (barely yellow).

4 Darken the Values and Highlight

Using the no. 3 round and Carbon Black, go over the dark wing markings, leaving the edges Burnt Umber. Stipple around the wing markings using the no. 000 round and Burnt Umber. Use only one application here; you do not want this too dark. Take the no. 000 round and Warm White mixed with Yellow Light and lay in the wing edges. Follow this with Warm White along the edge of these yellow edge markings only on the wings the light is passing through. Use your finest brush tip and go over the veins using Carbon Black for the forewings and Burnt Umber for the hind wings. When dry, stipple with the no. 000 round using Ultramarine Blue Deep and a little Warm White for the blue area and Cadmium Orange and a little Cadmium Yellow Mid for the orange area.

Problem/Solution

If your lighter color values are not what you want, do not keep applying more paint. Overpaint the area with White and start again. This will save time and provide a cleaner color.

5 Finish the Body

Use the no. 0 round to fill in the head and body with Carbon Black. Then use the no. 6/0 liner to lay in the antennae with Carbon Black, and with Warm White to lay in the little hairs on the side of the thorax and head. After it has dried, overpaint the white with Cadmium Yellow Mid. Once this has dried, lay in a few strokes with Yellow Light to create depth on the hairs. Then using the same brush, go over a few hairs with Raw Sienna to further increase the depth. Now use the no. 000 round and a mixture of Nimbus Grey and Payne's Grey to highlight the eyes, thorax and antennae. Then use the same brush and a mix of Warm White and Carbon Black to highlight the dark spots where the light is hitting the reflective wing. Keep in mind the ups and downs of the wing. Use only one coat and base your value on how strongly the light is hitting these areas. Use your sharpest tip and highlight the veins on the shadowed wings using Warm White with a little Carbon Black, increasing the amount of Warm White as you move into the areas that direct light is hitting.

Slight differences in color values and subtle hues show contour and shadows. As we stepped up the color and light in one area, we strengthened the shading or shadow on another area simply by toning one area up or down.

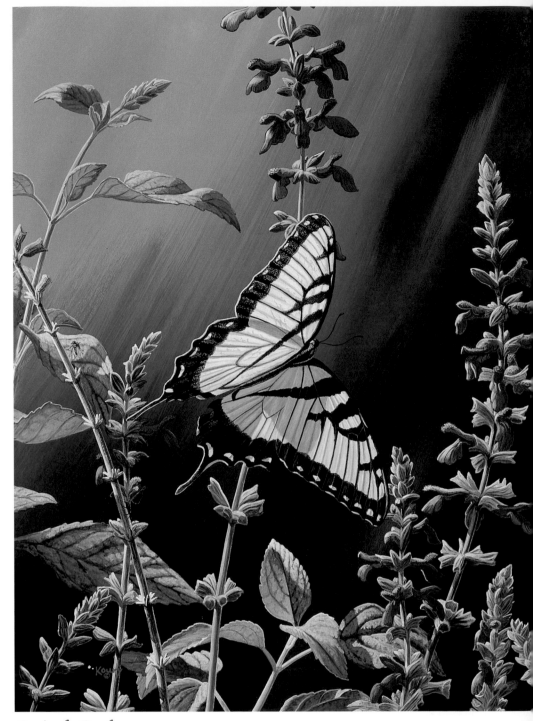

Passion for Purple
Tiger Swallowtail
12" × 9" (30cm × 23cm)

Utilizing Wing Positions

The placement of your butterfly, the positioning of its wings and the values of your background each can work to create a greater impact. In the examples on this page, placement, wing positioning and background values have all been used to create interesting compositions and increase drama.

Wing Position

The light on this fritillary is enhanced by the relatively dark background, which pushes the butterfly forward. The wing position creates an interesting shadow on the back wing, further deepening the piece and carrying the eye from the brightest value on the forewing upward along the rear wing.

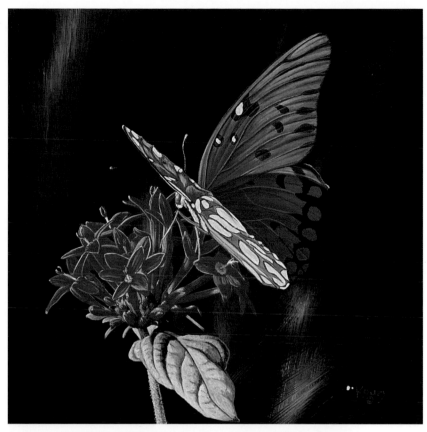

Fritillary on Pentas
Gulf Fritillary
7" × 5" (18cm × 13cm)

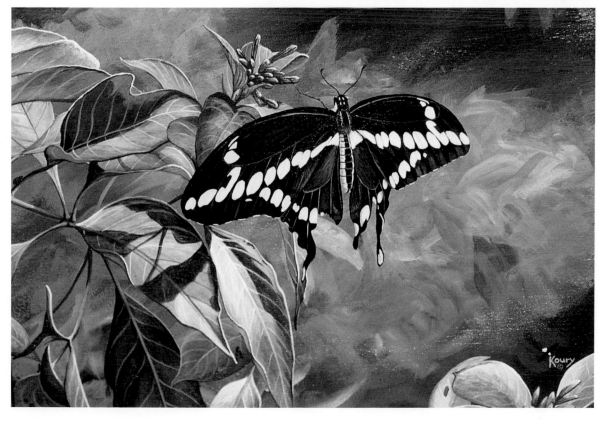

Background

The butterfly is positioned over a multi-hued background, which serves to push the butterfly forward. The spread wing position and dramatic wing markings draw the eye to the center of the butterfly's body.

Black Beauty
Giant Swallowtail
7" × 10"
(18cm × 25cm)

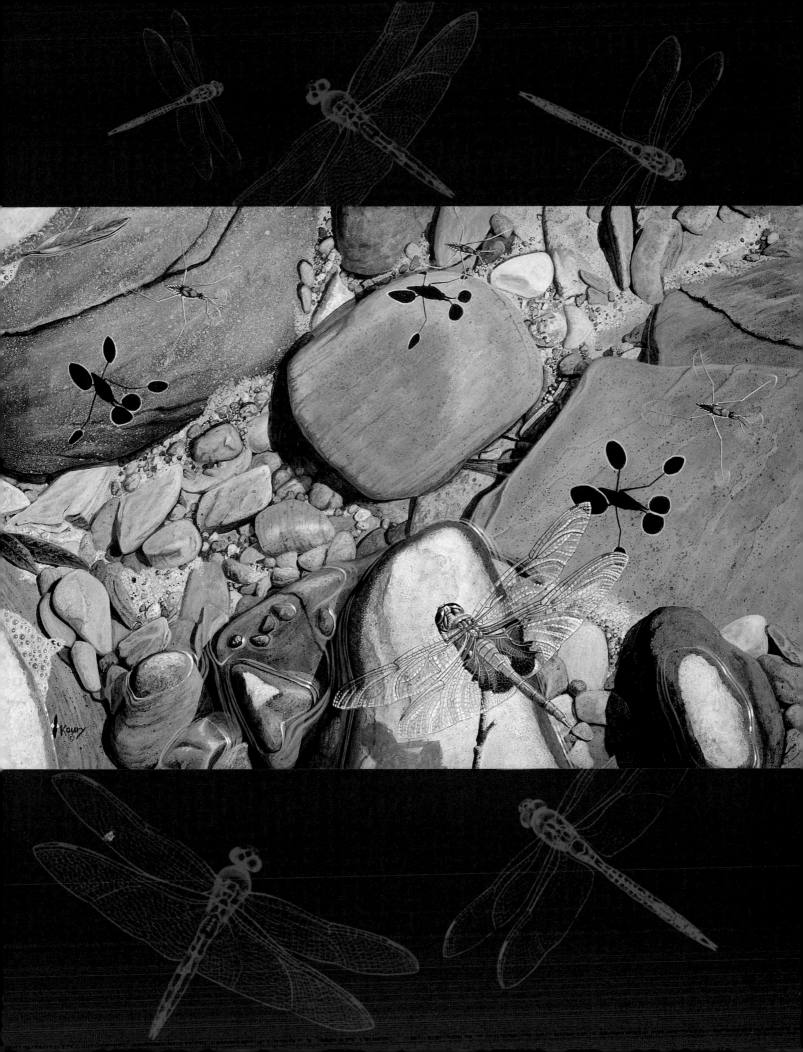

DRAGONFLIES AND DAMSELFLIES

Flight—I am always fascinated by the ability certain creatures have to fly. Dragonflies and damselflies are the most agile flyers in the insect world, due in large part to four marvelous wings and how they use them. I could watch them for hours on end while they venture out from a favored perch and return again.

The amazing colors of their bodies and their wonderful eyes become my focal point. This chapter focuses on how to achieve those wondrous transparent wings, as well as how to create the be-jeweled bodies and colorful eyes.

Dragon Rock
Dragonfly and Water Striders
8½" × 12" (22cm × 30cm)

Anatomy of Dragonflies and Damselflies

Dragonflies and damselflies are two of nature's little jewels, ranging from 1" to 4" (3cm to 10cm) in length. The outside of their bodies functions as the skeleton. It is not made of bone, but rather of a light, hard yet flexible material called *chitin*. The external shell or casing is usually very reflective and highly colored, exhibiting all the colors of the rainbow as well as some jewel-like metallic colors. The colors of these outer shells make dragonflies and damselflies not only two of nature's most beautiful creatures, but also a ton of fun to paint. Their bodies are usually long and slender with two sets of wings, usu-

ally about the same length. Scientists are still trying to find out just how these wings function and how dragonflies and damselflies actually fly. These critters are in the scientific order Odonata and are found virtually everywhere, yet they are strongly associated with water. They are predacious, and some species eat huge numbers of mosquitoes. Their young are aquatic and also predacious and are called *naiads*. They may spend up to a year in the water before emerging and becoming adults.

Dragonflies and damselflies are unusual in that they are the only two-winged insects with prominent marks

at the ends of the wings, sometimes dark, other times a lighter color. It is believed that these spots, which are filled with fluid, act as counterbalances that may reduce vibrations caused by air flowing over the wings. Their wings are truly wondrous! They are supported by a network of veins that carry fluids and nerves throughout the wings. The clear or membranous portions of the wings are mostly nonliving cuticle. The arrangement of the veins is one of the defining features of each species of dragonfly, acting as a major classification tool. These wondrous wings can move in unison or independently, allowing

Dorsal View

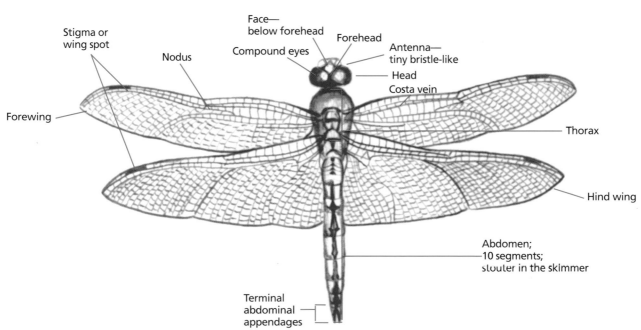

Stigma or wing spot · Nodus · Face—below forehead · Forehead · Compound eyes · Antenna—tiny bristle-like · Head · Costa vein · Forewing · Thorax · Hind wing · Abdomen; 10 segments; stouter in the skimmer · Terminal abdominal appendages

Skimmer Dragonfly
Notice the hind wings overlap the body, and in this particular example, the abdomen tapers away from body.

the insect to stop abruptly, turn on a dime and even fly backwards. Simply put, they make the dragonfly one of the most agile flyers there is. The wings of all dragonflies are not the same shape, so keep this in mind when painting them.

Dragonflies also come in several slightly different body shapes and are divided into families: darners, skimmers, clubtails, petaltails, spiketails, cruisers and emeralds.

The dragonfly's front pair of wings is shaped differently than the rear pair of wings, and at rest they are held straight out to the side. Damselflies have four wings as do dragonflies, but their wings are shaped identically. At rest a damselfly's wings are normally held above the body, or to the side as in the spread-winged damselfly. This is one of the best ways to tell the difference between these critters. Size is another distinguishing factor; dragonflies are usually larger than damselflies. Both dragonflies and damselflies have very short bristly antennae.

Both of these insects spend a great deal of time foraging, defending territories and mating. They hunt on the wing, catching their prey in midair. Smaller insects, ones that we may not be able to see, are caught with their mouthparts. Larger prey are captured in their spiny legs. Dragonflies and damselflies tend to hunt from a favored perch, which allows us to pull up a seat and watch. The best time to watch these behaviors is later in the day when the critters have warmed up. They are best photographed in the morning, however, when they are not as active and tend to remain still when approached. These critters present all kinds of jewel-tone and metallic colors to paint. Their eyes are fascinating to me; in some species they are very colorful. Most are clear-winged, but some are tinted yellow, red or orange and have colored patterns or markings.

Dorsal View

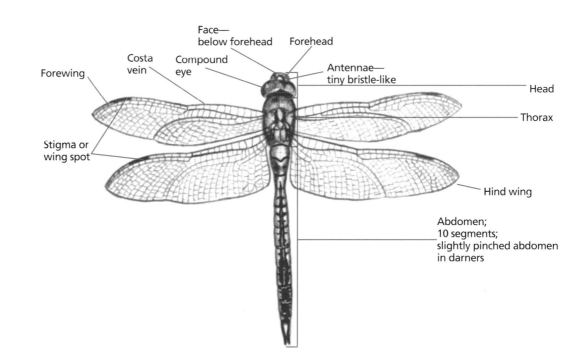

Face—
below forehead Forehead
Costa Compound
vein eye Antennae—
Forewing tiny bristle-like
 Head
 Thorax
Stigma or
wing spot
 Hind wing
 Abdomen;
 10 segments;
 slightly pinched abdomen
 in darners

Darner Dragonfly
In larger dragonflies, the hind wings do not overlap and the abdomen widens, then tapers as it moves away from the body.

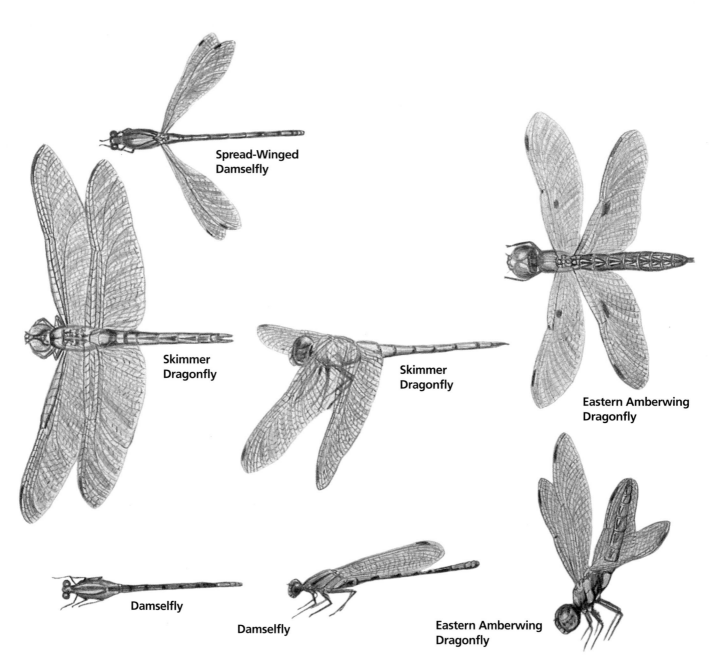

Spread-Winged Damselfly

Skimmer Dragonfly

Skimmer Dragonfly

Eastern Amberwing Dragonfly

Damselfly

Damselfly

Eastern Amberwing Dragonfly

Dragonflies and Damselflies

Dragonflies are usually larger and more thick-bodied than damselflies. Dragonfly wings consist of two sets of differently shaped wings while damselflies have four wings that are identical. Dragonflies hold their wings out to the side when at rest, while most damselflies hold their wings together above their bodies (with the exception of the spread-winged damselfly which holds its wings to the side when resting). Both dragonflies and damselflies have stigmas (darker colored spots) at the tips of each wing and most are beautifully colored.

The eastern amberwing is a smaller species of dragonfly and is shown here (lower right corner) with the tip of the abdomen held toward the sun. It is believed this behavior helps to prevent overheating by reducing the amount of body surface exposed to the sun.

Achieving Translucency in Dragonfly Wings

The demonstrations in this section will center around painting these beautiful insects and achieving the translucency of their wings. We will again use the sketching/cutout method used in the previous chapter and stress the importance of a good accurate sketch. The bodies need to appear slim and delicate, so it is very difficult to correct anatomical mistakes with these guys—it may be necessary to start over with these critters, so do not be disappointed; just be patient!

Dragonfly Materials List

Palette

- Burnt Sienna
- Burnt Umber
- Carbon Black
- Cadmium Yellow Mid
- Dioxazine Purple
- Green Light
- Hooker's Green
- Payne's Grey
- Raw Sienna
- Sapphire
- Turner's Yellow
- Ultramarine Blue
- Ultramarine Blue Deep
- Warm White

Brushes

- no. 6/0 liner
- nos. 5, 2, 1, 0, 00, 000 rounds

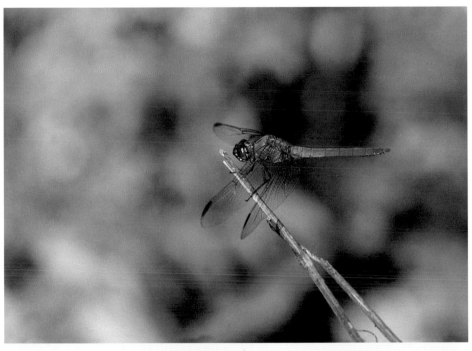

Reference Photo:
Dragonfly Body Posture
Don't be alarmed if you see only two pairs of legs in your dragonfly reference photos; some dragons have reduced front legs that are held between the head and thorax and are very hard to see.

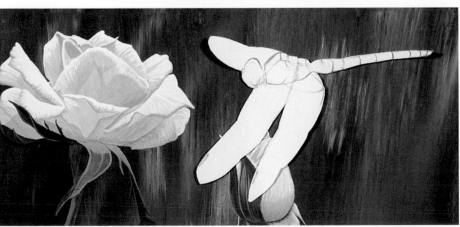

Cutouts

You can use a cutout with the wings or without. With the wings will make it a little easier since getting the wings right is a little tricky.

Cutout of Dragonfly with Wings
Situate the onionskin cutout of your sketch in the composition and outline using a no. 6/0 liner. The color that you use to do the wings will depend upon the background. I use a hue that won't disappear into the background, yet is just barely visible. The body can be outlined with a mix of Warm White and water. For this painting, I used Payne's Grey thinned with water to trace the wings.

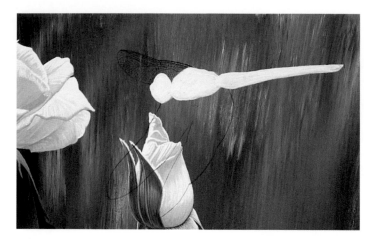

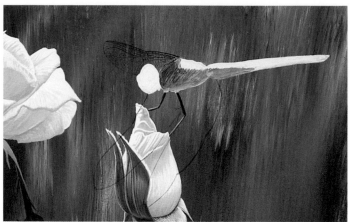

1 Fill in Body and Lay in the Far Wing

Use the no. 0 round to underpaint the body with Warm White but do not fill in the wings, legs or antennae. Do this until the background color has been completely covered where the body is.

Now using the no. 6/0 liner and a wash of thinned Burnt Umber and a little Burnt Sienna, begin laying down the veins of the far wing. Do not overload the brush tip. If the first application isn't dark enough, you can go back over it. I load my brush, take a short stroke on my easel surface, and then go to the painting. You can always go over these lines again. Start at the body and draw the tip of the brush out ending at the edge of the wing tip. There are two very important veins that I really try to get right in each wing: 1) The first vein after the leading edge of each wing, because this vein and the leading edge define the colored spot at the front ends of each wing, and 2) The vein that subtly divides the wing into two components and meets the back edge of the wing where there is a slight notch. Using the same brush and paint, continue filling in the veins. Work parallel to veins at the front of the wings then out toward the back edge of the wings. Remember to keep the brush tip sharp. Be careful not to go past the edges as you pull out your lines. Again using the same brush and paint, use small strokes to connect the lines flowing outward. It's okay if the veins overlap the white of the body; once this wing is in, you can go back and cover with Warm White.

Doing the wing veins believably is the most difficult part. Be patient and use a color very close to the background color. When you are satisfied with the wings, go over them with the correct color.

2 Fill in the Body Color

Now that you have completed one side, the second two wings will be easy! Using the no. 2 round and Ultramarine Blue Deep mixed with a little Carbon Black, lay in the two far legs. When this is dry, go over the centers of the legs with a mix of Payne's Grey and Warm White, trying to stay in the center of each section. Use your finest brush tip for this. Next use the no. 5 round and Warm White and cover any overlapping Burnt Umber and Burnt Sienna. Once this has dried, mix Turner's Yellow with a little Raw Sienna and fill in the thorax and about one-third of the abdomen color, using the no. 3 round. We are using the lightest values present in the body color to convey bounce light on the underside of the body. When this is dry, mix Burnt Sienna with Burnt Umber and water. Lay in this wash leaving the very bottom of the thorax yellowish. This wash, when finished, should not be too dark. Carry the brown up to the top of the thorax. You will come back later to add the markings.

Reflective Light

Hard-bodied insects really tend to show reflective light, in this case on the underside of the dragonfly. Reflective or bounce light is the light that is being reflected from various surfaces, such as light reflected off a petal to the underside of a critter. Being able to see and convey this effect will add a great deal of dimensionality to your painting. You will work with this again in the following chapters.

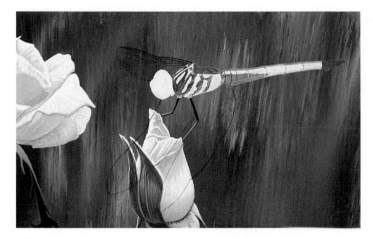

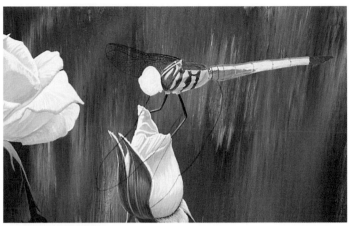

3 Continue Body Undercolor and Markings

Use your finest brush tip now and be patient. Mix Warm White and water and lay in markings on the thorax. This will take at least three coats to get a good white. Next, using the same tip, use a thinned Burnt Umber to lay in the segments of the abdomen. There should be eleven segments varying in size. Now mix Ultramarine Blue with Warm White and lay in the top edge of the abdomen. Then mix Ultramarine Blue Deep with Dioxazine Purple and fill in the last three segments. Next, with just Ultramarine Blue Deep, fill in the top of the thorax where the wings attach to the body.

4 Contour the Body

Using your finest brush tip, mix Turner's Yellow with Cadmium Yellow Mid and water. Lay this wash over the white markings on the body or thorax. Use more Cadmium Yellow Mid for the markings on the front of the thorax and more Turner's Yellow around the rest of the thorax. Once this has dried, use Raw Sienna and slightly darken the lower parts of the thorax where you have laid your yellow mixture. Think "round" here! Next, mix a little Cadmium Yellow Mid and Warm White with water, and ever so gently wash over the brown markings on the front of the thorax and down to the front bottom corner of the thorax. Now mix Warm White with water and lay a fine wash over the yellow markings on the front of the thorax. The thorax is very close to being finished now.

5 Continue Contouring the Body

Now move to the abdomen. Using Cadmium Yellow Mid and the no. 1 round, lay this in on top of your yellow underpaint, just below the midline. Next brush on Raw Sienna just below the Cadmium Yellow Mid to begin rounding out the abdomen. When this is dry, mix Raw Sienna and Burnt Sienna with water and lay in the bottom of the abdomen just along the bottom edge; carry it up just slightly at the division lines of the abdomen. When this has dried, use Burnt Umber to go over the last application, trying to stay as close to the bottom edge of the abdomen as you can. This should really start looking dimensional or round. Mix Ultramarine Blue Deep and Carbon Black with water and lay in the bottom of the rest of the abdomen. Go over the bottom half of the last three segments.

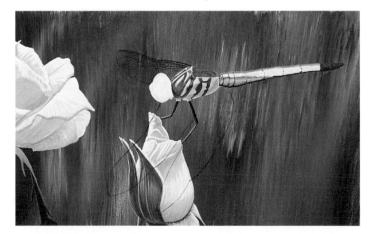

6 More Contouring

Mix Ultramarine Blue Deep with Carbon Black, and using the no. 1 round, lay in the tops of the last three segments. Next mix Ultramarine Blue with a little Ultramarine Blue Deep and lay in the rest of the abdomen, leaving the very top edge of it the lighter undercolor. When this is dry, use the Ultramarine Blue Deep-Carbon Black mixture to lay in the very bottom edge of the abdomen and go back over the dividing lines between the segments. Then move to the top of the thorax where the wings attach. Mix Sapphire with Warm White and, using the very tip of your brush, lay in the areas that are sort of stepped down the thorax. When this has dried, use Warm White to highlight the tops of these "steps."

7 Finish Contouring

Mix Warm White with water and, using the no. 0 round, lay in a white wash over the top of the abdomen. Don't worry about going over the dividing lines. Work this until there is a strong value change from the bottom to the top of abdomen. When you have the value change where you want it, mix Carbon Black with a little water and lay in the dividing lines again. Then use Warm White and your finest brush tip to highlight these dividing lines. Next move to the thorax and highlight the top of the thorax and the yellow areas where the light should be the strongest.

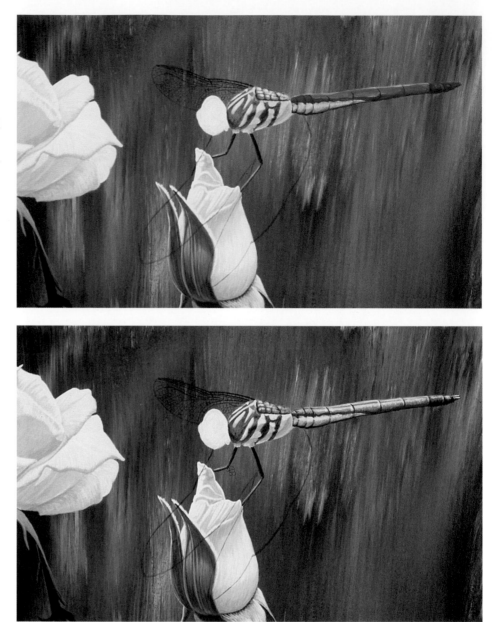

Problem/Solution

Mistakes are easily made when painting this small. A quick decision and a clean, wet brush can usually scrub off mistakes in the newest layer without lifting the older layers. Dab off excess water with a paper towel.

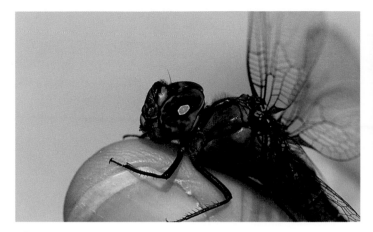
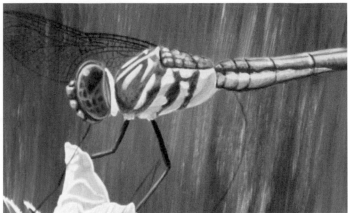

8 Work the Head and Eyes

Using the no. 2 round and Hooker's Green, lay in the underpaint on the projection in front of and below the eyes. Now using the no. 000 round and Warm White, make five small touches with the tip over the Hooker's Green. Working your way down, leave the Hooker's Green around the outer edges and in the dividing areas.

Mix the Green Light with Cadmium Yellow Mid and fill in the five smaller Warm White touches you just laid down. When this has dried, use Warm White to highlight each section with a tiny dot.

Mix Hooker's Green with Green Light and fill in the top of the far eye and just the edges of the near eye. Then follow this application with just Hooker's Green, laying down paint just inside of the prior application. Now using your finest brush tip and Warm White mixed with water, brush over the top outer edge of the far side eye. Use the same Warm White and lay in the top of the closer eye.

When this is dry, go over this top area of the near eye with Green Light. Next mix Hooker's Green with Green Light and lay in the front edge of the closer eye, carrying it about one-third of the way into the eye. Be slow and gentle here. Try to get an even transition to the next step.

With the tip of the no. 000 round, darken the backside of the head and follow the contour of the eye using Ultramarine Blue. Carry this to the green in the front of the eye. Now use Burnt Umber and your finest brush tip to fill in the eye spots. These need to be slightly darker toward the back and bottom of the eye. Use Carbon Black and slightly darken these spots. Now highlight the bottom edge of the eye with a mixture of Cadmium Yellow Mid and water. Use this same mixture to place a highlight on the bottom of the face. Both of these highlights are the result of bounce light from the rose.

9 Finish the Head and Legs

The white area right behind the head is the insect's front leg. Many dragonflies hold their front pair of legs up between their head and thorax. With your finest brush tip and Warm White mixed with a little water, dab the upper-back portion of the eye and each of the four sections of the nose and mouth.

Now use the same mixture to lay in the complete front leg. When this is in, lay in the two legs on this side of the body using Warm White. When the front and side legs have dried, fill them in with Carbon Black mixed with just a little Ultramarine Blue Deep. Use Warm White mixed with water to highlight the leg areas where the light hits. Then with your finest brush tip and Carbon Black, lay in the little spikes on the legs. Use just one application here. Now use Warm White mixed with a little water and lay in the eye spot highlight. This will probably take three washes because you want a strong reflection here.

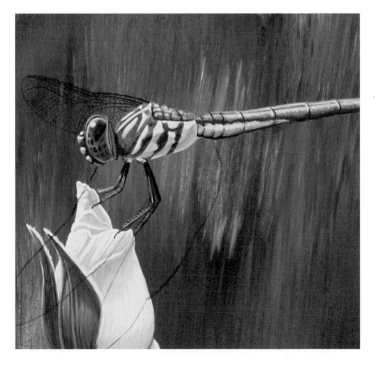

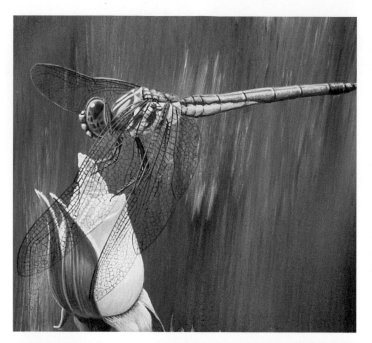

10 Lay in the Near Wing and Tinting

This is the tricky part. Using the no. 6/0 liner trace out the wing veins using Burnt Umber and a little Burnt Sienna thinned with water. Take your time and work from the body outward. Remember the important veins we mentioned earlier and follow the same method. Parallel the forward veins, and fill in the cross veins. If you make a mistake, quickly clean the brush, re-wet and remove the mistake by scrubbing the line off. Then dab it off with a paper towel. I have done this many times, so stick with it.

Remember, the wings are not flat. They have valleys and peaks that help them to be more efficient. These valleys and peaks reflect light, which you will portray with highlighting. This method can be used with different tints; just keep the mixture thin and work one coat or glaze at a time.

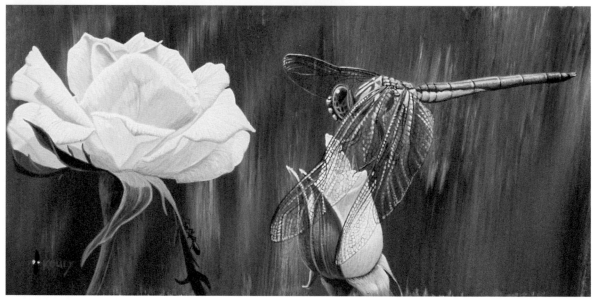

11 Finish the Wings and Highlighting

Tint and fill in the spots on the wing tips. Mix a very thin wash of Warm White, a little Carbon Black and water. This mixture must be really thin. You can always darken it, but it is tough to lighten. Using the no. 5 round, apply the wash from the base of the wings outward. Paint one coat, let it dry and see how it looks. Usually one coat is all that's needed. Use the no. 000 round and Warm White to highlight the reflective areas of the wings. Be aware that too much tint or highlight will make the wings look heavy.

The Watch
Dragonfly
4" × 7⅛"
(10cm × 20cm)

44

Painting Damselflies and Their Wings

Painting lifesize damselflies using a cutout is very difficult. In these circumstances, I do the sketch and cutout, but I trace only the top edge of the body cutout while tracing the total edges of the wings. This gives me the correct size and positioning. Then I fill in the body using the top line as a reference. You're going to like painting these wings after surviving the dragonfly.

Remember, you don't have to paint these insects life size; just make sure the environment around them is sized proportionately.

Cutout of Damselfly With Wings
Trace only the top edge of the body and around as much wing as possible.

Damselfly Materials List

Palette
- Burnt Sienna
- Carbon Black
- Payne's Grey
- Sapphire
- Ultramarine Blue
- Ultramarine Blue Deep
- Warm White

Brushes
- no. 6/0 liner
- nos. 3, 2, 1, 0, 00, 000 rounds

1 Underpaint the Body

Everything is small here! Using the no. 2 round fill in the body with Warm White. Use your top reference line to size the body. When this has dried, using the no. 000 round and a mixture of Ultramarine Blue Deep with a little Warm White, lay in the lower part of the thorax and eye and the bottom edge of the abdomen. Use Ultramarine Blue and a little Warm White for the last three sections of the abdomen. Then using the no. 1 round and Carbon Black, fill in the rest of the abdomen. Use the no. 000 round and Ultramarine Blue Deep mixed with a little Carbon Black to fill in the back portion of the head. Then use your finest brush tip and lay in the legs, far side first, using Warm White. Then go over the back sides of each leg with Sapphire.

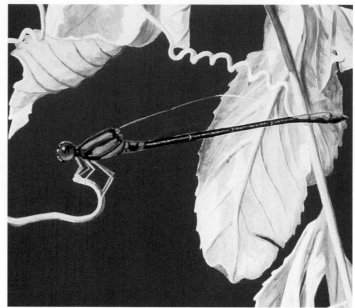

2 Paint the Eyes

Using Carbon Black and the no. 000 round, fill in the nose and slightly below the eyes. When this is dry, use Warm White to lay in three tiny spots on top of the Carbon Black. Now use Ultramarine Blue and the no. 000 round to go over the underpaint on the eye. When this is dry, move to Ultramarine Blue Deep and darken the areas of the eyes that are farthest from the strongest light source and add the facet in the eye closest to the viewer. When this is dry, mix Warm White with a little Sapphire and lighten the lower edge of the eye using the tip of the no. 000 round. Follow this with just Warm White on the tip of your brush to add a highlight to the eye.

3 Define the Body

Using Payne's Grey and your finest brush tip, lay in the dark markings on the thorax and first part of the abdomen. When this is dry, use Warm White with a little Sapphire and lay in the sections of the abdomen using the no. 000 round. Use the no. 000 round for the rest of the body, using Payne's Grey to separate the three sections at the end of the abdomen. Then use Warm White to highlight the sections of the abdomen lengthwise. Go over the very middle of the lengthwise wash with a mixture of Warm White and Burnt Sienna, and dab small specks of Warm White when dry. Now use Carbon Black and go over the Payne's Grey markings on the thorax and abdomen.

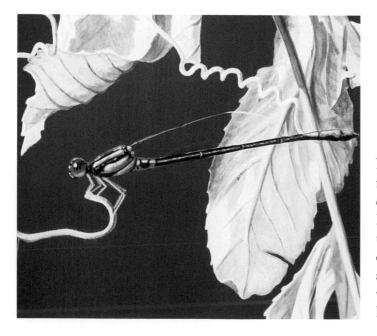

4 Highlight the Body

Now using Warm White and your finest brush tip, highlight the thorax by dabbing on layers of Warm White. Highlight the black portions with a thin wash of Warm White, then go over this with a thicker Warm White application (reduce the amount of water in the mix), dabbing where the light is strongest.

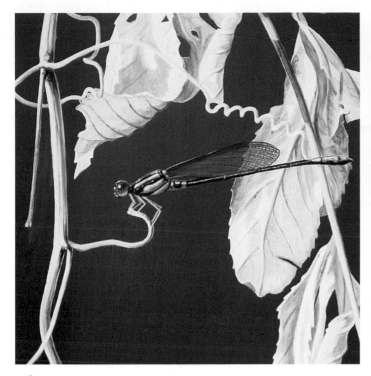

5 Lay in the Wings

Because the damselfly's wings rest together, we will only do the outermost veins on the far wing, implying the rest by doing the near wing.

These wings are so small that to try to do each vein life size would be futile, so you will just imply veins, leaving some out. The lengthwise veins are the most important, so using the no. 6/0 liner and a thin wash of Carbon Black, lay in the outermost veins, then follow these in parallel moving downward toward the tip of the wing. Using the very tip of your brush and short strokes, lay in the cross veins. Now mix a thin wash of Payne's Grey, a little Warm White and water, and using the no. 3 round, lay in the wash from the wing base outward. Let this dry before adding another wash—usually one will do.

Like dragonflies, these little guys have wings with valleys and crests which reflect light differently. Use your reference shots to determine how much highlighting you will need. Overuse of highlighting gives the wings a heavy feeling, not the light, translucent effect that is needed here.

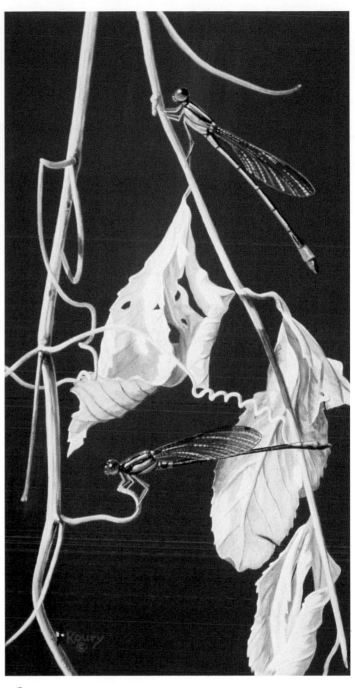

6 Highlight and Finish

Use the no. 6/0 liner and a mixture of Carbon Black and Ultramarine Blue Deep to add the dark spots to the ends of the wings. Now highlight with a thin mix of Warm White and water. Highlight a little and wait until dry before adding a new layer.

Nature's Jewelry
Damselflies
8" × 4" (20cm × 10cm)

chapter 3

BEES

When I visualize bees, I see warm sunshine, shades of green, flowers and wonderful colors. Yes, I get a warm fuzzy feeling. I am constantly amazed at their flight ability because they are so aerodynamically challenged.

They also present separate, yet related, challenges from an artistic perspective: how to paint soft and fuzzy, hard and glossy, yet light, airy and transparent all wrapped up in one little package. In this chapter we will confront these challenges and learn to create that wonderful little critter out on your flowers.

Lucky
Bumblebee on Clover
5½" × 12" (14cm × 30cm)

Anatomy of Bees

THE BUMBLEBEE

Bees are probably one of the most recognizable insects in nature, forever busy collecting nectar and pollen. Bees occur almost everywhere and range from solitary species to highly evolved colonial species. They are members of the third largest group of insects, the order Hymenoptera. We will be working on two of these members: the bumblebee and the honeybee. One of the characteristics of this order is two pairs of wings: either transparent, or tinted from sienna to black with a dark leading edge on the front wing. Bumblebees are easily recognizable by their hairy and somewhat heavy bodies. Bees are social, living in colonies. Bumblebees make their hives in the ground, sometimes using old rodent burrows. Colonies support queens, drones (males) and workers (sterile females). Sterile females forage, construct the hive and tend the larvae. Bumblebee queens are the only members of colonies to survive the winter and these queens produce the new colony in the spring.

Lateral View

Dorsal View

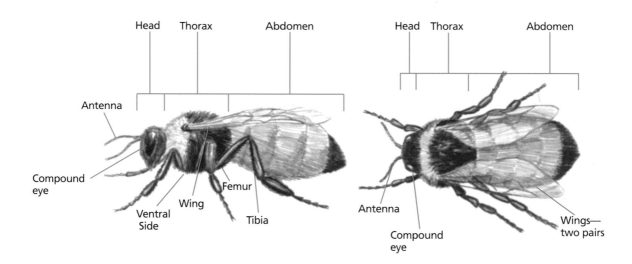

Sketch of a Bumblebee

Bumblebees are characterized by large plump, hairy bodies. The bumblebee has yellow to golden hair covering most of the abdomen and black or dark hairs on the thorax surrounding a small bare area. The carpenter bee, a close relative, has an all-black abdomen. The two sets of wings are tinted Raw Sienna to golden.

THE HONEYBEE

Honeybees are very similar to the bumblebee with a few exceptions. Typically a large portion of the colony survive the winter; in fact, the queen could not start a new colony alone. New queens are produced each year, and if they survive the queen mother, they will leave the hive with a portion of the sterile females to start a new colony.

These insects are so important to our agriculture that without them we would have a very difficult time. Many of the foods we eat, such as fruits, nuts, berries and legumes, are dependent one way or another on bees and other insect pollinators. Our meat industry is also dependent on insects for the pollination of many of the forage crops that animals eat. Honeybees in particular are designed to do these jobs best because the forked hairs on their bodies enable them to pick up pollen and move it from one flower to another better than insects with straight or no hair. They work as a social unit and because they overwinter and don't die off, they are ready to forage as soon as the plants need them.

Recent studies of honeybees have revealed a form of communication that resembles a dance. When one of the worker bees locates a rich source of nectar, she returns to the hive and begins a highly complex dance, which communicates the direction of the nectar source to the rest of the hive. Anatomically, these bees have another twist. They have a flattened area on the upper portion of each hind leg that has tiny stiff hairs on which the bee stores pollen gathered while foraging. These pollen sacs on the hind legs can be seen rather easily, and the pollen along with honey is fed to the larvae.

Lateral View　　　　　　　　　　　　　　**Dorsal View**

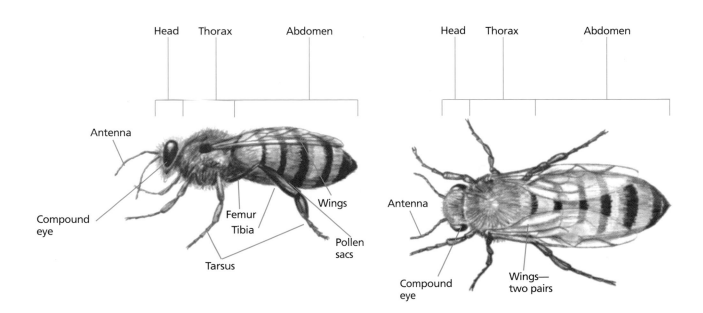

Sketch of a Honeybee (female)

The honeybee is also hairy like the bumblebee, although not quite as plump and somewhat smaller. The abdomen is golden and black and the thorax has golden or yellowish hairs surrounding a small bare area in the center. The hind legs have a segment used for carrying pollen; this segment is enlarged and flattened.

Painting the Bumblebee

Before working on the translucency of the wings, we need to create a believable-looking bee—a hairy, somewhat plump, soft-looking insect with various parts of its anatomy portrayed as hard and glossy. Achieving a believable look is not as hard as you might think. Remember as we are doing these steps that you don't have to paint life-size bumblebees—they range from ½"-12" (1cm-30mm) in length. Work in a size that is comfortable for you, and make sure the environment you create is in proportion to your insect's size.

Reference photo of bumblebee

Bumblebee Materials List

Palette
- Burnt Umber
- Cadmium Yellow Mid
- Cadmium Yellow
- Carbon Black
- Nimbus Grey
- Payne's Grey
- Raw Sienna
- Titanium White
- Turner's Yellow
- Warm White
- Yellow Light

Brushes
- no. 6/0 liner
- nos. 2, 1, 0, 00, 000 rounds

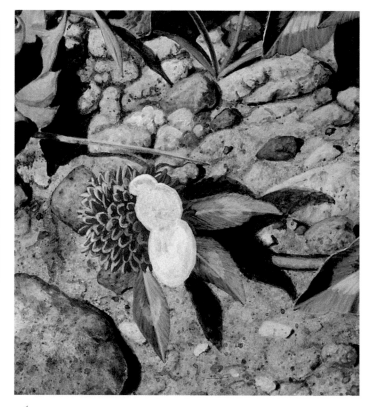

1 Place the Bee

Situate the bumblebee into a setting, then trace around an onionskin cutout of the bee and fill in the body with Warm White.

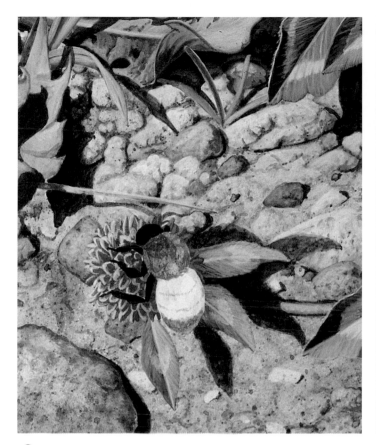

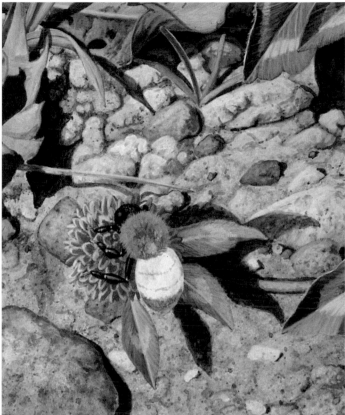

2 Lay in the Body and Legs

Using the no. 0 round and a mixture of Carbon Black and water, lay in the head and the legs. With a mixture of Burnt Umber and Raw Sienna and the no. 2 round, lay in the thorax. Then using the no. 0 round and the same mixture, lay in the last section and the dividing lines of the abdomen.

3 Underpaint and Contour the Legs

Use the no. 000 round or sharpest brush tip and Warm White mixed with water to lay in the hairs on top of the head between the eyes, using the very tip of your brush to dab in the little hairs. Then with the same mix and brush, lay in this lighter value in the center of each leg segment. This should begin to round out and contour the leg segments. When this has dried, use the same brush and Payne's Grey thinned with water to highlight the center of your last application on the leg segments. Be sure to do this only where direct light is striking. Now use your finest brush tip and Warm White to lay in little highlights on the legs. When the legs are completed, mix Turner's Yellow, Raw Sienna and water, and use the no. 6/0 liner to lay in the little hairs on the front of the thorax. With your finest brush tip and the same mixture, start on the body and work in a circle, finishing your stroke moving away to lay in these light values as if they are little hairs.

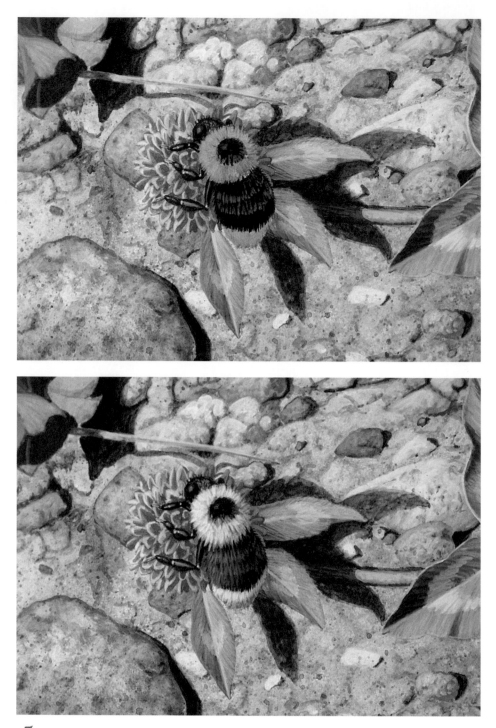

4 Define and Deepen the Body Hairs

Using the no. 2 round and Carbon Black, lay in the black sections of the abdomen and the dark spot on the top center of the thorax. Next, using the no. 6/0 liner or sharpest brush tip and mixing Turner's Yellow with a little Burnt Umber and water, use short strokes originating from the very edge of the light areas of the body outward to lay in the hair tips on the abdomen and thorax. Then using the same brush and a mixture of Carbon Black and water, lay in the hair tips around the edges of the dark areas (the black segments of the abdomen, thorax and head). Start the strokes right at the edges and pull out with the tip of your brush.

Now mix Cadmium Yellow Mid, Yellow Light and water, and using the same short strokes and the very tip of your brush, lay in the little hairs on the front of the thorax. Start these strokes toward the center of the thorax and move outward. Space them out, allowing areas of the underpaint to show. Then move to the abdomen. Using the same method, lay in the light hairs, again leaving streaks or areas of the underpaint showing. Now mix Carbon Black with a little Warm White and water. Using the same method as above, lay in the little hairs on the abdomen at the defining lines of the abdomen. On the last black section of the abdomen, use Carbon Black and the same brush to carry some black hairs into the yellow section, or last section, of the abdomen.

5 Soften the Body Hairs and Contour

Again, use the no. 6/0 liner or sharpest brush tip. Now use Yellow Light thinned a little with water and the same short strokes as before to lay in more little hairs over the last application. Allow the previous values to show through between these lighter hairs. When these have dried, mix Warm White with a little Yellow Light and water, and using the same short strokes, highlight the areas of strong light. Next use a mixture of Warm White and water to highlight the black hair areas. Just a few strokes are all that's needed here. The lighter and lighter value applications will define, soften and contour the body.

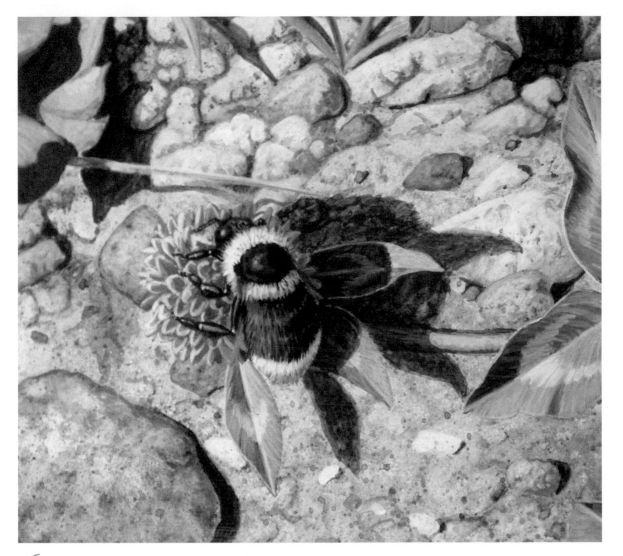

6 Finish the Head and Thorax

Use the no. 000 round and Carbon Black to lay in the antennae. When this is dry, mix Payne's Grey and water and highlight the center of the antennae, leaving the outermost edges Carbon Black. With this same mixture, highlight the eyes and the spot where the strongest light is reflected on the thorax. Follow this application with Warm White and highlight the center areas of the Payne's Grey application on the antennae. This highlight defines the strongest areas of light on these reflective surfaces. Be sure to allow the Payne's Grey to show around the edges of your highlighting. Use the no. 0 round and widen the dark circle on the thorax using Carbon Black. Next use your finest brush tip to pull dark hairs into the golden area at the back of the thorax.

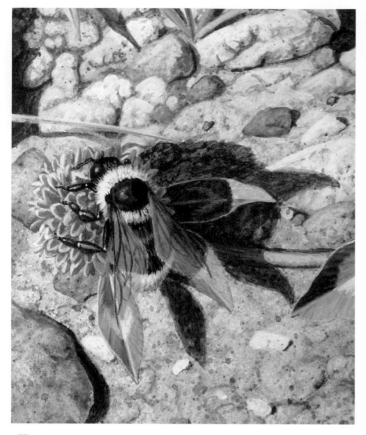

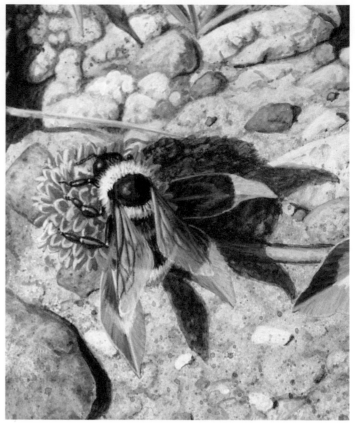

7 Lay in the Wing Veins

Carry the wing tips out past the abdomen about ⅜-inch (10mm). At rest, the two pairs of wings overlap slightly. Here the wings are slightly spread, each forming a rough triangular shape. These wings should be about ¼-inch (6mm) at their widest point. Using the no. 6/0 liner and a thin mixture of Burnt Umber and water, lay in the outer edges of the wings. Start your stroke at the body and pull the brush tip toward the ends of the wings. This edge line should be very thin, particularly on the trailing or back edge of the wings. Now, using the same brush and mixture, lay in the veins of the wings working from their base outward. Notice that the outer margins of the wings are not heavily veined. These applications may take a few coats.

Next mix a very thin wash of Payne's Grey and Warm White. Start slightly back from where the wings begin and lay in a thin wash between the veins. When this is dry, lay in another thin wash between the veins using Cadmium Yellow Mid on the left wing and Raw Sienna mixed with Cadmium Yellow on the right wing.

8 Continue the Wings

Begin applying the tint by mixing a very thin glaze or wash of Raw Sienna, Cadmium Yellow Mid and water. Using the no. 2 round, start at the base of the wings, moving out to the ends of the veins. Allow this initial glaze to dry. If it's not the tint you wanted, then do a second glaze. Notice that the tips or outer margins of the wings are slightly lighter. Apply another wash from the midpoint to the end of each wing using Warm White mixed with a little Payne's Grey. The wings should now have a color shift from slightly darker at the base to slightly lighter at the outer edges. Use your finest brush tip and a very thin Warm White and water mix to go over the yellow and sienna tints between the major veins. Lay this on the side that the light is coming from.

Tinting

When the wings are tinted, the insect's body and landscape should show through. Don't over-tint or you will lose the transparent effect.

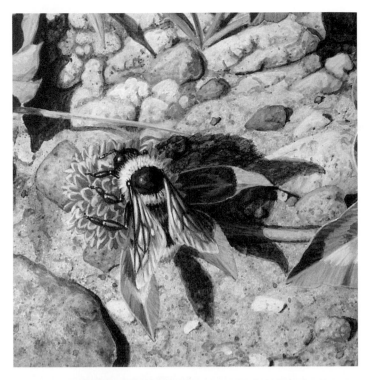

9 Pull out the Veins and Highlight

Using the no. 6/0 liner, mix Burnt Umber with water and lay in the front edge of the wings going only to the tip. Then mix Carbon Black with Burnt Umber and water and go over the front edge only to the halfway point of the wings. Using the same mixture and brush, go over the veins of the wings, darkening them slightly. Now thin Warm White and a little Cadmium Yellow Mid with water and highlight the area just next to the veins and at the wing margins using the no. 1 round. When this application has dried, mix Warm White with water and, using the no. 000 round, highlight the areas of the wing where the strongest values are. Use Titanium White thinned with water and the no. 000 round to highlight the last application, highlighting areas of intense light only. Go over the dark leading edge with a Carbon Black-Warm White mix using the no. 6/0 liner. Lay this down right in the center of the vein.

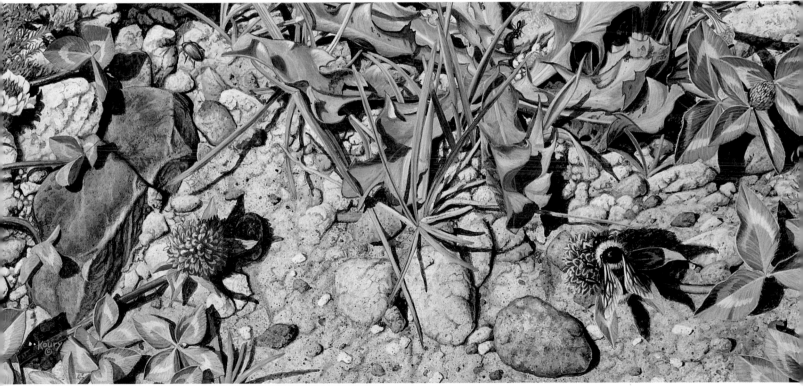

Lucky
Bumblebee on Clover
5½" × 12" (14cm × 30cm)

Painting the Translucent Wings of a Honeybee

The honeybee's posture in this demonstration is going to make laying in the wings a little tricky. The abdomen is straight, but the head and thorax are now curled over the daisy, forcing the wings up and away from the abdomen.

Honeybee Materials List

Palette

- Burnt Sienna
- Burnt Umber
- Cadmium Orange
- Cadmium Yellow Mid
- Carbon Black
- Gold Oxide
- Payne's Grey
- Raw Sienna
- Titanium White
- Turner's Yellow
- Warm White
- Yellow Light

Brushes

- no. 6/0 liner
- no. 4 shader
- nos. 3, 2, 1, 0. 00. 000 rounds

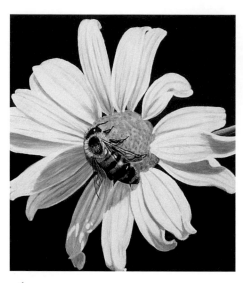

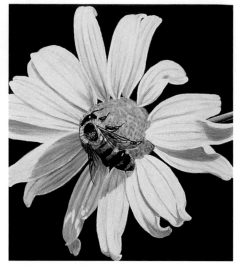

1 Lay in the Wing Veins

Use Turner's Yellow, Yellow Light, Gold Oxide and Raw Sienna to paint the bee before doing the wings.

When the honeybee body is complete, start on the right wing. Pull the outer edge of the right wing down to where it's about even with the end of the second-to-last section of the abdomen. Pull the left wing down to about the end of the third section of the abdomen.

Using the no. 6/0 liner and a mixture of Burnt Umber and water, lay in the outer edge of the wings stopping at the tips. Leave the back or trailing edge Warm White (the color used to trace the cutout when you placed the bee). Fill in the wing veins using the same mixture and brush, working from the body outward. As in the bumblebee, the outer margins of the wings are not heavily veined, so leave these areas blank or unveined.

2 Continue the Wings

Using the no. 3 round, mix Payne's Grey with water and lay down a glaze or wash moving from the base of the wings outward to the tips. Let this dry. It should look like a thin sheet of clear film has been placed over the bee's body and the background. To avoid tinting the wings too dark, apply very thin glazes. Allow each application to dry and evaluate it before adding another glaze or wash. If another coat is needed, use the same mixture and reapply from the base outward. Then using the same brush and a mixture of Cadmium Yellow Mid and water, lay in a very thin wash starting where the wing meets the body and pull this wash out to where the veins end. Use the no. 6/0 liner and a mixture of Burnt Umber and water to go over the wing veins after these tints have been applied.

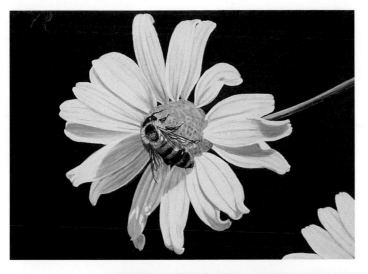

3 Pull out the Veins and Highlight

Using a mixture of Burnt Umber, a little Carbon Black and water, go over the veins closest to the base using the no. 000 round. Now mix Warm White with water and, using the no. 1 round, highlight the areas next to the veins and out to the wing tips. Then use the no. 6/0 liner or your sharpest brush tip and Titanium White to highlight the areas of the wing where the light is strongest. Be very careful when you are highlighting, because too much will reduce the transparency and cause the wings to look heavy.

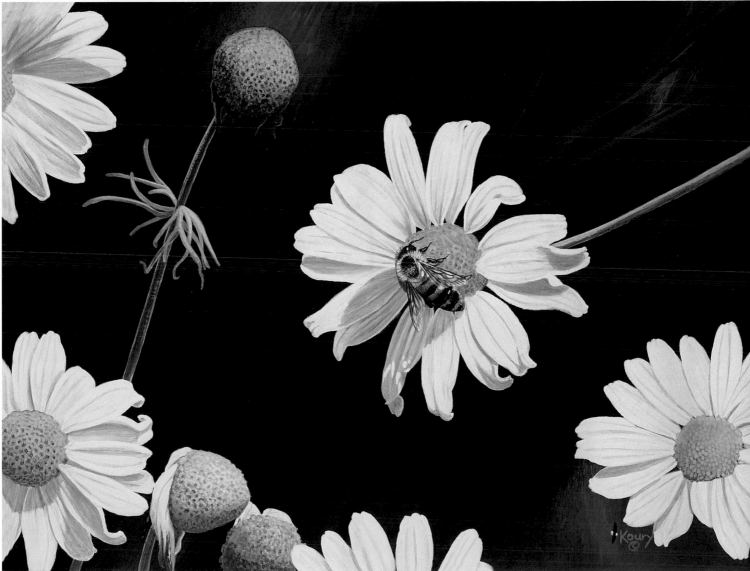

Daisy Refreshment
Honeybee
6" × 8" (15cm × 20cm)

BEETLES AND ARACHNIDS

*I*nsects are found almost everywhere; over a million different species have been identified. I like to think of them as miniature versions of mammals. Their world has its lions and its wildebeests—in other words, predators and prey on a much smaller scale. Wonderful and interesting stories unfold daily on a much smaller playing field—one that's easily accessible and easily observable. The vast majority of insects are beneficial in reality and all of them have a place in the web of life. As much as I dislike termites devouring my house, the world would be a big pile of wood if not for these efficient little insects. Dragonflies and their young put a healthy dent in the mosquito population, and without dung beetles where would we be?

In the eyes of an artist, insects are little jewels containing all the colors of the rainbow. These colors, combined with the insect's textures and iridescence, provide a wonderful subject to paint. In this chapter we will learn to create the textures and colors of beetles and arachnids. We will also work on achieving different effects of light to contour their bodies.

Gladiators
Tarantula and Tarantula Hawk Wasp
9" × 18" (23cm × 46cm)

Anatomy of Beetles

Insects have defining features that allow us to characterize and classify the various groups. Some have eight legs; most have six. Some have hard shells for their forewings, while others have leathery ones. Some insects, such as crickets, grasshoppers and mantises, go through simple metamorphosis, skipping the pupa stage. Other insects, the most familiar being butterflies, move through complete metamorphosis. Observable differences will help you sort out just what you are looking at and will also tell you a little about the insect's behavior.

There are more species of beetles, order Coleoptera, than any other animals on earth. They are the largest order in the animal kingdom. Although not all are called beetles, they all share the characteristics of the beetle. A defining feature is the beetle's forewings, which are called *elytra*. These forewings are hardened shell-like coverings for the membranous hind wings used for flying. When a beetle is not flying, the elytra typically meet in a straight line down the middle of the back. The elytra open and pivot forward to allow the hind or flying wings

to function when the beetle flies. Beetles' bodies are surrounded by an exoskeleton consisting of three divisions: the head, thorax and abdomen. Their antennae are diverse and most have large compound eyes made up of tiny compartments called *ommatidia*. Each ommatidium has a lens, a crystalline rod and a collection of light-sensitive cells. The compound eye can contain from 2 to 36,000 ommatidia. Beetles undergo complete metamorphosis. They have chewing or biting mouthparts. They may be predaceous or vegetarian, scavengers or pollinators.

Lateral View

Dorsal View

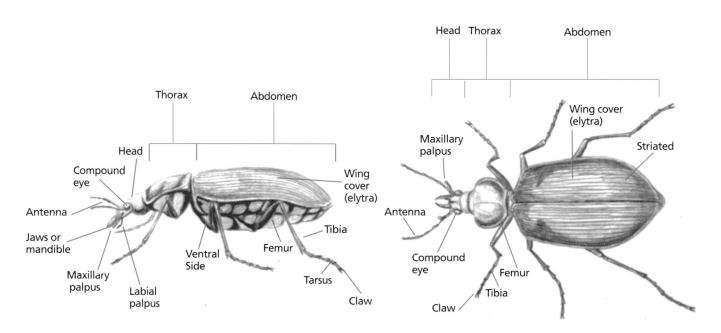

Fiery Searcher Beetle
1" to 1½" (3cm to 4cm) in length.

THE LADYBUG

The ladybug is probably one of the most familiar beetles and maybe one of the most beneficial. It is easily recognized by its round shape and vivid color. Some are spotted and others are not. They can be yellow, red, orange, or various shades of these colors, as well as black. The larva is typically black with orange, yellow or red spots or bands, reminiscent of the beaded skin and color of the gila monster, a venomous lizard of the southwestern U.S. and Mexico. Both larvae and adults feed on aphids and scale insects (sap-feeding insects that feed by boring holes in the plant and sucking the sap), as well as insect eggs, mites and smaller larvae. They act as a natural control of aphids and scale insects, and many gardeners buy them to release them into their gardens. Some species of the ladybug seek shelter in places such as under leaf litter or in houses.

REFERENCE MATERIAL

Insects can be observed almost anytime; they are forever active and in a vast variety of places. I am always looking for these little characters, and I find them in some amazing places. I sketch both from live insects in the wild and museum collections, as well as from my own roadkill collection. Photography is a great aid here because, as with live specimens, you don't have to handle or harm them. I use a 105mm macro lens and a flash whenever possible, taking several shots from many different angles. I read all I can about the insects I see and then look for them again. I am always surprised and amazed at what I see. All of this leads to paintings that tell stories, whether subtle or obvious.

Lateral View

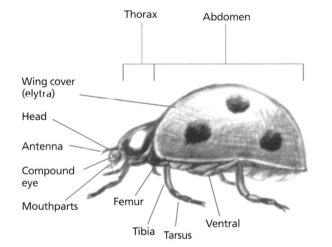

Dorsal View

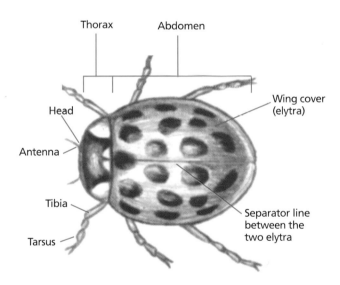

Ladybug Beetle
1½" to 3" (4cm to 8cm) in length.

Anatomy of Spiders

Spiders are in the order Araneae and are not insects at all. They belong to the phylum Arthropoda under which insects form a branch or class called insecta. Spiders belong to another branch of the phylum Arthropoda; they are within the class Arachnida. Within this class, another branch leads to the order Araneae, or spiders. Whew! Now that we have that straightened out let me continue, Spiders are one of our most beneficial crea-tures, serving to keep the insect popula-tion under control. They have several defining features. Spiders have eight legs, each made up of seven segments. Their bodies have two parts—not three, like the insects; they have a cephalothorax, which is both the head and thorax, and an abdomen. They are further defined by having a "waist," called the *pedicel*, and they have no antennae. They spin silk through spin-nerets and seem to have different types of silk for different occasions. Some spi-ders use their silk like a hang glider or parachute, spinning out enough to get caught in the breeze, so they can ride it to a new location. All are predaceous and feed on insects and some small mammals. They do not go through complete metamorphosis and the young, which are miniature copies of the adults, are called spiderlings.

Lateral View **Dorsal View**

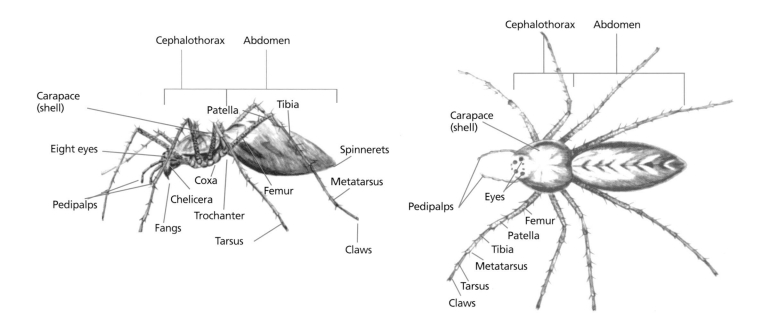

Lynx Spider
½" to ⅝" (1cm to 2cm) in length.

Capturing Colors and Light on Smooth Surfaces

In this demonstration we will work on portraying rich color in fairly intense light. The smooth roundness of a lady-bug's shell, or *elytra*, provides a perfect subject for learning how to maintain vivid color while contouring a form with varying values. As you work, picture the insect's rounded shell in your mind. Notice how one small part of the shell reflects more light than any other part. Moving away from this tiny hotspot the color gradually darkens, making the shell appear round. You will imitate this contouring effect by making gradual value transitions as you apply the paint.

Ladybug Materials List

Palette
- Brilliant Violet
- Burnt Sienna
- Burnt Umber
- Cadmium Orange
- Cadmium Yellow Mid
- Cadmium Scarlet
- Carbon Black
- Hooker's Green
- Gold Oxide
- Napthol Red Light
- Napthol Crimson Scarlet
- Payne's Grey
- Pine Green
- Raw Sienna
- Ultramarine Blue Deep
- Warm White

Brushes
- no. 6/0 liner
- nos. 0, 00, 000 rounds

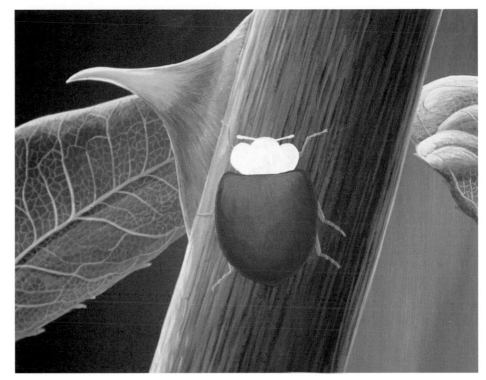

1 Establish the Base Colors

Place the ladybug, lay a Warm White underpainting and let dry. Using the no. 0 round and a mixture of Raw Sienna and Cadmium Yellow Mid, lay in the body parts beneath the shell or elytra. When this has dried, mix Gold Oxide with Raw Sienna and go back over the middle parts of the legs. On the lighter side of the ladybug, use a little Cadmium Yellow Mid to highlight the legs. On the darker side, mix a little Burnt Sienna with Gold Oxide and go over the centers of the legs. Keep your color mixtures thin; you don't want the application too heavy. Also wait for each application to dry before the next is applied.

When the legs are in, use Warm White to cover the overstrokes on the body. Next use the no. 0 round and a mixture of Napthol Red Light and water to lay in the base of the elytra. This is a very thin line around the outer portion of the shell. Then mix Cadmium Scarlet and Napthol Crimson and follow this line around the dark side of the shell. You want this darker value around the base where there is a definitive ridge on the edge of the elytra. Leave the top three quarters of the elytra white. Now using the same brush and a mixture of Napthol Crimson and Napthol Red Light, lay in the three quarters that were left white. Work the shell color, blending color values from light on the top left side to dark as you progress down toward the bottom and right side of the shell. Once the reds have dried, mix Burnt Umber and Napthol Crimson and continue to darken the right side of the shell down to the bottom, remembering that the shell is round, not flat. You want a gradual value transition from dark red to slightly lighter as you approach the highest part or top of the back.

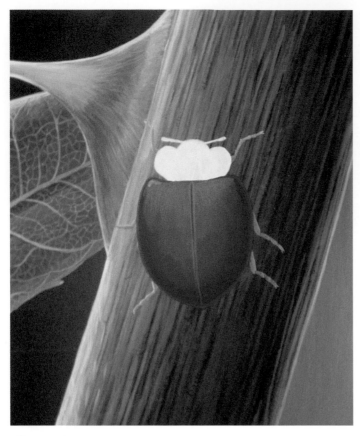

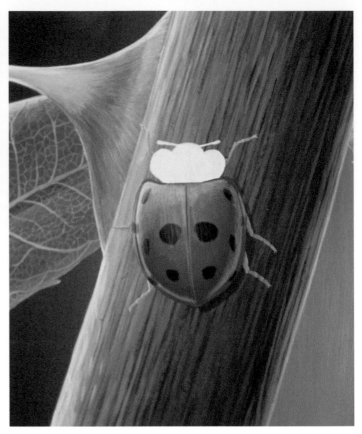

2 Lay in the Dividing Line

Using your sharpest brush tip and a thin mixture of Burnt Umber and Napthol Crimson, lay in the dividing line between the two elytra, down the middle of the back. Remember, the shell is round so the line should curve to portray the curve of the shell. This line is important because it defines the separation of the two elytra, and it's your landmark for the next steps. This next one is tricky if you're painting life size, so be patient. Again using your sharpest brush tip, use Napthol Red Light and go over the thin ridge around the very base of the elytra on the shaded side and down to the bottom of the shell. This little ridge defines the base and helps to pull out the contour of the elytra. Once this is in, mix Napthol Crimson with Burnt Umber and use the no. 0 round to lay in the shading on the side of the shell just above the base edge you applied in the prior step. This layering of similar colors will help to push up the top of the shell and increase the illusion of roundness.

3 Lighten and Highlight

Begin to lighten up the high-intensity areas of the shell, using the no. 0 round and a mixture of Cadmium Scarlet and a little Warm White to overpaint the top portion of the shell. Keep this Warm White wash thin so the underpainted colors show through—the red should be lighter red, and where the spots are, the black should be lighter black. Be careful not to cover your defining midline.

When dry, use Carbon Black and the no. 00 round to lay in the spots on the back. When laying in the spots on the side of the body, remember the contour or shape of the shell. Spots on the side should be thinner than those on the top because the shell is angling away from you. Make a thin mixture of Warm White and water. Use the no. 0 round to go over the shell where the light is the brightest. Next take your sharpest brush tip and the same mixture and lay down a line right next to and on the left side of the dividing line between the elytra.

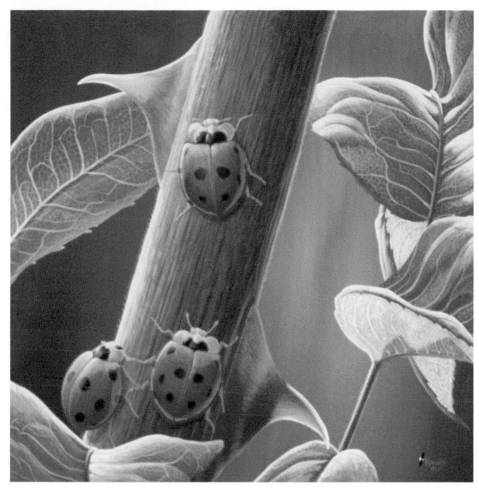

4 Lay in Markings on the Head and Thorax

Use the no. 0 round and Raw Sienna mixed with a little Gold Oxide to lay in the base color on the thorax and head. This may take a couple of washes. Now use the no. 0 round to lay in the black markings on the thorax and head, mixing Burnt Sienna with Napthol Crimson to do the outer edges of the markings. When this is dry, fill in the black using Carbon Black, leaving the very outer edges Burnt Sienna–Napthol Crimson. Lay in the eyes with Carbon Black and fill in the antennae with a mixture of Burnt Sienna and Gold Oxide. Using the same brush and Warm White, highlight the eyes, but not too brightly. Staying with the no. 0 round and Warm White, highlight the left side of the tiny ridge between the eyes, then the remaining areas of the antennae, head and thorax. Remember, this insect is not in direct light, so the highlights need to be soft.

Thorny Traffic
Ladybugs on Rose Stem
8" × 8" (20cm × 20cm)

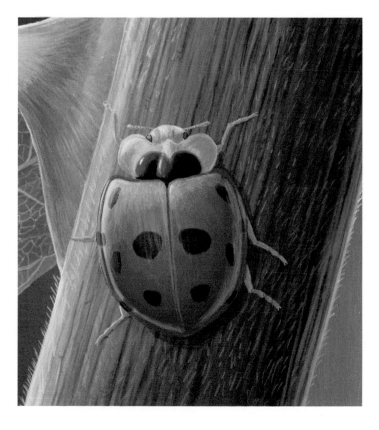

Detail

We have used a gradual value shift to achieve contour, essentially rounding out the shell of the ladybug. Using washes and highlights to imitate the effects of light hitting the shell enhances the illusion of roundness. With each painting I do, I try to get better and better, making the ladybug more and more believable. Try to do the same each time you paint, even if it's your fiftieth ladybug.

demonstration two

Capturing Colors and Light on Striated Surfaces

In this example we will use the colorful and somewhat metallic fiery searcher beetle. This beetle is very swift afoot and is an efficient caterpillar hunter. His elytra are striated with subtle pocks, textures that lift the contours of the surface and create slight color shifts. These small valleys and peaks in the elytra reflect light in such a way as to create a metallic or jeweled effect. As we work through this step-by-step demonstration, be patient. The results will be worth it.

Fiery Searcher Beetle Materials List

Palette

- Brilliant Green
- Brilliant Violet
- Burnt Sienna
- Burnt Umber
- Cadmium Yellow Mid
- Carbon Black
- Dioxazine Purple
- Gold Oxide
- Hooker's Green
- Napthol Crimson Light
- Nimbus Grey
- Payne's Grey
- Pine Green
- Ultramarine Blue Deep
- Warm White

Brushes
- no. 6/0 liner
- nos. 2, 1, 0, 00, 000 rounds

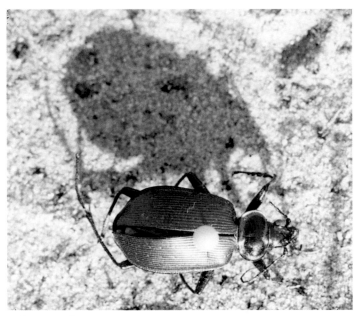

Reference Photo

1 Outline the Beetle
Place the beetle using a cutout to outline the body and underpaint with Warm White.

2 Fill in the Base Colors

Use the no. 6/0 liner and a thin wash of Payne's Grey to lay in the legs. This does not have to be opaque; it's just a guideline. When dry, use Dioxazine Purple over the Payne's Grey that you just applied. Once this has dried, use the same brush and Dioxazine Purple mixed with Carbon Black to go over the legs again, this time covering just the middles of the various parts and leaving the very outermost edges Dioxazine Purple. When dry, use Warm White to lay in the light areas on the legs. When this is dry, go over the Warm White with Ultramarine Blue Deep . On the dark side of each leg, lay in a small line next to the edge using Brilliant Violet.

Anywhere that you have carried color onto the white body outline can now be covered using the no. 2 round and Warm White. When dry use the no. 1 round and a mixture of Hooker's Green and Dioxazine Purple to do the outer edges of the jaws, head and thorax—just the very outer edges. Then lay in the eyes using Burnt Umber and Raw Sienna and highlight with Warm White. Using the no. 2 round and a mixture of Ultramarine Blue Deep and just a little Carbon Black, lay in the interior base color of the head and thorax. Use Hooker's Green to lay in the two ridges down the face and on the sun side of the face. Now using your finest brush tip and Payne's Grey, lay in the antennae and palps (the little appendages next to the jaw). When dry, go over the insides of these using Dioxazine Purple and a little Carbon Black. Using the same brush and a mixture of Pine Green and just a little Hooker's Green, lay in the base color of the elytra, leaving the very outer edge white.

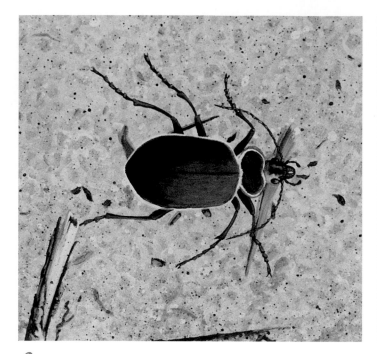

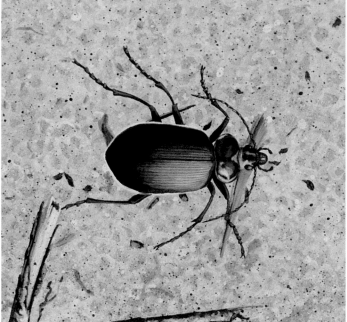

3 Define the Contours

Use the no. 1 round and Hooker's Green mixed with Brilliant Green to continue laying in the base color of the elytra. Start at the back and work forward. Next mix Cadmium Yellow Mid with Brilliant Green and lighten up the front side of the elytra where the light is strongest. Use the no. 6/0 liner and Warm White mixed with Pine Green to lay in the dividing line between the two elytra. This line runs down the middle of the back and curves slightly to reflect the roundness of the back. This line is your landmark from which all the striations of the back will follow, so if it's not right, overpaint it using the prior steps and lay it in again. When it's right, use the same brush and a mixture of Pine Green and a little Carbon Black to go over the line again, defining the separation of the two elytra.

4 Create Striations

Continue to lighten the elytra using Cadmium Yellow Mid and Brilliant Green. When there is a good transition from light to dark, use the no. 6/0 liner and a thin mixture of Hooker's Green and Brilliant Green to lay in the striations of both elytra. Start at the center and work outward toward the lightened side, trying to keep the lines an even distance apart. Don't go to the ends of the elytra until you have these lines in. Once these are laid in, follow the contour of the elytra and finish the ends, remembering these lines bend and pinch in to reflect the curve of the body. Next use a thin wash of Brilliant Green and Cadmium Yellow Mid to lay in the edge of the thorax using the no. 0 round. Use Ultramarine Blue Deep to darken the front part of the thorax using the same brush. Follow this with Warm White to highlight the thorax. This may take several layers.

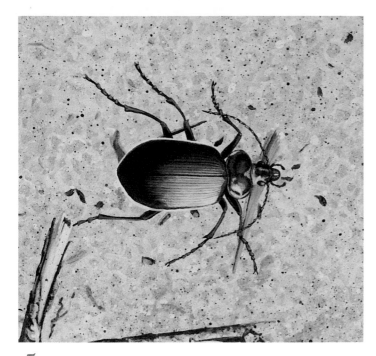

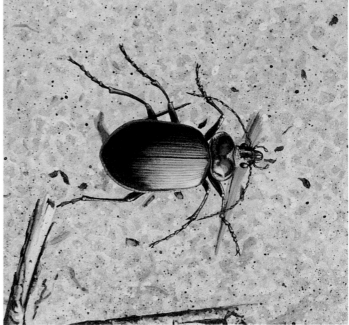

5 Accentuate the Striations

Now you need to really accentuate the striations of the elytra. Use the no. 6/0 liner and Brilliant Green to go over your striation lines again. This will probably take two coats. Then use a thin wash of Hooker's Green and the no. 2 round to go over the edges of the elytra all the way around. Once this has dried, use Warm White to go over the striations again where the light is strongest using the no. 6/0 liner. Now use the no. 00 round or your sharpest brush tip and Warm White to lay in a line around the very outside edge of the elytra.

6 Achieve the Metallic Effect and Highlighting

Using the no. 6/0 liner and Cadmium Yellow Mid mixed with Warm White, start at the striation in the middle of the back and stipple in dots moving from the front of the elytra to the back. Lay these stipples only on the very tops of the striations and stop before you reach the edges.

Now mixing Burnt Sienna, Napthol Crimson Light and a little Burnt Umber, use the no. 0 round to cover the line around the edges of the elytra.

Once this has dried, use Cadmium Yellow Mid and the no. 6/0 liner to go over the very tops of the striations, stippling as you go——but stipple only the direct light side. Then mix a little Cadmium Yellow Mid with Warm White, and using your sharpest brush tip, go over these stipples again using a dotting method: just touch the tip and move a little.

Stay with your sharpest brush tip and mix Cadmium Yellow Mid with just a little Gold Oxide and stipple over the white edges on the side and front of the thorax. Next, using the same brush with just Cadmium Yellow Mid and a little Warm White, stipple over the area you just laid down, adding just a few highlights.

Now use Warm White with your sharpest brush tip to lay in the highlights in the middle, or to the side receiving the strongest light on the legs, antennae and other appendages. When dry, go over these using the same brush and Warm White, applying layers Warm White to highlight the strongest light areas. This creates a rounded appearance.

7 Highlight and Finish the Metallic Effect

Use the no. 00 round and Warm White to lay in the pockmarks down the length of the elytra in the really light areas. Remember, this does not have to be very dark to convey the effect. Once these are in, mix Warm White with Brilliant Green and continue these pockmarks into the darker areas. Finally, use the no. 6/0 liner and Warm White to go over the highlighted areas again.

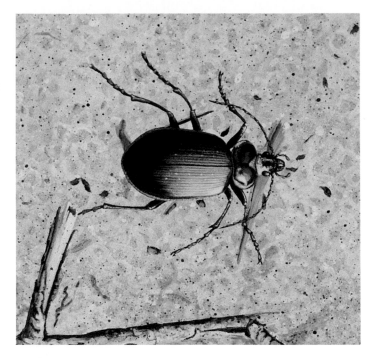

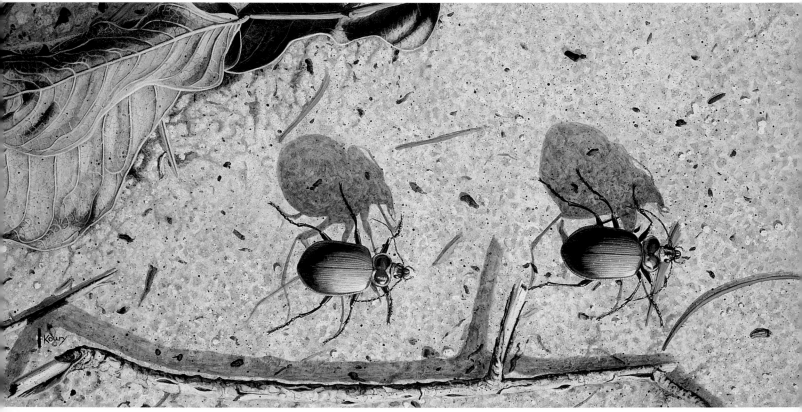

Two by Four
Fiery Searcher Beetles
6" × 12" (15cm × 30cm)

Achieving the Metallic Effect

Color layering using the stippling technique will help create the metallic effect.

Capturing Color and Translucency of Spiders

In the next two spider demos, we will learn how to create transparency and lay in hairs. These techniques can be applied to thousands of different critters from mammals to insects. In each of these, not to mention all the other examples throughout this book, practice and patience are the keys to portraying believable, touchable and dimensional subjects—so practice, get lost in your painting and have fun!

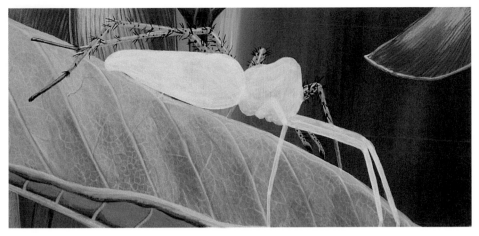

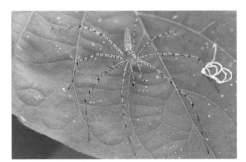

Reference Photo

Lynx Spider Materials List

Palette
- Burnt Sienna
- Burnt Umber
- Brilliant Green
- Cadmium Yellow Mid
- Carbon Black
- Green Light
- Nimbus Grey
- Pine Green
- Raw Sienna
- Warm White

Brushes
- no. 6/0 liner
- nos. 1, 0, 00, 000 rounds

1 Lay in the Legs and Establish the Base Color

Use the no. 6/0 liner and a thin wash of Warm White to lay in the legs and pedipalps at the front of the face.

Then use your very finest brush tip and a mixture of Carbon Black and Burnt Umber to lay in the spines or spikes on the back sides of the legs. Start at the leg with your brush tip and pull away, lifting your brush tip at the end of the stroke. Vary the length of the spines, and remember that we are laying in spines that will be partially covered by the leg.

Use the same brush and Warm White to go back over the legs. Now use Raw Sienna mixed with Cadmium Yellow Mid and the same brush to lay in the legs and the two pedipalps. The legs are defining features of spiders, so take your time here.

Next, using Nimbus Grey and the no. 6/0 liner, lay in the middles of all the legs, leaving the edges Raw Sienna-Cadmium Yellow Mid.

Using Burnt Umber and your finest brush tip dot the legs, making small marks down them. These are going to be the spots on the other side of the legs that will be slightly visible through the transparent ones. When dry, using the same brush and Nimbus Grey, go over the spots with a thin wash. We want to push these spots back, yet still see them.

When dry, use the same brush and a wash of Warm White to go back over the top sides of the legs, just above the centers yet below the top edges.

Finally, use Carbon Black and Burnt Umber with your finest brush tip to lay in the spikes on the sides of the legs visible to us.

Random Spots

When laying in spots on the legs, think random vs. uniform. Study your subject, and notice that the spots are not lined up in a regular pattern. Try to place them in random positions as you paint.

2 Lay in the Body Values

Use the no. 1 round to cover any over-painting on the body using Warm White. When dry, use the no. 1 round and Green Light to lay in the bottom edge of the cephalothorax, and use Cadmium Yellow Mid mixed with Raw Sienna to do the bottom edge of the abdomen.

Next mix Brilliant Green with just a little Pine Green, and using the no. 0 round, lay in this wash right next to your last lighter wash along the bottom of the abdomen. Carry it over the entire cephalothorax, leaving the edges Green Light. Now mix Green Light, Cadmium Yellow Mid and a little Brilliant Green and lay in the center and top of the abdomen.

When dry, use Cadmium Yellow Mid and Raw Sienna to lay in the under-color on the tip of the abdomen and at the bottom of the abdomen where it meets the cephalothorax. Then mix Green Light and Cadmium Yellow Mid and lay in another wash over the top of the abdomen and cephalothorax.

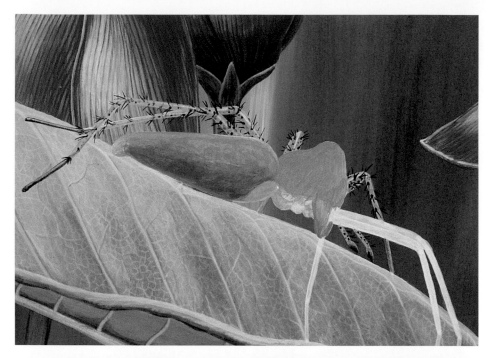

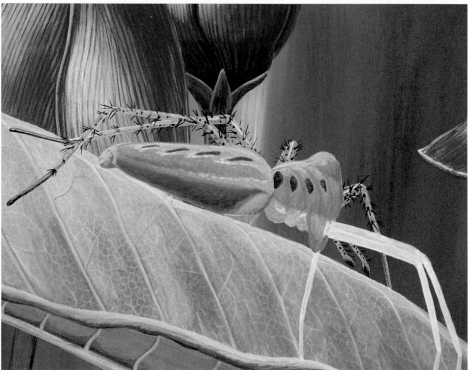

3 Continue Body Values and Contouring

Using the no. 1 round and Warm White, lay in the lateral line along the abdomen and the chevron-type markings along the top of the abdomen. When dry, go over these with Cadmium Yellow Mid.

Mix Brilliant Green with a little Green Light and use the same brush to lay in the section lines, starting at the upper portion of the cephalothorax and moving down to the legs. Use the same mix and brush to darken and contour the front of the cephalothorax. Apply this in thin washes, building up color. Next use the no. 0 round and lay in the markings on the top of the abdomen and cephalothorax using Burnt Sienna.

4 Finish the Body and Highlighting

Use Warm White mixed with Raw Sienna to lay in the lighter area where the eyes will be at the top of the cephalothorax using the no. 0 round. (Spiders have eight eyes, but only four are visible in this painting.) Then, using your finest brush tip and Carbon Black, lay in the eyes on the cephalothorax. Use a little Warm White to highlight the eyes. Next mix Warm White and Green Light to highlight the areas of strong light on the abdomen and cephalothorax.

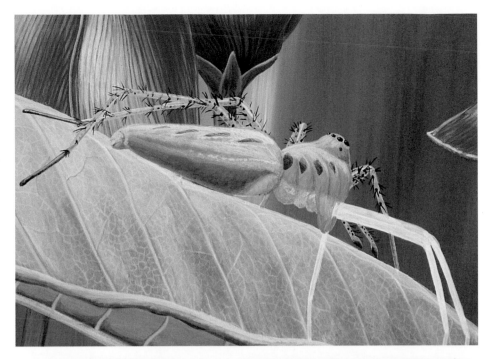

5 Complete the Legs and Establish Translucency

Using the no. 1 round and Warm White, lay in the base color for the legs in front of the abdomen.

When dry, use Cadmium Yellow Mid mixed with Raw Sienna along with the no. 6/0 liner to lay in the color along the edges of the legs. What you are trying to portray here is the translucent effect light gives to the legs of some spiders and insects.

Next use your finest brush tip and lay in the spines and dark spots on the legs. These spikes and spots are on the other side of the leg and will be slightly visible through the leg itself when you are finished. Now use Nimbus Grey and your sharpest brush tip. Lay this application down on the inside of the leg sections. Be careful to leave the outer edges the original Cadmium Yellow Mid and Raw Sienna. You want a slight color progression here from light on the edges to slightly darker in the middle, and you want to visually push back the dots on the other side of the leg.

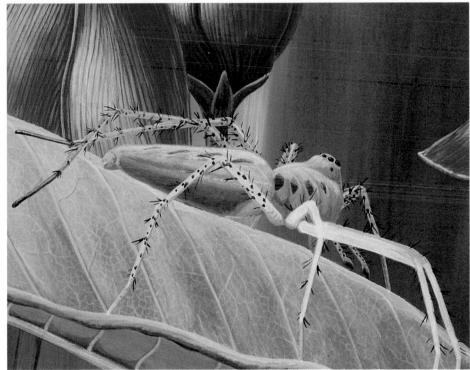

6 Continue the Translucent Effect

Use the no. 6/0 liner and Nimbus Grey to go over the center of the legs, pushing the dark spots back. Next, use the same brush to lay a thin Warm White wash in the very center of the legs and appendages. Use only one wash. Use the same brush and mixture and highlight the legs and appendages with a second application, laying this in only where the reflective light is strongest. Now use your sharpest brush tip and the process we used before to lay in the spines on the leg. Mixing Burnt Umber with Carbon Black, start at the leg and pull your brush tip outward, lifting at the end of the spine. Lay in the spines on the sides and fronts of the legs.

Little Green Hunter
Lynx Spider
4" × 6" (10cm × 15cm)

Painting the Tarantula

As you work on this demonstration, remember to move your brush in the direction the hair lies when you are laying in both base colors and defining colors. To achieve realism and depth, leave random spaces between your strokes.

Reference Photo

Tarantula Materials List

Palette
- Burnt Sienna
- Burnt Umber
- Cadmium Orange
- Carbon Black
- Gold Oxide
- Napthol Crimson
- Nimbus Grey
- Payne's Grey
- Provincial Beige
- Raw Sienna
- Warm White

Brushes
- no. 6/0 liner
- nos. 2, 1, 0, 00, 000 rounds

1 Establish Base Color and Lay in the Legs

Use the no. 6/0 liner and a thin wash of Warm White to place the tarantula.

When the base is dry, use the no. 1 round and Carbon Black mixed with Burnt Umber to fill in the base color of the legs. Use more Carbon Black on the tip of each leg. When the base color is dry, use the no. 6/0 liner and Warm White mixed with Nimbus Grey and, keeping your tip very fine, lay in the hairs on the edges and centers of the legs. Next, mix Burnt Sienna with a little Burnt Umber and use the same brush to go over the little hairs that line the edges of the legs. Start your stroke at the leg edge and pull your tip away and toward the end of the leg. The hairs should be oriented so they are pointing out and a little away from the body. Don't make this too thick; space the hairs out slightly. This should look sort of like a corona (or faint glow) around the legs. Now define the sections of the legs. Remember, spiders' legs are made up of seven segments, but in this painting only five segments are visible except on the second leg from the front. Use the no. 1 round and a mixture of Nimbus Grey and Provincial Beige to lay in the lines that define the sections.

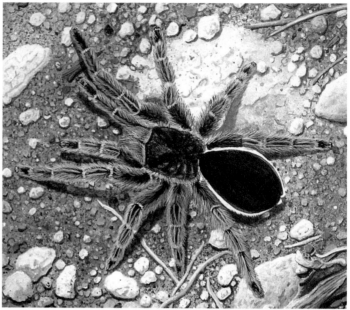

2 Continue the Legs and Lay in the Base Color on the Body

Highlight the lines on the leg sections using Warm White with a little Nimbus Grey. Use this mixture to lay individual hairs over the Burnt Umber base coat. Be patient and remember that you are just implying hairs here.

Once the legs are in, go back to the body and use the no. 2 round and Burnt Umber with a little Carbon Black to lay in the base color of the head and thorax.

3 Finish the Legs and Contour the Body

Use the no. 2 round and Carbon Black mixed with just a little Burnt Umber and Burnt Sienna to lay in the abdomen, placing the darkest values in the middle of the abdomen and where it attaches to the cephalothorax.

Move to the cephalothorax and the area in front of it where the fangs are. Use the no. 6/0 liner and Warm White mixed with Nimbus Grey to lay in the hairs, starting at the very front and moving toward the shell. Now mix Gold Oxide with Burnt Sienna and go over the hairs that you've just laid down with a very thin wash, using strokes originating from the front of the spider back toward the body. When this is dry, continue to layer using Nimbus Grey, going back over the area again using individual hair strokes.

Use the no. 0 round and fill in the area around the shell using Burnt Umber mixed with Carbon Black. Next use Nimbus Grey and the no. 6/0 liner to lay in the hairs around the edge of the cephalothorax. Start these strokes right at the edges, moving back and away from the body. When you are finished, layer a little color over this Nimbus Grey using Provincial Beige. It should look like a corona around the cephalothorax.

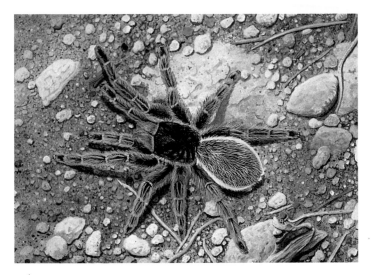

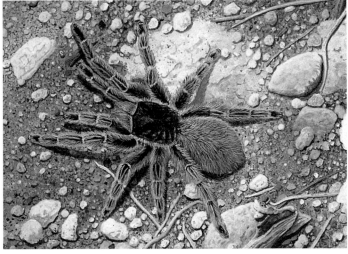

4 Lay in the Abdomen Hairs

Use your sharpest brush tip, to do the abdomen hairs with a mixture of Warm White and a little Nimbus Grey. Start at the very back of the abdomen and lay in the hairs working toward the middle of the body. Keep the hairs sparse at the back, and increase the density as you move toward the cephalothorax, always trying to leave a little undercolor showing. As you get to the tips of the hairs, curl them by twisting your brush tip. The hairs on the right side should bend or curl slightly to the right and the hairs on the left side should curl or bend slightly to the left. When you get to where the abdomen meets the cephalothorax, shorten your stroke or hair length and decrease the number of hairs that you lay in.

5 Paint the Second Layer of Abdomen Hairs

When dry, mix Burnt Sienna and Napthol Crimson with water to make a thin glaze. Use the no. 2 round and glaze over the hairs on the abdomen starting just a little back from the beginning of the abdomen and going clear to the end. You should now have a bunch of reddish hairs on the abdomen. When dry, you can really pull out the hairs by using your finest brush tip and Warm White to go over the hairs again. Be patient here. When the white hairs are dry, go over them using Cadmium Orange and Burnt Sienna. Use more Cadmium Orange on the top side of the abdomen and more Burnt Sienna as you work your way to the bottom of the abdomen.

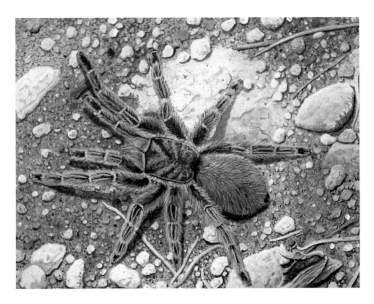

6 Add Hairs to the Rest of the Body

Use your sharpest brush tip and Raw Sienna to stipple in hairs on the shell of the cephalothorax. Start in the center with dots, and change the dots to short hair strokes as you move outward. Make these fairly random in direction and leave the edges of the shell the dark undercolor. Now mix Nimbus Grey and a little Payne's Grey, and starting at the edge of the body, use short strokes to lay in the lighter hairs that surround the shell. With the same brush and mixture, move to the head and lay in the shorter hairs first, then the longer hairs in the center. Again, leave some of the under-color showing through and overlap some of the hairs.

7 Highlight the Hairs and Deepen the Contours

Now mix Burnt Sienna with a little Raw Sienna. Use the no. 6/0 liner and highlight the tops of the hairs on the abdomen. Take your time here; done well this step will really add contour and depth to your spider's body. Using Raw Sienna and Warm White, highlight the abdomen hairs by laying in more paint on just a few of the hairs and their tips.

Now for the cephalothorax: Use the no. 1 round and Carbon Black to lay in the eyes. There are eight of these—two large ones and six smaller ones. When they are in, mix Carbon Black with a little Warm White and place a highlight in each eye. Follow this with Warm White where the eyes are most strongly highlighted.

Next, using the no. 6/0 liner and Nimbus Grey mixed with Warm White, highlight a few hairs on the sections of the legs where the light is strongest, and highlight the hairs at the front of the cephalothorax.

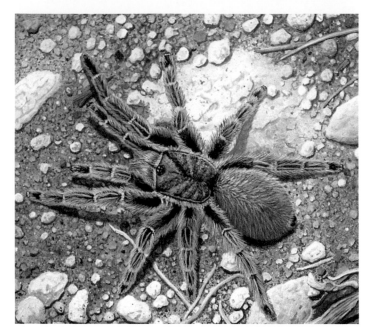

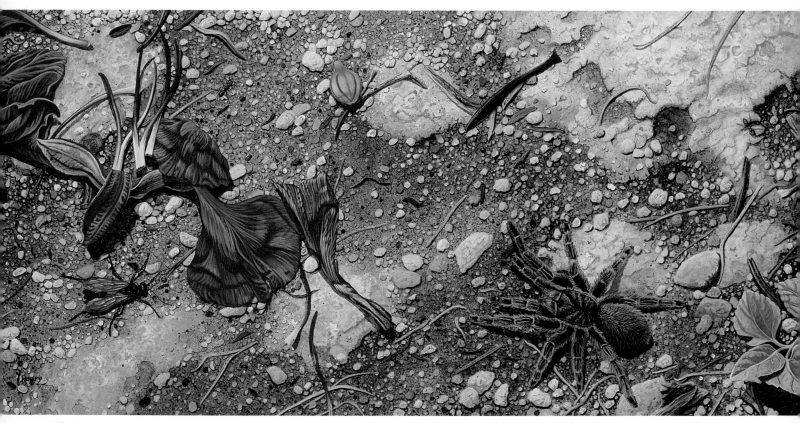

Gladiators
Tarantula and Tarantula Hawk Wasp
9" × 18" (23cm × 46cm)

Incorporating "Bounce Light"

"Bounce light" is the term I use for reflective light—light that does not hit the subject directly, but that hits it after reflecting or bouncing off another surface. Insects and other hard-bodied creatures make good subjects for practicing the portrayal of bounce light because of the reflective quality of their bodies.

Bounce light can come from anywhere, and its value or intensity is determined by the intensity of the direct light.

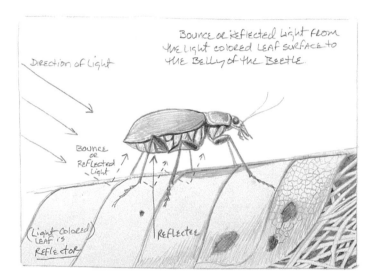

Determine Light Sources
Direct light is coming from above and slightly behind, while bounce light is coming from the fallen leaf the beetle is walking on. The object receiving direct light is the "reflector" and the object receiving bounce light from the reflector is the "reflectee."

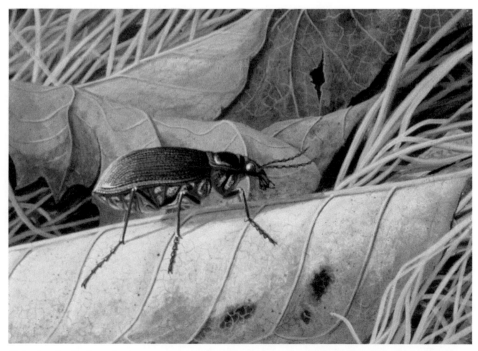

The Searcher
Fiery Searcher Beetle
4" × 5½"
(10cm × 14 cm)

Painting is all about how we portray light. The bottom or shaded side of an object does not always have to be dark. Be aware of bounce or reflective light on objects around you. Be aware of the light's color, intensity and the texture of the surfaces it hits.

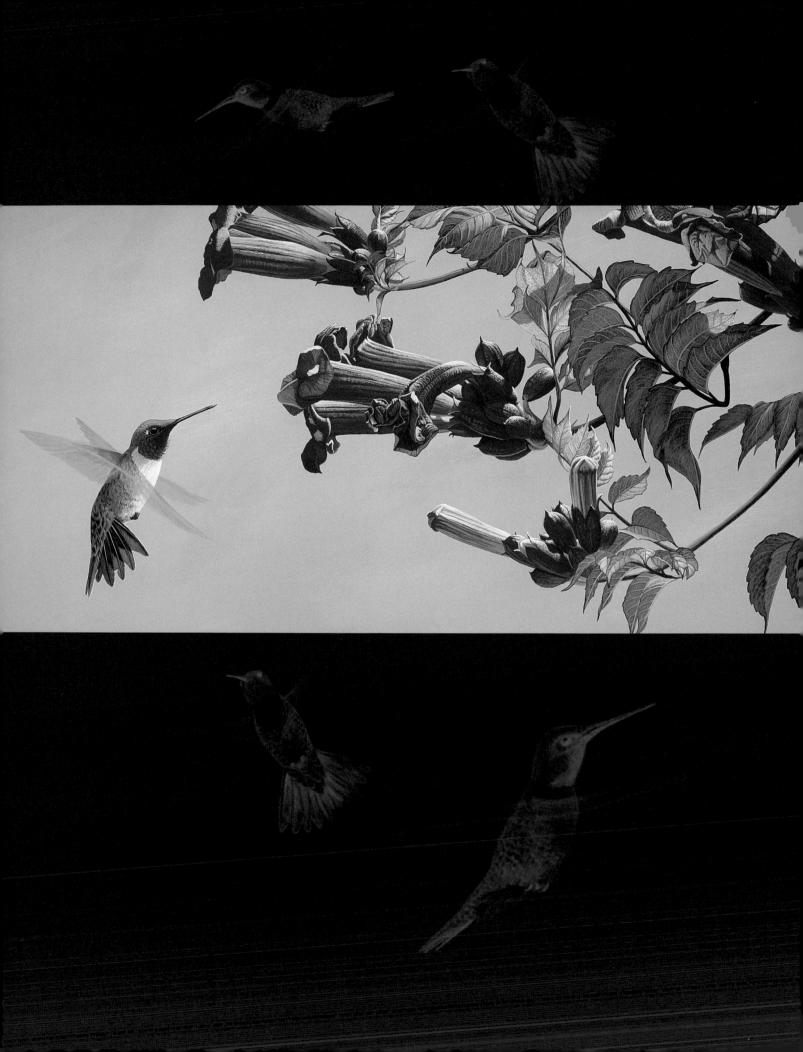

HUMMINGBIRDS

*T*hese complicated little feathered wonders are truly a joy to watch and even more fun to paint. From an artist's standpoint, humming-birds and their fluid postures can be very expressive. Their iridescent colors, tiny feathers and tireless wings provide a delightful challenge for the painter. Suggesting movement to the point that the viewer can almost hear the wings beating is quite an achievement! We will go through steps in this chapter that will help you paint the movement of those amazing wings.

What's on the Menu?
Ruby-Throated Hummingbird at Trumpetvine
9" × 18" (23cm × 46cm)

Anatomy of Hummingbirds

Hummingbirds are the tiny flying jewels of the sky, and highly complex little creatures. There are about 340 species of hummingbird, all of which occur only in North and South America. They are in the same class as birds (Aves) order Apodiformes and family Trochilidae.

Hummingbirds are little dynamos of energy possessing an incredible metabolism. The resting heart rate of a hummingbird is about 500 beats per minute; in active flight this heart rate may approach 1,200 beats per minute. Twenty-five to thirty percent of their body mass is made up of flight muscles which power wings unlike those of any other bird. Hummingbirds have long, narrow, very rigid wings which generate power on both the upstroke as well as the downstroke.

Hummingbird beaks come in many different shapes and are specially adapted for tubular flowers. The tongue is sharply forked at its tip and also may be fringed in some species. This amazing tongue is connected to a bony structure in the hummingbird's head called the *hyoid apparatus*, which allows the extraordinarily long tongue to be extended and then pulled back in. The tongue does not suck the nectar; instead, it uses a capillary action in which nectar flows along grooves in the tongue. When the nectar-soaked tongue is drawn back into the beak, the liquid is squeezed out and swallowed. Whether this happens when the tongue is drawn in or pushed back out is not quite clear.

The wondrous color of hummingbird plumage in a painting results from carefully reproducing the bird's feather structure rather than from using glittery metallic pigment. The tiny feathers have a minute and intricate pattern of platelets and air pockets, and it's the scattering of light reflected off these platelets that produce the bird's wonderful colors. These platelets are layered; the more layers, the more dazzling the color. Feathers on the body have concave platelets that reflect light in all directions, while the feathers that make up the gorget (neck and throat) have flatter platelets and more layers. What this means to the viewer is that the body is likely to have an iridescent color most of the time, because light is being reflected in all directions due to the concave shape of the platelets. The throat or gorget feathers, however, may appear dark to black because these platelets are flat and need light to hit them at just the right angle to light them up. Ornithologists believe the male hummingbird knows this, and orients his gorget just right with the sun in order to dazzle the females.

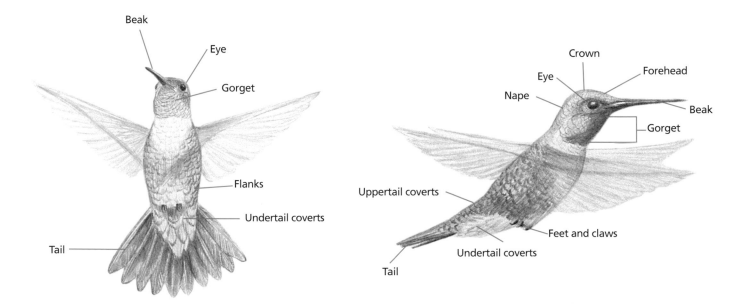

Sketches of a Ruby-Throated Hummingbird

WING STRUCTURE

Hummingbird wings are different from those other birds; they are more rigid and less flexible. This allows them to power through the upstroke as well as the downstroke.

Portraying this movement accurately means knowing the wing structure and how the wing moves through the air. The sketches below show how the wing pivots at the shoulder, allowing the leading edge to rotate up and down based on the stroke. The movement viewed from the side is almost a figure-eight pattern, with the trailing edge slightly below, then even, then slightly above the leading edge. Keep this pattern in mind when sketching and trying to figure out how to depict this movement. I enjoy portraying movement in these tiny wings because it is the essence of the hummingbird.

Hummingbird Wing Movement

1. Wing is farthest back and beginning its forward movement.
2. Moving forward; the top of the wing is slightly ahead of the bottom wing.
3. Moving forward; the top of the wing is still slightly ahead of the bottom, with the shoulder rotating.
4. Moving forward; the top of the wing is even with the bottom of the wing.
5. Moving forward; the top of the wing is behind the bottom, with the shoulder continuing to rotate.
6. Almost at the end of the forward stroke; the bottom of the wing is rotated up and ahead of the top.

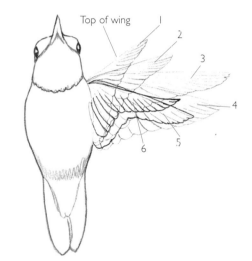

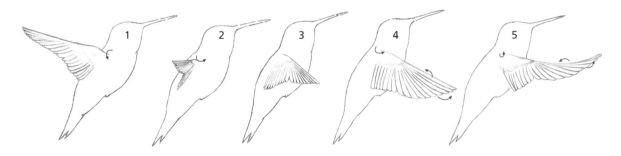

Hummingbird Wing Movement (Lateral View)

1. The wing is at the back of the stroke, starting forward. The top edge is ahead of the bottom edge. The shoulder is beginning its forward rotation.
2. The wing is moving forward, with the shoulder continuing forward and rotating. The top of the wing is ahead of the bottom of the wing.
3. The wing is continuing forward, with the top of the wing still leading the bottom.
4. The wing continues forward while the shoulder rotates. The top of the wing is trailing the bottom.
5. The forward stroke is now ending. The shoulder has rotated forward around its axis. The top of the wing is behind the bottom, which has rotated up and forward.

Gathering Reference Material

OBSERVING, SKETCHING AND PHOTOGRAPHING

I could watch hummingbirds for hours on end, and the best way to do this is to attract them to you. In North America, feeding hummingbirds has really caught on. Sixteen species nest in the United States; all but one in the western states. The only eastern variety is the ruby-throated hummingbird.

Hummingbird feeding and gardening are good ways to view these guys, but sketching and photographing them is really tricky. When sketching I rely on a mental picture that I have formed while watching, as well what I have learned about how the wings work. My sketches are quick and rough, with more emphasis placed on body position or *flight attitude*. Flight attitude is the orientation or posture (in that split second of time that you are painting) of the hummingbird's head, tail and wings. All of these components will imply where the bird has come from (direction), whether he's hovering, or where he's going. The wings are laid in with just a stroke, indicating how they arch around the body.

Photography can be very tricky because we all want that beautiful gorget to be lighted up in our photos. This takes a lot of planning. Watch for favored flowers and perches, notice the angle of the light, set up for optimum light, and wait. Using a flash will help, but the gorget still may not light up. I use the lay-in-wait method, and when the natural light hits the gorget just right, I release the shutter and hope. There are workshops available if you want to take your hummingbird photography to a more advanced level. In any case, the worst it can be is a great time shared with a little winged jewel.

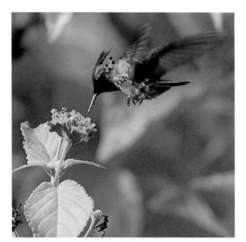

Male Tufted Coquette

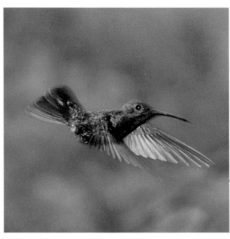

Black-Throated Mango

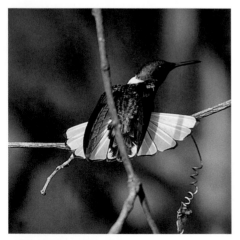

White-Necked Tacobin

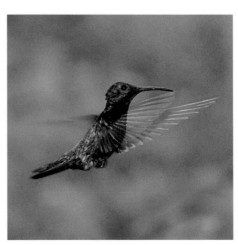

Black-Throated Mango

Portraying Hummingbird Wing Movement

Implying movement in your work and carrying it off in a believable manner can add a dynamic quality to your painting. Birds in flight naturally lend themselves to this. The techniques used here can be used on other birds and flying insects.

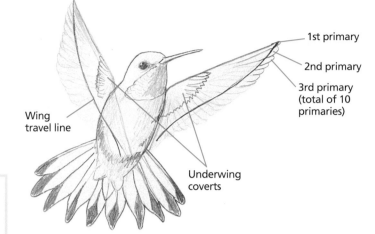

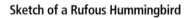

Sketch of a Rufous Hummingbird

Rufous Hummingbird Materials List

Palette

- Brilliant Green
- Burnt Sienna
- Burnt Umber
- Cadmium Orange
- Cadmium Yellow
- Cadmium Scarlet
- Carbon Black
- Green Light
- Napthol Crimson
- Napthol Red Light
- Nimbus Grey
- Payne's Grey
- Pure Green
- Raw Sienna
- Warm White

Brushes

- nos. 2, 1, 0, 00, 000 rounds

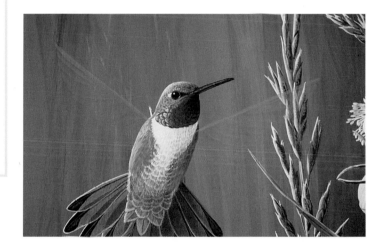

1 Lay in the Wing Guides

Prior to working on the wings, complete the hummingbird body using Carbon Black, Brilliant Green, Green Light, Pure Green, Nimbus Grey, Cadmium Scarlet, Napthol Red Light, Napthol Crimson, Cadmium Orange and Burnt Umber. When complete, let dry and start on the wings. The hummingbird wing is fairly straight and rigid. Use a good no. 2 round here. Mix a very thin, watery wash of Payne's Grey and a little Warm White. Load your brush and start where the shoulder meets the wing. Pull your brush outward, stopping at the end of the first feather on the very tip of the wing. Without reloading your brush, use just the tip to follow the outer edge of the first feather. Use the same watery wash to lay in the tip of the second feather. Repeat this for the remaining feathers. When you begin to use up the paint in the brush, reload and draw your brush across the easel surface or a piece of paper to remove the excess paint. You want these lines to be faint. Shorten the feather length as you progress toward the body.

This "shadow" of a wing will be your guide for the next applications.

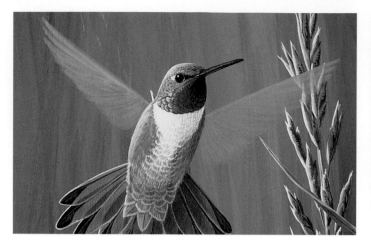

2 Detail the Wing Feathers

Using the same watery wash of color from step 1, fill in the wing and detail it just a little more. Use the no. 2 round and start at the wing tip. Lay your brush tip right at the bottom edge of the first feather and pull back toward the body. You want this line to portray the bottom edge of the first feather. Carry this line to where the primary feathers meet the underwing coverts (second layer of feathers under the wing that slightly overlap the primaries). Move down to the second primary feather and again start at the bottom, pulling toward the underwing coverts. As you continue laying in the bottom edges of these wing feathers, remember that these feathers get more and more vertical as they approach the body.

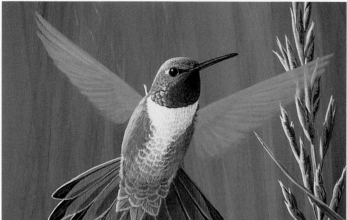

3 Fill in the Wings

Make sure that your last application is dry before you fill in the wings, or you will lift it off. Use the same watery wash from step 1 and start at the wing tip. Now with a loaded brush, fill in the feathers to the underwing coverts. When finished, the primaries should be ghosted in with the tips faintly represented, moving to a somewhat less transparent effect in the feathers closer to the body. Now using the same wash and brush, start at the first underwing covert and lay the brush tip where the feather should start, pulling back to the body. Use this stroke with each underwing covert feather: start at its tip and pull back to the body. When the coverts are all laid in, the wing should look fairly complete, yet transparent.

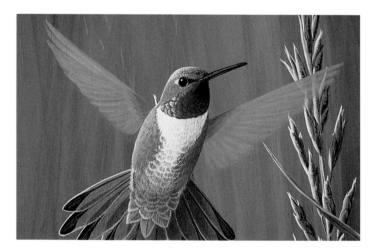

4 Finish the Wing

Use the no. 2 round with a watered-down mixture of Raw Sienna, Burnt Sienna and Payne's Grey. Reduce the transparency on the area of the wing right next to the body because this part of the wing is not moving as fast as the rest of the wing or the wing tip. Start at the body where the wing attaches and lay in your paint, moving away from the body and making each stroke mimic a feather (only the feathers that make up the underwing coverts). Let each application dry before going over it again. You want this area to move from dark near the body to transparent rusty at the tips of the underwing coverts. On the sun side, use Raw Sienna and a little Cadmium Yellow Mid to lighten up the area where the wing joins the body. If you make a mistake on the wings, depending on the background, you may have to paint over it and start again. Be patient. This takes time, practice and confidence to get it right. When the wings are in, go back and repaint any overstrokes on the body.

5 Begin the Wing Movement

The lines and strokes you will lay in here will in essence determine the flow of your piece. The wing sweep can be graceful and uplifting, while also giving the viewer a good idea of your hummer's flight attitude. He can be hovering, turning or going up or down based on where you carry the wing travel line. Scan back to the hummingbird sketches on page 85. The wing travel line is the heavier line that begins at the first primary wing tip, runs back across the wing and ends in a transparent first primary on the other side of the stroke. This line undulates slightly to portray the rotation of the wing as it moves. Using the no. 2 round and the same watery mixture of Payne's Grey and Warm White from step 1, start at the tip of the first primary and lay in a faint wing travel line.

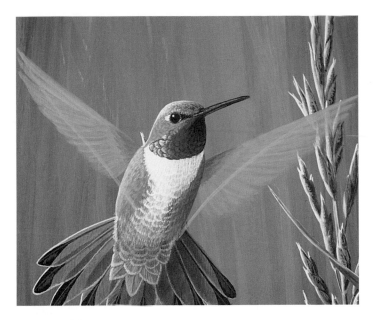

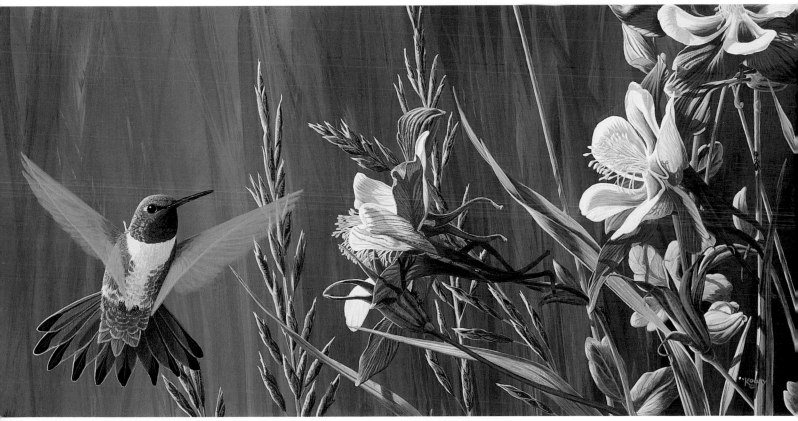

Wildflower Feast
Rufous Hummingbird
7" × 14" (18cm × 36cm)

6 Finish Wing Movement

When dry, start the next feathers. Lay your brush tip where the second primary would be and pull the brush toward the body and angle for the wing travel line. Do only this one stroke for each feather, and remember that each feather gets shorter and more vertical. When dry, apply a second coat with the same wash and brush. You want this to be milky, yet transparent. Finally, mix Warm White with just a little Payne's Grey and go over the wing travel line. It should stand out a little more than the transparent wing feathers.

Portraying Wing Motion From the Side

In this demonstration we will use the same steps you learned on pages 87-89; the variation is laying in the far wing first. Finish the body of the bird, using the same colors from the demonstration on page 87, then do the far side. Any overpainting onto the body may be fixed after the wing is laid in. Keep in mind that the path you choose for the far wing will determine the path for the near wing. The wings work in unison, so the near wing should nearly echo the path of the far wing.

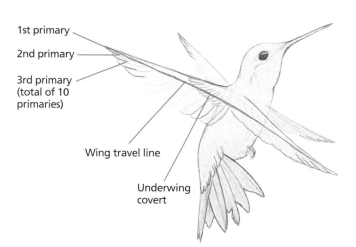

1st primary

2nd primary

3rd primary (total of 10 primaries)

Wing travel line

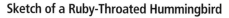

Underwing covert

Sketch of a Ruby-Throated Hummingbird

Ruby-Throated Hummingbird Materials List

Palette
- Payne's Grey
- Pine Green
- Warm White

Brushes
- nos. 2, 0, 00, 000 rounds

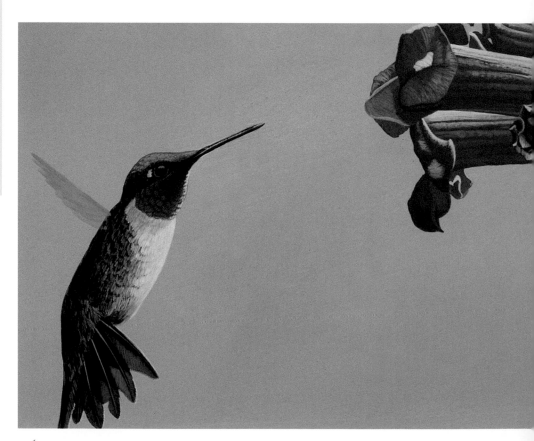

1 Lay in the Wing Guides

Use the no. 2 round and Payne's Grey mixed with Warm White and water. Start right at the body and pull out the line for the first primary. Without reloading the brush, lay in the primary feather tips as you did in step 1 on page 87, using a very transparent wash. This is your guide for the following washes or layers.

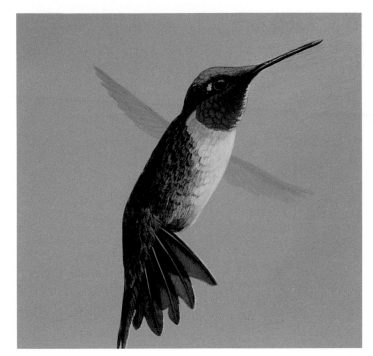

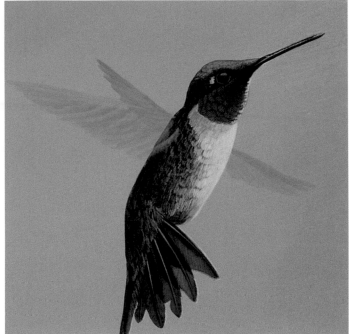

2 Finish the Other Side of the Wing Path

Fill in the far wing, using the same mix and brush from step 1. Start at the second primary tip and pull back to the body. Work your way down the wing, starting at the tips and pulling back toward the body. When the wing is filled in, check the look. It should suggest very transparent feathers. Next carry the far wing stroke to the other side of the body. Starting at the body again and making sure that your starting point matches the path the wing would take, pull your stroke away from the body, lifting the tip of the brush at the end.

This far wing should be very transparent and not as detailed as the near wing. Suggest the feathers with your strokes. Start at the body again and use the same wash and brush. Pull out the second primary and then the third and fourth and so on until you reach the body with the feather tips. Each stroke should ever-so-slightly overlap the last stroke. Now you should have a good portrayal of the far wing. Before going on, cover up any overstrokes on the body. I know these wings look tiny, but remember that they are on the far side and will look OK once the near wings are in.

3 Lay in the Near Side Wing Guides

Use the same brush and mixture as in the prior steps. Start where the wing meets the body and pull out the first primary feather of the near wing, mimicking the path of the far wing but a little lower. When you have your first primary feather in, lay in the tips of the remaining feathers. There are ten primary feathers and at least four secondary feathers. Remember, think transparent.

Now you are going to see some color buildup where the wings overlap. Keep your washes thin and do not worry; you want the far wing to sort of disappear where there is overlap.

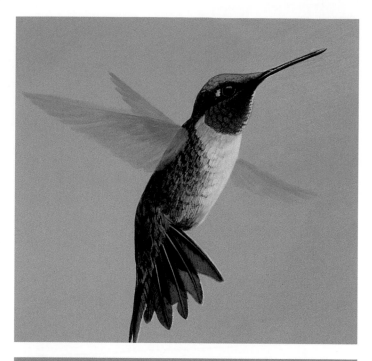

4 Detail and Fill in the Near Wing Feathers

Using the no. 2 round and a mixture of Payne's Grey and Warm White, start at the tip of the bottom of the second primary feather and pull back toward the body and top edge of the wing. What you are doing here is detailing the lower edge of each feather. Continue down the wing.

Using the no. 2 round and the same mixture, start at the feather tips and pull to the covert feathers with the wash. Continue this around the wing. Then using the same mix and brush, start at the underwing covert tips and pull back toward the body and top of the wing.

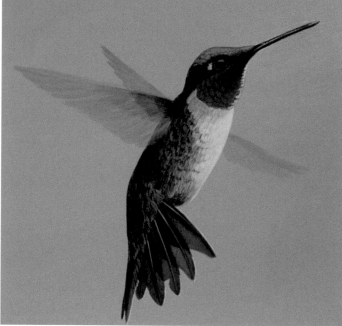

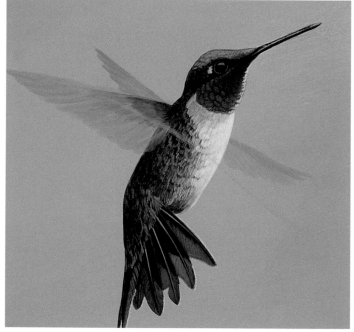

5 Finish the Near Wing

Mix Pine Green with Payne's Grey and water to make a very thin wash. With the no. 2 round, start at the body where the wing attaches and pull out and away, finishing at the tips of the coverts. Let each wash dry before going over it again. Keep in mind that this part of the wing is slightly darker or more opaque than the rest.

6 Lay in the Wing Travel Line

Use the no. 2 round and the mixture of Payne's Grey, Warm White and water used in step 1 to lay in the wing travel line as we did in the previous demo, page 89. Start with your brush tip at the tip of the first primary and pull a slightly undulating line to the end of the first primary on the other side of the wing stroke. Keep this initial line faint; we will go over it later to pull it out.

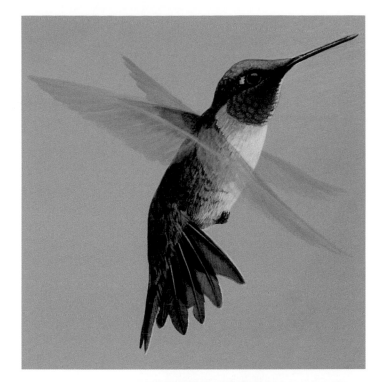

7 Finish Wing Movement

Lay your brush tip where the second primary would be and pull the brush toward the body, angling for the wing travel line where your stroke should end. Do only one stroke for each feather as you work your way up the wing, and overlap the previous feather just slightly. Let the wing dry before you lay in any more washes. Remember, this needs to be transparent. Now mix Warm White with water and just a little Payne's Grey to go over the wing travel line, lifting it up slightly.

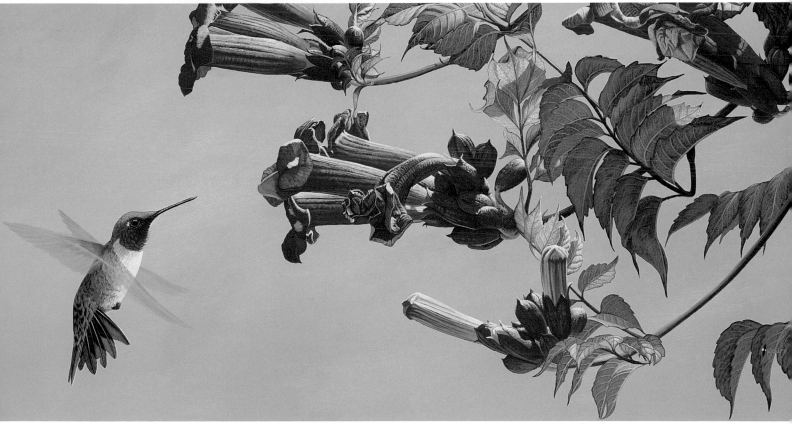

Implying motion and feather/wing structure at the same time is tricky. Do not be disappointed if your wings initially look heavy. This is almost a "feel" that you will get better and more comfortable with as you at with practice.

What's on the Menu?
Ruby-Throated Hummingbird at Trumpetvine
9" × 18" (23cm × 46cm)

Flight Attitudes and Wing Positions

In the examples here, notice the differences in body posture and wing paths. The colors you use to do the wings will vary depending on the background color.

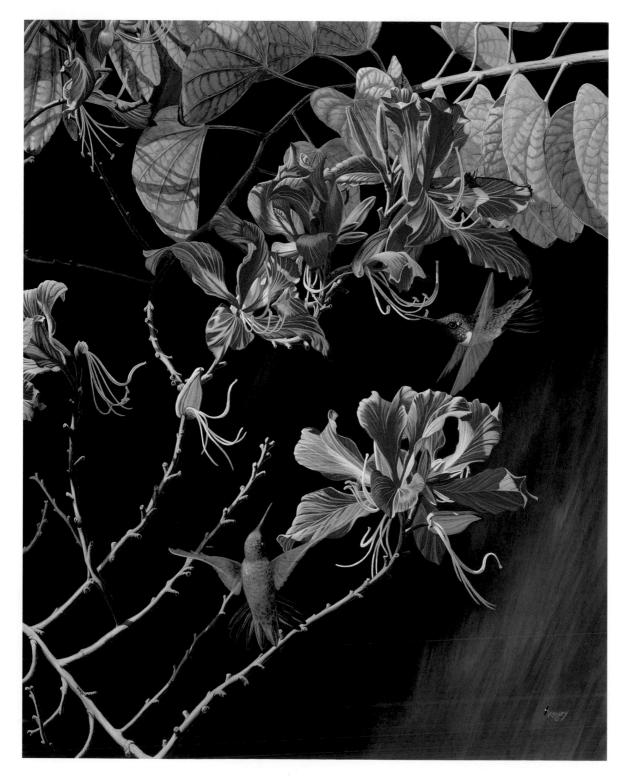

The object here was to portray the flight attitude of a hummer that had just flown in from above and was in the process of transition from diving to leveling off, then eventually hovering. This was achieved by placing his body horizontally while having the tail still pointed upward.

Emeralds and Orchids
Wild Orchid Tree and Ruby-Throated Hummingbird
23½" × 18½"
(60cm × 47cm)

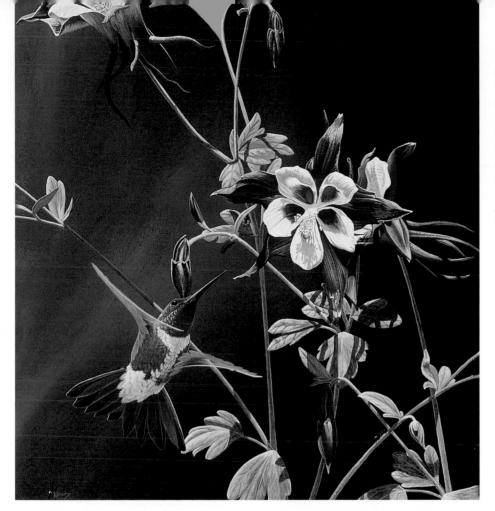

I wanted this hummer to come from below and slightly behind the flower, implying from his flight attitude that he was going up to the columbine. This was achieved more through the positions of , body, tail and head than through those of the wings. Notice how the body tilts to the right and the tail fans out, which implies a braking action. Finally, the face and bill point upward to the flower.

Almost Missed It
Rufous Hummingbird at Columbine
12" × 10" (30cm × 25cm)

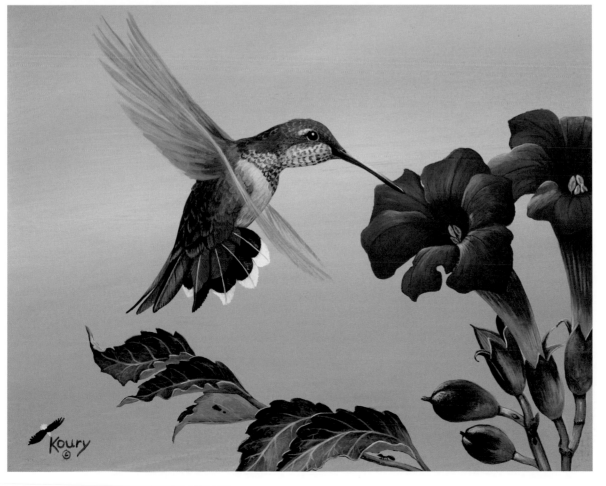

This example shows how you can change the color of the wings to a certain extent to portray them against a different background. Notice how the wing colors get darker closer to the body. This suggests that the parts of the wing closer to the body are not moving as fast as the wing tips.

Grandma's Hummingbird
Rufous Hummingbird
5½" × 7"
(14cm × 18cm)

AMPHIBIANS
AND
REPTILES

*T*he trick to painting reptiles and amphibians is getting into their skin, which many times is their signature. In this chapter we will work on how to achieve various skin types from dry to wet, rough to fairly smooth, and how that skin would look if it were partially wet.

Learning the Game
Baby American Alligator
9" × 18" (23cm × 46cm)

Anatomy of Amphibians and Reptiles

Amphibians and reptiles are probably one of the most interesting and diverse groups of critters on this planet. They range in size from 1" (3cm) or less to 20' (6m) or more. They inhabit almost every conceivable habitat. They are mostly *ectotherms*, meaning that they maintain optimal body temperature by actively using muscle or hormonal systems as well as by basking. They are able to suspend body functions and in essence enter dormancy. Their food requirements are minimal, so they can get by on very little. Many are carnivo-

rous, some are opportunistic, and still others are plant eaters. Typically they have dry skin covered with scales. There are a few exceptions to this, such as salamanders, frogs and some toads. All have defense mechanisms, whether it be biting and scratching or camouflage and coloration.

Frogs and toads are in the scientific order Anura, with ranges from above the Arctic Circle to the southern tip of South America. Frogs and toads are the most widely distributed amphibians, with nearly 3,700 species. Toads genus

Bufo normally have warty, sometimes dry-looking skin; while a typical frog genus Rana has relatively smooth skin and long legs. The order Anura is further divided into a variety of families. Distinguishing characteristics of the family Pelobatidea (spade-foots) include vertical eye pupils and a single sharp-edged black spade on each hind foot for burrowing downward, rear end first. Another family, Leptodactylidae, tropical frogs, is distributed throughout the American tropics. The two families that we will be working with are toads,

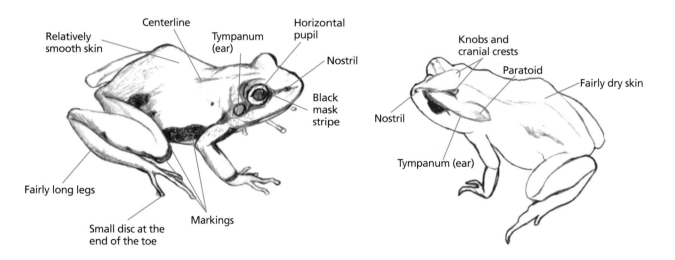

Sketch of an Ornate Chorus Frog

Sketch of a Southern Toad

(Bufonidae) and tree frogs (Hylidae) and their allies. While tree frogs are characterized by a slim waist and normally long limbs not all are necessarily tree climbers.

Among the family Iguanidae are a species of lizard reminiscent of the dinosaurs; they are called the Basiliscus. There are four known species of Basilisks distributed from tropical Mexico through central and northern South America. They are commonly found around water and are arboreal, meaning they climb trees and are very comfortable among the branches. They are mainly insect eaters. Basilisks are swift and agile and can reach a length of three feet. They can raise up and run on their hind legs, but what really sets them apart is their ability to run across the surface of the water prior to sinking. This feat is accomplished by speed of movement, specialized scales on the bottom of their hind feet, surface tension, and air pockets created as their feet slap the water and are withdrawn quickly.

Gators have some amazing adaptations as well. They are born with a healthy set of sharp teeth and are virtual eating machines; yet their metabolisms allow them to go quite a while without food. They have external ear flaps just behind the eyes and when these are pressed down, the eyes will go down into openings in the skull. The protective coloration of the gator turns a grayish black with age. With luck, this creature could live well over fifty years and reach 14' (4m) or more in length.

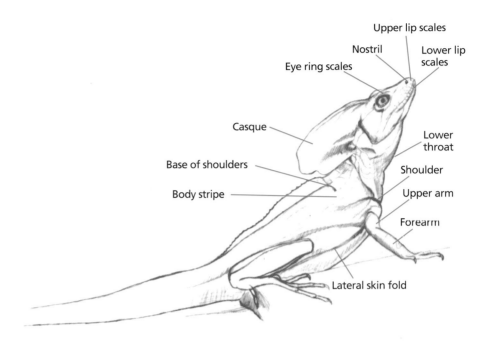

Sketch of a Basilisk Lizard

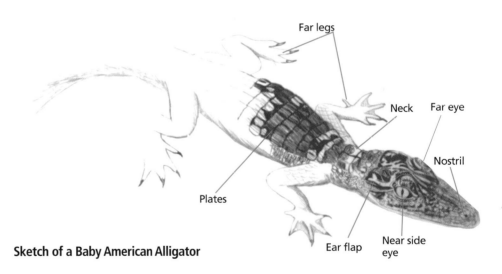

Sketch of a Baby American Alligator

Gathering Reference Material

Gather as much information as possible about your subjects before actively seeking them out. Field guides, and a wealth of other printed information about amphibians and reptiles are readily available. If you find these critters interesting, prepare yourself by learning about their preferred habitats, food sources and active and passive times. Why all of this information, you ask? (This is hopefully becoming a recurrent theme.) Knowing something about specific animals , not only will help you find them more easily, but also will help you recognize unique behaviors that you may include in your paintings. Remember, "stories" add drama to your work.

Sketching and photographing reptiles and amphibians is ideal, if you can do it from a comfortable distance. Find those creatures that maintain small territories, spend a great deal of time doing very little (conserving), or that just lie in wait for a meal to come along. Sketch quickly, trying to capture the flow of the lines or the curve of the body. Try to be as patient as the critter you are watching. Other reptiles and amphibians are not quite as easy to observe. Look for tree frogs and toads at night with a flashlight, headlamp, camera and flash unit. Larger reptiles require long distance viewing, for your comfort and theirs. Photograph them with a 200mm or larger lens, and as always, try to position yourself to catch the best light on the subject.

Reference Photo: Southern Toad
See demonstration two on page 106.

Reference Photo: Basilisk Lizard
See demonstration three on page 109.

Reference Photo:
Baby American Alligator
See demonstration four on page 113.

Painting the Damp Texture of a Frog's Skin

The example in this demonstration is the ornate chorus frog (*Pseudacris ornata*). Use the eye as a reference point to help you get the rest of the anatomy right.

Frog skin is moist and must appear that way to the viewer. The contours of the frog's reflective body should correspond to areas of strong light in order to suggest moistness. By carefully increasing the contrast in certain areas we will create the look of a damp frog.

Ornate Chorus Frog Materials List

Palette
- Amethyst
- Burnt Sienna
- Burnt Umber
- Cadmium Orange
- Cadmium Yellow Mid
- Carbon Black
- Dioxazine Purple
- Gold Oxide
- Green Light
- Nimbus Grey
- Olive Green
- Pine Green
- Raw Sienna
- Vermilion
- Warm White

Brushes
- no. 4 shader
- nos. 3, 2, 1, 0, 00, 000 rounds

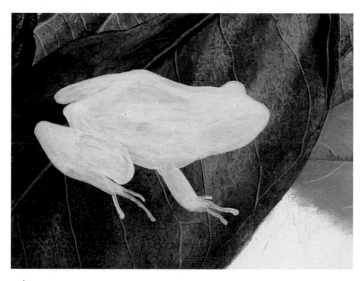

1 Establish Frog Placement
Use the no. 4 shader (no. 3 round for tight spots) with Warm White to lay in the frog's shape.

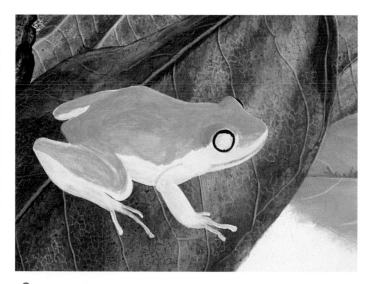

2 Lay in the Base Color
Use your no. 3 round and Green Light mixed with a little Cadmium Yellow Mid and lay in the areas of green on the head, body and hind legs. In some areas you will work from light to dark, and in other areas, from dark to light. The contours of the body and its edges determine which to use.

Use the no. 0 round and Nimbus Grey to draw in the legs and mouth. Also use Nimbus Grey to lay in the outside perimeter of the eye. Then go over this perimeter with Carbon Black. Next use a little Dioxazine Purple mixed with Burnt Umber to lay a guideline for the markings above the mouth line.

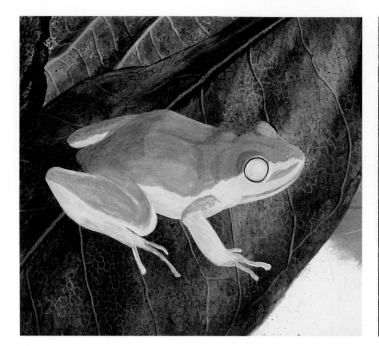

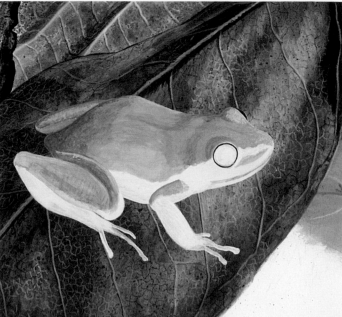

3 Establish Underlying Shading or Contouring

Use the no. 0 round and a thin mixture of Pine Green, Green Light and water to lay in the line above the eye that defines the roundness at its base. Then lay in the center-line from between the eyes to the shoulders, and the line that lies at the base of the far eye. You're dividing the body into quadrants. These lines are not straight: they follow the contours of the body you are painting. How you shape them determines the contours of the body. Lay in the line that defines the head from the shoulders, then the line that divides the shoulders from the body. Once these reference or quadrant lines have been laid in, go back over lines of the head, shoulders and back and widen them slightly. Use Warm White and thin the black circle inside the eye. Then mix a little Vermilion with Raw Sienna and lay in the base color on the front leg.

4 Continue Shading and Contouring

Now use the same brush and mixture of Pine Green and Green Light. Lay in the dividing line on the back leg and then shade upward towards the body along this line. Use the same mixture and brush to shade the long section of the hind leg. Again with the same mix and brush, shade in the rump upward to just past the far hind leg. Now mix Dioxazine Purple, Amethyst and a little Warm White and water. Lay in the underside of the far hind leg. Then with the no. 0 round and Cadmium Orange mixed with a little Warm White, lay in the edges of the hind leg.

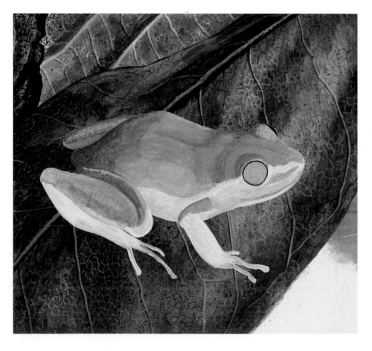

5 Continue Shading and Contouring

Now mix Warm White with a little Nimbus Grey and, using the no. 2 round, lay in the lower face and jaw by going over the underlying Warm White. Carry this down the body to the hind leg, on the front leg, belly, upper arm, and head and neck areas. Starting at the eye, use the no. 1 round and Cadmium Yellow Mid mixed with a little Gold Oxide. Fill it in so that it looks like a big yellow eye.

6 Begin the Eye and Body Markings

Use Gold Oxide and the no. 1 round to go around the outer edge of the eye, just slightly down over it. Now using your sharpest brush tip and Carbon Black, lay in the outer edges or perimeter of the eye and pupil. Use the same brush and Warm White to lay a thin line around and on the middle front of the eye, up and over the top to the middle lower back of the eye. Go over the line with Cadmium Yellow Mid, laying it right next to your Carbon Black line. This line separates the black from the colored portion of the eye.

Mix Cadmium Yellow Mid with a little Gold Oxide and lay in the eye color over the yellow that is already there, darker toward the front, back and bottom of the eye. Using your finest brush tip and Burnt Umber, stipple in the darker markings. When dry, use Carbon Black to stipple in more markings and go over the line around the eye again, using the very tip of your finest brush. Use Warm White to highlight the eye.

Mix Dioxazine Purple with Burnt Umber and water and use the no. 0 round to lay in the mouth line, starting at the front of the face and working back toward the shoulder. Using the same brush and mix, lay in the markings on the face. To make the eye appear moist, mix Dioxazine Purple with a little Warm White. Use your finest brush tip and don't overload it. On the back side of the eye—the side away from the light source—lay in a very thin line just inside the black.

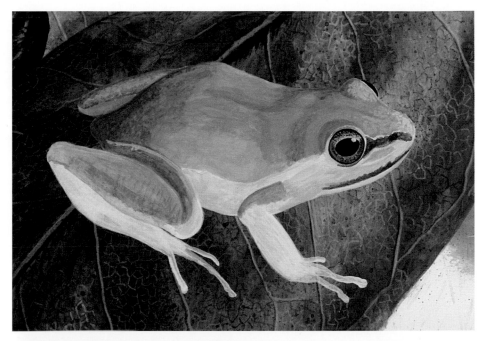

7 Lay in the Body Markings

Using the no. 0 round and a mixture of Burnt Sienna and Dioxazine Purple, lay in color on the upper arm, middle belly, lower leg and body. Then using your finest brush tip and a mixture of Nimbus Grey and Dioxazine Purple, lay in the outer edge of the lower part of the leg closest to you. Do the same on the knee. Next mix just a little Vermilion with Warm White and lay this on the bottom edge of the lower jaw. Now use Nimbus Grey and lay in the toes and feet using the same brush. Mixing Green Light with a little Cadmium Yellow Mid and Raw Sienna, lay in the top of the front foot and back edge of the front leg.

8 Finish Color and Turn Up the Light Intensity

Stipple the markings using your finest brush tip and a mix of Dioxazine Purple, Burnt Umber and a little Warm White. Lay in the edges of the ear, creating the circle that defines the tympanum. Use the same mix and stipple the dark markings, keeping them dark where they meet a fold or crease in the skin. When this is dry, use the same brush and Gold Oxide to highlight the dark markings where the light is strongest. Next, use Cadmium Yellow Mid and stipple the golden areas. Now use Warm White to stipple the white areas and along the edges of the dark markings. For the body, use the same brush and Green Light mixed with Warm White. Lightly stipple the contours of the head and body, working from dark (less stippling) in the valleys to progressively lighter (more stippling) toward the peaks.

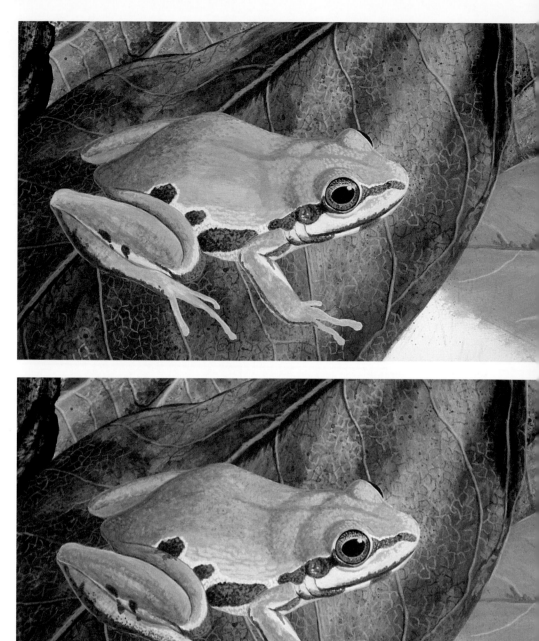

9 Continue Stippling the Body and Legs

While you are working on this step, keep in mind that although all the skin is moist or wet, only certain areas will reflect light intensely. This reflective or wet look is achieved by not overdoing the Warm White highlights; it's more a cumulative effect than just a single dot.

Using your finest brush tip, continue to stipple using Green Light mixed with Cadmium Yellow Mid to lift the texture of the skin and highlight the lighter areas. Keep in mind the shape of the body. Next move to the feet; again use your finest brush tip and stipple a mixture of Burnt Umber and Dioxazine Purple down the legs to the toe tips. To darken areas of the body and legs, use Green Light mixed with a little Olive Green.

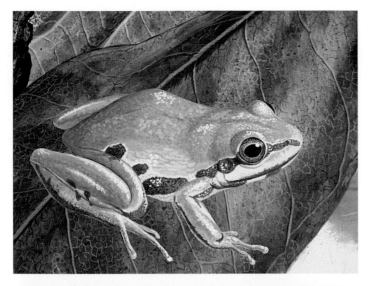

10 Finish the Wet Look and Maintain Vivid Color

First lay in the texture along the side of the body. Mix Cadmium Yellow Mid with a little Warm White, and with your finest brush tip, lay in the line along the side of the body, being careful not to cover the undercolor between the lines. Use this same brush and mixture to highlight the front and hind legs, keeping in mind the roundness of the limbs. Again using the same brush and mixture, stipple along the valleys and ridges of the body, defining the eyes. Now to really bring out the wet look, use Warm White and a little water to highlight, using the stippling method to define the texture of the skin on the higher points. You want the light to gradually intensify as it moves toward the points of strongest reflection.

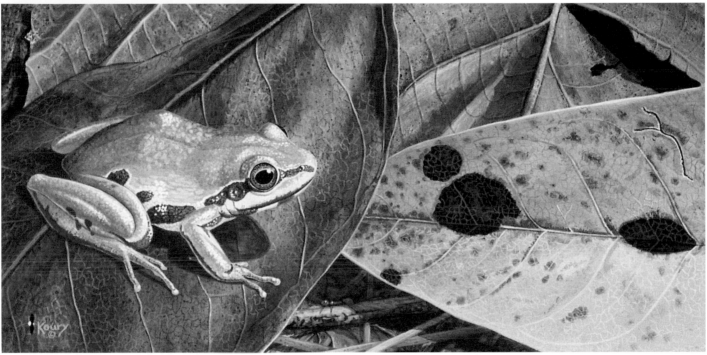

11 Complete the Stippling

It may take three layers of stippling to get the intensity you want. Try to be accurate with each application, leaving lines of base color between the stippling. This defines the skin texture.

Chorus Frog
4" × 8" (10cm × 20cm)

Detail
Southern Chorus Frog

Portraying the Dry Texture of a Toad's Skin

In this demonstration you will learn to simulate the texture of rather bumpy toad skin. Toad skin is not as reflective as frog skin, so to get that dry-looking quality, keep contrasts to a minimum, using closer values for color changes and saving bright white for features to be highlighted, such as bumps.

Southern Toad Materials List

Palette
- Burnt Sienna
- Burnt Umber
- Cadmium Orange
- Carbon Black
- Gold Oxide
- Nimbus Grey
- Payne's Grey
- Raw Sienna
- Ultramarine Blue
- Warm White

Brushes
- no. 4 shader
- nos. 1, 0, 00, 000 rounds

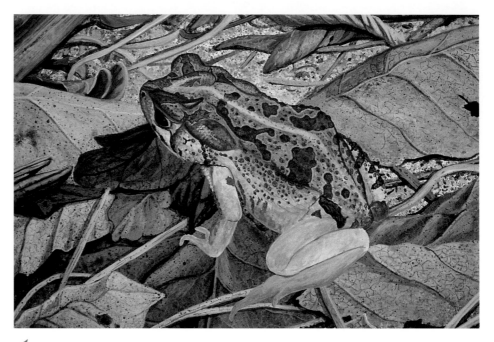

1 Lay in the Base and Start the Markings

After placing the toad and using Warm White with the no. 4 shader to paint in its base shape, you are ready to add its markings. Use Payne's Grey and Ultramarine Blue around the eye. Mix Burnt Umber with Burnt Sienna and use the no. 1 round to lay in the base color on the toad. When dry, mix Raw Sienna and a little Burnt Umber to lay in the darker markings on the frog's body and face. These markings indicate raised bumps on the skin.

Now use the same brush and a Carbon Black–Nimbus Grey mix to lay in the dark markings on the toad's side, face and legs. Use these same colors, but with less black, and make lighter gray markings on the side and legs as well.

Using the no. 00 round, add some stippled highlights on the bumps near the face and place a highlight line along the frog's back with Warm White.

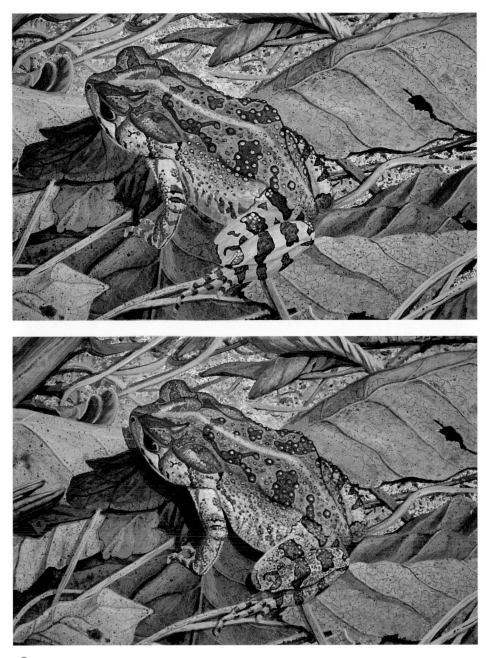

2 Add Lighter Color Values and Raise Bumps

Use the no. 0 round with Warm White and water to make smaller bumps over the large bumps on the back and legs, laying this color more on the near side of the bumps and leaving the far side the original color. As you lay in these smaller bumps, keep the light source in mind and remember that these bumps are round.

Use the very tip of your brush and a Gold Oxide–Cadmium Orange mix to stipple in dots around the large bumps. Be sure to allow the base color to show around these stipples.

Next mix Carbon Black and Warm White, and use the no. 0 round to stipple in dots on the black markings, covering more black where the light is strongest. Where there are sienna bumps over black markings, white in the bumps using Warm White and the no. 0 round. When dry, lay in Burnt Sienna over some of the white spots. When this is dry, add Burnt Sienna and let dry. Use your finest brush tip and a little Warm White to lay a small light spot on the side of the bump nearest you. When dry, go over these dots on the near side of the bump with Cadmium Orange mixed with Gold Oxide.

3 Highlight and Raise the Bumps

Use Warm White and your finest brush tip to begin laying in small light areas on the near side of the larger bumps. Starting below the crests on the upper back, move to the middle on the side and then to just above the crests on the lower body. Remember, the toad's body is rounded, and the light hitting it is coming from over your right shoulder, so the light on the spots is going to be different as you move from the top of the body down to the legs. Mix Warm White with a little Nimbus Grey, and using the same brush, begin laying in the side and belly of the frog using the same stippling method as before.

4 Continue Stippling

When you have finished the large bumps, use the same brush tip and color mix to stipple the smaller ones around the large ones. Mix Warm White with a little Nimbus Grey and use the same brush to stipple in the bumps in the areas with black spots. Base your color here on the color you are working on. Make your value slightly lighter to highlight the bump. Use Warm White mixed with water and stipple the bumps in the light areas.

Then use Warm White to highlight the light area bumps, again laying in spots on the bumps where the light is most concentrated. Use only one wash except in areas of higher intensity. Go over these once more.

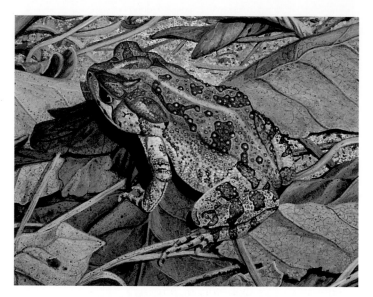

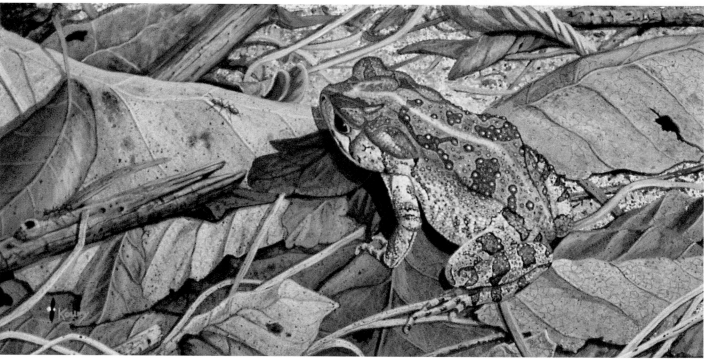

Just Snacking
Southern Toad
4⅛" × 8¼"
(10cm × 21cm)

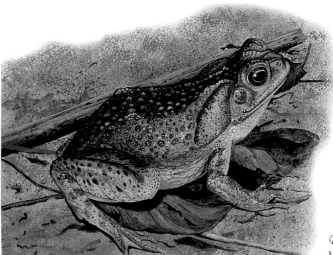

Detail
Marine Toad

Painting the Dry Texture of a Lizard's Skin

The skin of the basilisk lizard is relatively smooth, yet it's covered with scales, giving it almost a beaded appearance. Areas of strong shadow are great for portraying skin texture and scales. Instead of making tiny beads, you will use lines and highlights to suggest scales across the side of the body and on portions of the tail. These detailed scales, if done well, will carry the illusion of scaliness over the entire body. We will be working on a brown basilisk lizard from the Yucatan.

Basilisk Lizard Materials List

Palette
- Burnt Sienna
- Burnt Umber
- Cadmium Yellow Mid
- Carbon Black
- Fawn
- Nimbus Grey
- Olive Green
- Payne's Grey
- Raw Sienna
- Raw Umber
- Turner's Yellow
- Warm White

Brushes
- no. 6/0 liner
- nos. 3, 1, 0, 00, 000 rounds

1 Place the Lizard
Use the no. 1 round and Warm White to place and lay in the shape of the lizard.

2 Lay Base Colors on the Head and Start the Scales
The head is going to be the focal point of this painting simply because of that *casque*, the flap of skin on its back, reminiscent of the lizard's flying dinosaur ancestor. With this in mind, you really want to get the head right. Use the no. 3 round and a base color of Nimbus Grey mixed with a little Warm White for the white areas, and a mixture of Burnt Sienna, Olive Green and Raw Umber for the darker areas. Using the no. 6/0 liner and Nimbus Grey, with a little Carbon Black, lay in the line that defines the mouth, and follow this with a line just below that, marking the bottom edge of the row of scales where the lower lip would be. Using the same mixture and brush, lay in the line above the mouth that marks where the upper lip scales are. Now again using the same brush and mixture, divide these lines into plates or scales using vertical strokes. With the no. 6/0 liner and Payne's Grey mixed with Nimbus Grey, start laying in the dividing lines of the scales below the lip scales. Make the first row slightly smaller than the lip scales. Continue below the mouth and decrease the size of the scales as you work to the bottom of the chin and mouth.

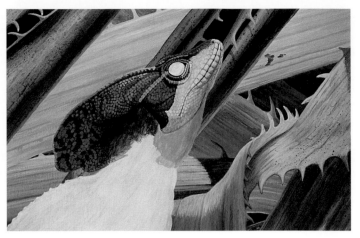

3 Build the Facial Scales

As you lay in the lines between the scales, keep in mind the contour of the area and bend your lines accordingly. Continue above the lips and in front of the eye. Lay in the circular line around the bottom and front of the eye, then the next line out and finally the third line out. Then using the tip of your no. 0 round, lay in the scales on these lines using Warm White. Finish the white area by laying in small scales up to the darker color. Vary the shape of the scales. Staying with the same brush and Warm White, lay in the line that makes up the stripe behind the eye and the smaller scales along the back of the jaw and below.

5 Highlight the Scales and Start the Eye

Using your finest brush tip and Warm White, begin at the upper lip and highlight each scale. Start at the back top of the scale, pull down the back edge and along the bottom edge. One coat should work for these scales. For the bottom lip, use the same brush and Warm White to highlight the top edge and a little bit of the sides of each lip scale. Move to the remaining scales above the lower lip, and dab their tops with Warm White. For the lower throat below the jaw, dab the area where light strikes, leaving the shaded area alone.

Use Fawn and the same brush to highlight the darker scales, using the same dabbing method and keeping the light in mind . Fill in the eye using Cadmium Yellow Mid and Raw Sienna. When dry, lay in the pupil using Carbon Black. When this is dry, mix Burnt Sienna with a little Burnt Umber and stipple in the flecks starting at the outer edges and moving toward the pupil. Stop before you reach the pupil, leaving the thin ring of gold around it. Now use your finest brush tip and lay in the outer perimeter of the eyeball using Carbon Black.

4 Continue with the Facial Scales

For the darker area of the head, suggest scales above the eye, at the curve of the jaw and the base of the head. Mix Burnt Sienna with a little Fawn, and using the tip of the no. 0 round, lay in a row of scales around the back of the eye. Now go to the top of the eye, and using the brush tip, lay in the scales along the ridge and around the eye. Allow the base color to show between scales. Continue the scales, in a semicircular pattern starting at the top of head just below the crest. For the cheek, use the same mixture and a slightly semicircular pattern to dab in scales to the shadow of the jaw. Now use the same mix and brush to lay in the scales of the flap. Start with small scales out to about halfway toward the head and increase in size as you move toward the top edge and back of the casque. From this point to the end of the flap, use Olive Green mixed with a little Turner's Yellow to lay in the greenish scales.

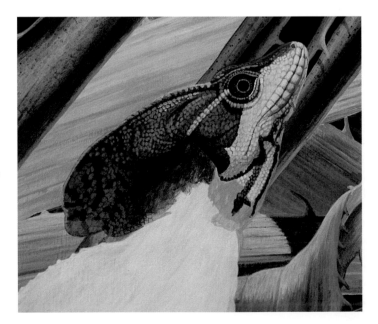

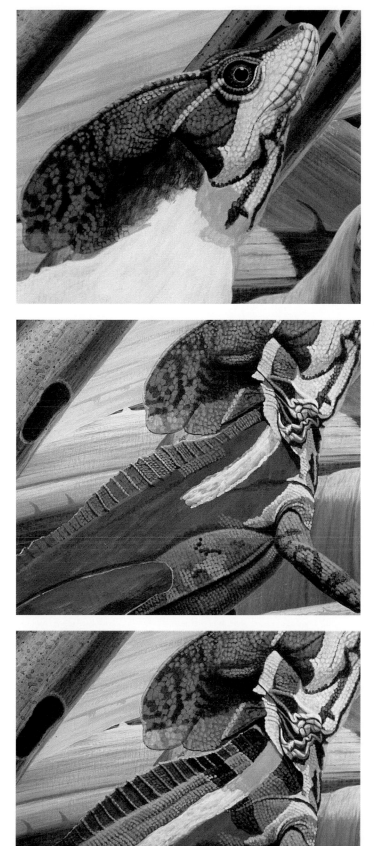

6 Finish the Eye

Using your sharpest brush tip and Burnt Umber, stipple the outer portion of the eye—fewer stipples on the top of the eye, more around the bottom. Next mix Payne's Grey with a little Warm White and water. Lay the wash over the top edge of the eyeball. This simulates the reflective quality of the moist eye surface and brings the eye to life. When dry, use Warm White and place a dot on the middle top of the eyeball. This spot should not be too white because the light is not strongly reflected by the eye.

7 Lay in Body Scales

Starting behind the shoulders at the base of the skin crest along the back, use the no. 0 round and Fawn mixed with a little Burnt Sienna. Start laying in the body scales by dabbing with the tip of your brush. Work in a semicircular pattern and keep the folds of the skin in mind . By laying in these scales in a semicircular pattern, you are bringing out the roundness of the body. When you get to the strong shadow along the bottom of the lateral skin fold, leave this area alone.

8 Lay in the Stripe Scales and Highlighting

Use the tip of the no. 0 round and a mixture of Turner's Yellow and Olive Green in a dabbling motion to lay in the scales of the stripe. Start at the neck fold and work following the semicircular scales above and below the stripe toward the tail.

Next use the same brush (or your sharpest brush tip) and Fawn to highlight the scales starting at the top of the back, stopping at the bottom of the folds and then starting again, working your way down. Leave the shadows untouched. Remember, there is a pattern to scales that usually reflects the contours of the reptile. Try to retain this pattern as you are laying in scales.

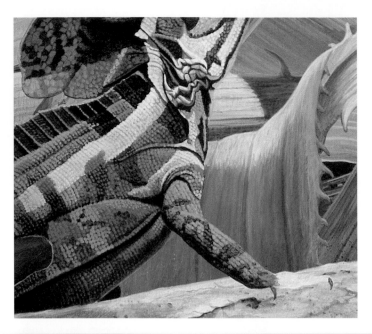

9 Lay in the Scales of the Front Leg

Use your finest brush tip and Olive Green mixed with a little Turner's Yellow to start the scales at the shoulder, keeping in mind that due to the angle of the leg, these scales will be flatter than the scales of the lower leg. Work in a semicircular motion, dabbing in the scales and working down the leg. When you reach the elbow, round out the scales a little, leaving the dark areas for another application. Where the shadow on the lower leg meets the lighter area, stipple lightly with the tip of your brush. Now mix Olive Green with a little Warm White and dab in the scales in the dark markings, stopping where the shadow darkens under the arm. Next mix Warm White with just a little Fawn and highlight the dark markings, laying in the lightest color toward the top edge of the forearm.

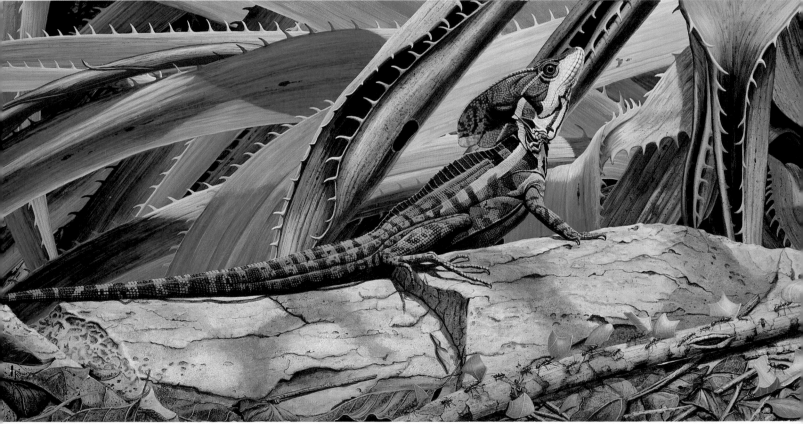

10 Finish the Feet and Claws

Using your sharpest brush tip and a mixture of Olive Green and a little Turner's Yellow, lay in the scales of the toes, dabbing along the tops of the toes and down the sides, leaving the very bottom dark. Carry these scales down to the claws and then use Burnt Umber mixed with a little Carbon Black and the same brush to lay in the claws. Go back to the top of the feet and highlight using Fawn mixed with a little Warm White. With the same mixture and brush, highlight the claws. Start at the top and pull a thin line toward the tips. Dab in the scales and let dry. Use Warm White mixed with water to pull a line right over the top of the feet and toes where the light is strongest.

Bad to the Bone
Basilisk Lizard With
Leaf-Cutter Ants
9" × 18"
(23cm × 46cm)

Painting an Alligator Half in the Water

You've painted your alligator; all his scales and color patterns are in place. Now, how do you make him look like he's in the water? Painting a critter in water is tricky. Many factors can affect the finished product: the color of the water, the angle of the sun, shadows, and whether the water is still or moving.

In this demonstration, you will be putting the water in and highlighting the gator's skin above the waterline. The water is slightly tan in color like weak tea, almost clear.

Alligator Materials List

Palette
- Burnt Sienna
- Raw Sienna
- Carbon Black
- Raw Umber
- Gold Oxide
- Turner's Yellow
- Olive Green
- Warm White
- Payne's Grey

Brushes
- no. 10 filbert
- nos. 2, 1, 0, 00 rounds

1 Create the Shiny Wet Look

Place the alligator and lay in his patterns using Turner's Yellow, Raw Sienna, Burnt Sienna, Gold Oxide and Olive Green. Let the alligator dry.

Then use the no. 0 round and a mixture of Warm White and water to lay in the reflective highlight around the front nostril and the far eye.

Use Warm White mixed with a little Payne's Grey to lay in the light area over the near eye and earflap. Use the same mixture and move down the back of the head and onto the neck. Keep in mind the contours. Using the same mixture and brush, move down the body, laying in the reflective areas on the plates of the back and both far legs.

Using the no. 1 round and the same Warm White and water mixture used on the far eye, lay a wash over the fold above the eye and the Raw Sienna line on the ear. Use the same brush and mixture to highlight the highly reflective areas of the earflap, the back of the head and the neck. Then move to the plates on the back and highlight their contours.

Push the legs back and make them seem to be underwater with a mixture of Warm White with Raw Umber and water. This should be a real thin wash. Think of it as a slightly tinted film. Use the no. 10 filbert, load the brush tip and lightly stroke this mix across the two front legs, the back far leg and just over the right foot where light is striking it.

Now mix more Warm White with water and keep it really watery. Start where the water meets the nose and, using the no. 2 round, pull the brush tip down the length of the face. As you follow the contours of the face, jaw line and neck, you are establishing the waterline. Think of the surface of the gator's face at the waterline; it's not flat, so your line should not be too straight. Now using the no. 0 round and the same mixture, start behind the neck and pull down the body.

2 Fill in the Water Line

Next, with the same brush, follow your line down the body using a second wash of the same mixture and thicken the reflective layer of the water. This is the water that lies right next to the body but isn't touching it. You want this reflective strip to be transparent and uniform at this stage. Starting at the tip of the nose, use the no. 2 round and a watery mixture of Warm White and Raw Umber to lay a second line down just ⅛" (3mm) from your first line, which is also your waterline. Refer to this as the outside line. Follow the same contours as the waterline. When you get to the neck, just behind the head, widen the line a little more. Follow this down the length of the body to where the tail is completely submerged. Then go back and fill in between this line and the waterline with a thin wash of the same mix, making it just a little less transparent. Apply these washes very lightly; use just the tip of the brush. Let dry.

3 Contour and Highlight the Water

Now use the no. 00 round and Warm White mixed with water. Strengthen the reflection on the waterline right next to the body. This is where the surface of the water is slightly curved up right where it meets the body. This curve provides a stronger reflective surface than flat water, which is further from the body of the gator. Keep strengthening this reflection with washes as you work down the body, letting each wash dry between layers.

Using the no. 1 round and Carbon Black, lay this in just above the waterline on the dark scales down the body. Mix water with just a little Raw Umber and go over the middle area between the waterline and the outside line along the body from the neck down.

4 Complete the Water and Body Highlights

Use the no. 00 round and Warm White mixed with Raw Umber and water to go over the outer edge of the outside line, starting again at the tip of the nose. This is where the water has begun to lie down. Move toward the body a little with your wash after the outside line has been laid in. This may take a few washes; let each dry before going back over it. When this has been laid in, go back to the body and strengthen the wet highlights. The procedure in this step demonstrates how to use washes of Warm White to knock down the submerged portions and highlight the reflective edges of the water. This same method can be used with different water tints and Warm White.

Learning the
Game
Baby American
Alligator
9" × 18"
(23cm × 46cm)

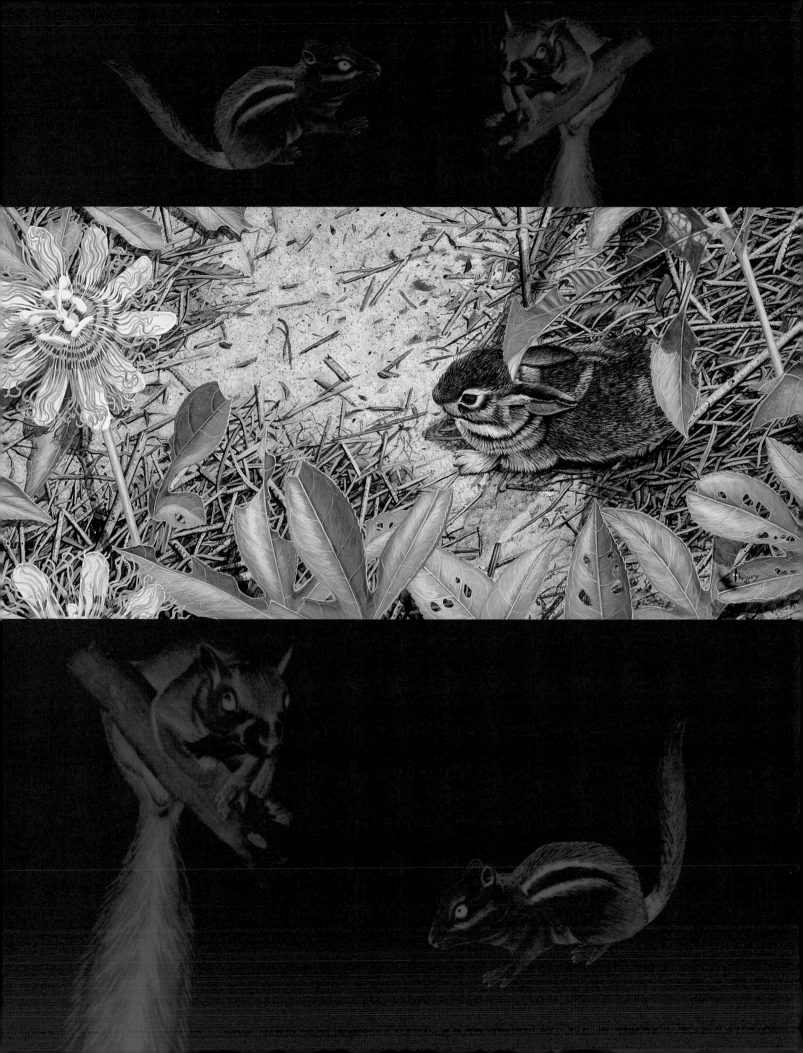

SMALL MAMMALS

*P*ainting fur presents several interesting challenges; foremost of these is achieving a soft, believable result. In this chapter we will work on three basic variations of fur: short, medium and long. We will learn how to simulate fur without creating a porcupine!

Spring Arrival
Baby Cottontail Rabbit
9" × 18" (23cm × 46cm)

Painting Long, Medium and Short Fur

To achieve realistic-looking fur, the hair needs to look soft and deep, and the body needs to have a dimensionality or roundness. Much of this involves implying hair rather than painting each strand, very much like implying scales or feathers. I use a series of layers, each built upon the other. The first layer is the underpaint; then the body contours are laid in using color shifts or shading. Fur also lends itself to watery color washes to soften or change the color of an area after it has been laid down. When laying in hair, be very aware of the nap—the direction the hair lies on the body—and follow this direction with your strokes. In this chapter we will use a rake brush, because it's wonderful for fur.

The animals that we will be working with here exhibit different colors and hair lengths. We will start with a baby rabbit which will be our medium-length hair example. This will be followed by a chipmunk and finally a gray squirrel. The rabbit's fur is heavily flecked with dark hairs while the chipmunk has wonderful color shifts in the form of bands. The squirrel is fairly consistent in his coloring; the tail is its calling card and is fun to paint. The chipmunk and the squirrel are in their summer coats and the rabbit is in its immature coat, which brings up an important point: the fur on animals changes according to the seasons. They grow thicker coats in the autumn in preparation for winter, and shed these coats for a cooler outfit in the warmer months. With these changes can also come changes in coloration, so keep these things in mind. As always keep in mind the roundness of the animal and be aware of how light hits its body.

Reference Photo: Gray Squirrel
See demonstration three on page 125.

Reference Photo: Baby Rabbit
See demonstration one on page 119.

Reference Photo: Chipmunk
See demonstration two on page 122.

Painting the Soft Fur of a Baby Rabbit

Soft fur is usually a dense coat made up of many very fine hair follicles. To paint its fuzzy texture, we need to avoid overdefining individual hairs or creating too much contrast between light and dark areas.

Most young mammals have this soft fur and many—including mink, beaver and rabbits—retain their thick luxurious coats into adulthood.

Baby Rabbit Materials List

Palette
- Burnt Sienna
- Burnt Umber
- Carbon Black
- Fawn
- Gold Oxide
- Nimbus Grey
- Payne's Grey
- Provincial Beige
- Raw Sienna
- Raw Umber
- Warm White

Brushes
- no. 6/0 liner
- ¼-inch (6mm) and ⅛-inch (3mm) rakes
- nos. 2, 1, 0, 00, 000 rounds

1 Lay in the Face and Eye

Use the no. 1 round and a mixture of Raw Sienna, Burnt Sienna and water to lay in the underpaint around the nose and along the top edge of the face. Use short strokes, angling backward, originating in the white and ending outside the white. Stop when you reach the ear.

Mix Burnt Umber with a little Carbon Black to lay in the little dark hairs, starting in the sienna area and finishing just outside the body.

Mix Raw Sienna with a little Burnt Sienna and use the no. 1 round to lay in the lower portion of the nose. Mix Nimbus Grey with a little Raw Sienna and lay in the lower lip, continuing back to below the eye. Mix Burnt Umber with Burnt Sienna and water and use your finest brush tip to go around the perimeter of the eye. Lay in the iris using Carbon Black. With the no. 0 round and Payne's Grey mixed with a little Warm White, lay in the lower edge of the eyelid. Really water down the gray-white mixture and lay a

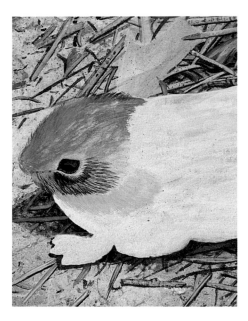

thin wash across the top half of the eyeball. Next, mix Warm White and Raw Sienna and, starting at the upper edge of the eyelid, lay in short strokes moving back and toward the edge. Mix Burnt Umber and Burnt Sienna and, using the ⅛-inch (3mm) rake, start at the bottom edge of the eye ring and lay in strokes moving down and back.

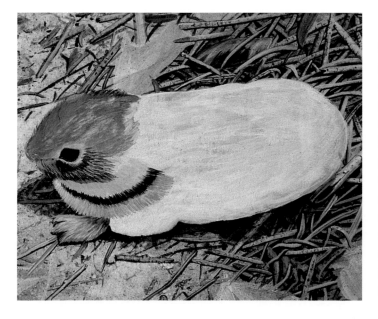

2 Start Painting the Body

Use a mixture of Nimbus Grey and a little Payne's Grey with the rake to lay in the white ring below the chin. Go over this with a thin mixture of Raw Sienna and water using the no. 0 round. Mix Burnt Umber with Carbon Black and use the no. 6/0 liner to lay in the black hair ring below the white ring. Mix Raw Sienna with Burnt Umber and lay in the last ring using the same brush. For the front paw, mix Raw Sienna with a little Warm White to lay in this underpaint over the white. Use the Nimbus Grey-Payne's Grey mix and the no. 0 round to lay in the gray hairs at the front of the paw. Use the same brush and a Burnt Umber-Raw Sienna mixture to lay in the edge of the first toe and the shadow where the front paw meets the body. Use a little Burnt Umber to lay in hair strokes, moving toward the body.

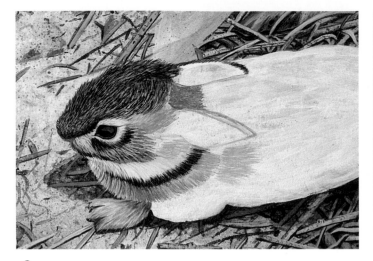

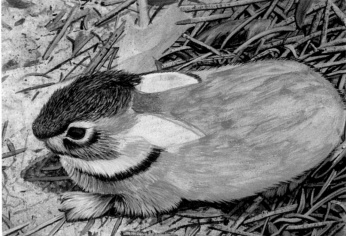

3 Lay in the Top of the Head and Ear Edges

Moving back up to the nose and forehead, mix Burnt Umber with Carbon Black. Using the tip of the no. 000 round start at the top of the nose and dab around, then pull the brush in the direction of the hair as you move away. Carry this to the top of the head until it is covered. Now use Carbon Black with just a little Burnt Umber and the no. 1 round. Start at the middle of the head and lay in the darker spot at the top of the head with just a few strokes. Lightly draw in the outline of the ears, using the no. 2 round and Raw Umber.

Using the no. 000 round, go down to the white band at the neck (see step 2), and use Warm White to lay in the little hairs over the undercolor. Then with Nimbus Grey mixed with a little Carbon Black, lay in little hairs over the Warm White. For the next band down, mix Burnt Umber with Burnt Sienna and lay in little hairs over the Raw Sienna band. Space them out and start right at the black band. Mix Raw Sienna with Burnt Sienna and use the ⅛-inch (3mm) rake to lay in the area of hair between the ears.

4 Contour the Body With Underpaint

Use the ¼-inch (6mm) rake and a Raw Sienna-Burnt Sienna mix to underpaint the hairs behind the front paw, doing the front two thirds of this area. For the remaining area use Nimbus Grey and Burnt Umber. Use a Nimbus Grey-Provincial Beige mix to lay in the underpaint starting where the front arm ends and moving around the body. Midway up the body, change to Raw Sienna and little Provincial Beige.

For the foot and forearm, use the no. 000 round and Burnt Umber to lay in the hairs and shadow at the top of the paw and the beginning of the forearm. Continue with Warm White over the top of the paw. Move back to the forearm and use Warm White mixed with Raw Sienna to lay in little hairs. Mix Nimbus Grey with Provincial Beige and lay in the hind foot with the same brush. Use Carbon Black to separate the toes.

Use Burnt Umber to shade the top below the body hairline. Use Nimbus Grey and Provincial Beige to lay in the body line. Mix Burnt Umber and Carbon Black, use your finest brush tip and lay in the little hairs that start at the top of the body and move away from the edge.

5 Lay in Hairs and Create Depth

Use just the tip of the ⅛-inch (3mm) rake with a watery mixture of Burnt Umber and a little Carbon Black to paint the body hairs, starting behind the forearm at the neckline and leaving some of the undercolor showing. Use the same mixture and brush for the top of the back. Let dry. Use the same rake and Nimbus Grey mixed with water to go back over the hairs on the side of the body. Mix Warm White with Raw Sienna and go over the hairs on the back, behind the top ear and on the back of the rump. Use the no. 000 round and Carbon Black mixed with water to lay in random black hairs, starting at the shoulder and neck and moving along the back.

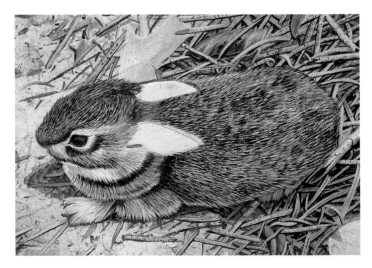

6 Paint the Ears

For the ears, underpaint the top and bottom ear with Provincial Beige mixed with a little Burnt Sienna. For the inside of the bottom ear use Fawn with a little Burnt Sienna. Using the no. 000 round and a mixture of Burnt Umber and a little Raw Sienna, lay in the hairs on the ear; go all the way to the edge. Use Carbon Black and a little Burnt Sienna to paint the dark hair band around the top of the ear. Mix Carbon Black with a little Warm White and highlight the tip of the black band. For the neck and face, mix Carbon Black with a little Burnt Umber and, using the no. 6/0 liner, lay in a few hairs on the Raw Sienna hair above the foot. Use Warm White mixed with Raw Sienna to lay in hairs on the sienna ring, starting just below the ear and following this back to the cheek. Space these strokes slightly apart, leaving some underpaint showing. Now use Warm White and the no. 6/0 liner to highlight the hairs on the white ring. These will take two or more washes. Then move to the sienna ring below the black and highlight it. Start at the bottom of the black ring and pull down. Use Warm White to lay in hairs on the bottom ear.

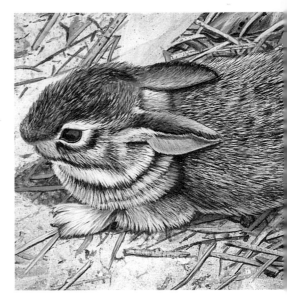

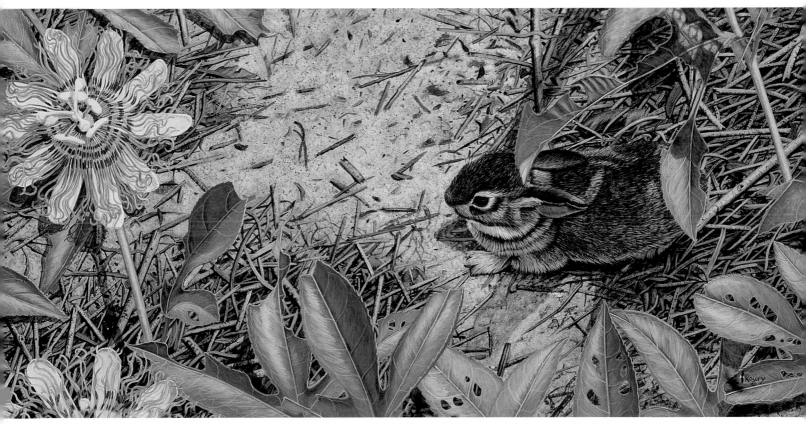

7 Highlight and Finish

Use the no. 6/0 liner and Warm White mixed with a little Raw Sienna to work areas of highlight, starting with the far side of the face, then the base of the near ear, the back of the neck and the spots where light hits the back. Use your ⅛-inch (3mm) rake and lay a thin wash of Gold Oxide and water over the area between the ears and let dry. Use Warm White and the no. 6/0 liner to highlight a few of the hairs. Now use Burnt Umber and the same brush to lay in the whiskers and eyelash hairs. Begin at the body, lifting the brush tip at the end of the stroke.

Spring Arrival
Baby Cottontail
Rabbit
9" × 18"
(23cm × 46cm)

Blending Stripes and Colors on Fur

The object in this demonstration is to work high-contrast areas together, laying dark hairs next to light hairs to get a believable, smooth transition. The chipmunk in this painting has two very dark stripes bordering a white stripe along its back; we will concentrate on these high-contrast color transitions.

Chipmunk Materials List

Palette
- Burgundy
- Burnt Sienna
- Burnt Umber
- Carbon Black
- Nimbus Grey
- Raw Sienna
- Warm White

Brushes
- no. 6/0 liner
- no. 4 shader or cats' tongue
- ⅛-inch (3mm) rake
- nos. 0, 00, 000 rounds

Sketch of an Eastern Chipmunk
4" to 6" (10cm to 15cm) in length.

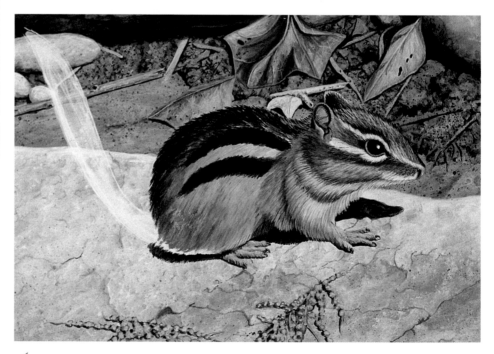

1 Define the Edges of the Markings

After placing and blocking in the chipmunk with Warm White, lay in the base colors with Warm White, Raw Sienna, Burnt Sienna and Burnt Umber. Paint the dark stripes with the no. 4 shader or cats' tongue, using a mixture of Burnt Umber and Carbon Black.

When dry, use the no. 6/0 liner and Burnt Sienna thinned with water to lay in a very thin transition band on both sides of each black stripe, following the lay of the hair. Next, use this same Burnt Sienna and water mixture to lay in a transition band on the edge of the stripe along the top of the back. Now use the same brush and Carbon Black. Start in the black stripes and randomly pull out hairs on both black stripes into the Burnt Sienna bands.

2 Create Depth in the Hairs of the Stripes

Using Warm White mixed with water and the no. 6/0 liner, start at the top edge of the white stripe and pull down and back, spacing out the strokes and bunching them up where the light is strongest. Let some of your strokes trail slightly into the Burnt Umber edging.

Next, extend the dark stripe forward to the back of the shoulder. Mix Burnt Sienna with Burnt Umber and use your finest brush tip to lay in the two dark stripes to the back of the shoulder. Then use the same brush and Carbon Black to lay in little hairs over the colors you just laid in. Use the same brush and Warm White to extend the white stripe forward to the back of the shoulder, using the same strokes as before. Next mix Burnt Umber, Burgundy and Warm White with water. Use the no. 6/0 liner to lay in the hairs along the top stripe, allowing some of your strokes to trail into the Burnt Sienna. With the same mixture and brush, move to the top edge of the lower dark stripe. Start your stroke here in the Burnt Sienna band and pull back and slightly upward. Space out these strokes. Now use Warm White and your finest brush tip to lay in hairs over the Raw Sienna below the lower stripe.

3 Continue Developing the Hairs

Mix Carbon Black with a little Warm White and water. Lay in random hairs over the dark stripes starting at the front of the body. As you work back on the lower stripe, increase the number of hairs you lay in as you get above the thigh, where there is a strong light reflection. Move to the next stripe up and lay in random hairs. Then go to the stripe on the top of the back. Mix a little Burnt Umber with Burnt Sienna and water. this is going to be the first of two washes over the lower black stripe, so keep it thin. Use the ⅛-inch (3mm) rake and lay this wash down over the last half of the lower black stripe. Use the same mix to lay a wash over the very top of the back about halfway up the back toward the head; let dry. Use Carbon Black and the no. 6/0 liner to lay a few random hairs over the area that just received the wash. When dry, use Carbon Black and a little more Warm White to lay in just a few lighter hairs on all of the dark stripes. Next mix water and Raw Sienna, and use the ⅛-inch (3mm) rake to lay a wash over the white area below the lower black stripe.

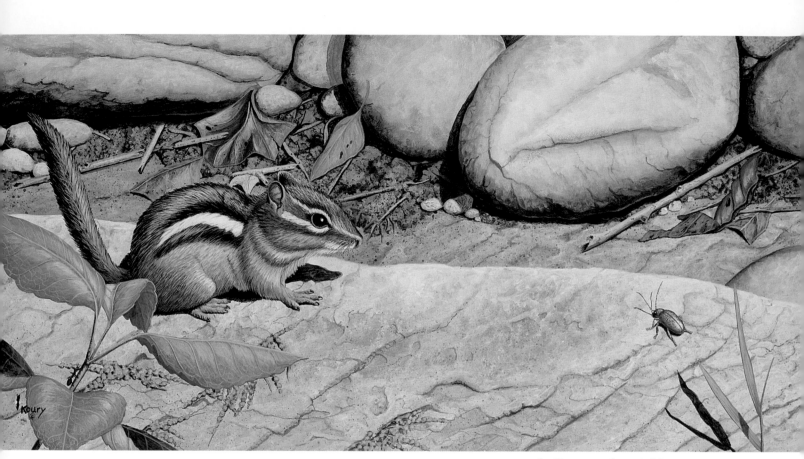

4 Finish Blending the Body Hairs

Mix Burnt Sienna and a little Burnt Umber and use your finest brush tip to lay in little strokes at the line where the top dark line meets the white. Start just inside the white and stroke up into the black. Next go to the bottom of the white line and do the same, carrying your stroke slightly into the white from the lower black line. Now, using the same mixture and brush, go to the bottom of the lower black line and lay in small hairs, starting in the Raw Sienna and carrying them into the black. Next, using Warm White mixed with Nimbus Grey, lay in tiny lines right on the white stripe. Spread these out. When dry, use Warm White and go back over the white stripe, building up the white area next to the Nimbus Grey lines. Then mix Warm White with a little Raw Sienna, go to the bottom of the lower black line and lay in hairs slightly overlapping the Burnt Sienna. There should be a smooth transition from color to color between the stripes.

Checking Out the Neighbors
Eastern Chipmunk
7" × 14" (18cm × 36cm)

Painting the Bushy Tail of the Squirrel

This gray squirrel braves a huge open field to get to the seeds we put out for the birds. Once he reaches my backyard, he makes himself at home and stays quite a while. His salt and pepper body fur is short and dense, somewhat shorter than that of the rabbit and the chipmunk.

His real draw, however, is that wonderful bushy tail, which he flicks with increasing frequency as he gets more excited. In this demonstration, we will work on painting that delightful tail.

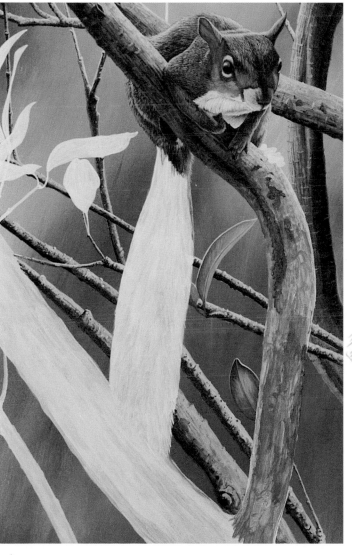

Sketch of a Gray Squirrel
8" to 12"
(20cm to 30cm) in length.

Gray Squirrel Materials List

Palette
- Burnt Sienna
- Payne's Grey
- Burnt Umber
- Provincial Beige
- Carbon Black
- Raw Sienna
- Gold Oxide
- Warm White
- Nimbus Grey

Brushes
- no. 6/0 liner
- no. 4 shader
- ¼-inch (6mm) rake
- nos. 0, 00, 000 rounds

1 Place the Tail

After you have placed the squirrel, lay in the form using the no. 4 shader with Warm White. When this dries, use the techniques shown in the previous demonstrations to lay in the upper body and face, with Raw Sienna, Burnt Sienna, Carbon Black, Nimbus Grey, Payne's Grey and Warm White. Complete the belly using Nimbus Grey, Warm White and Raw Sienna.

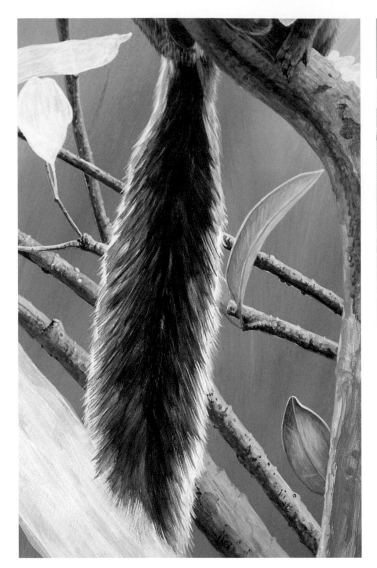

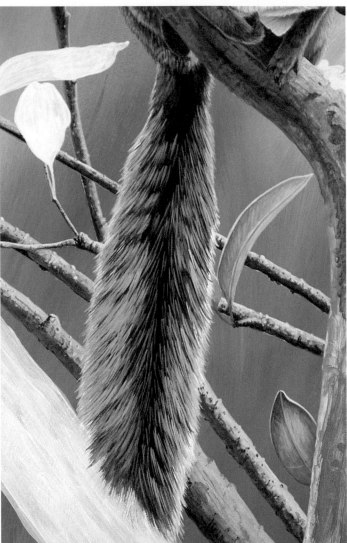

2 Underpaint the Tail

Mix Burnt Umber, Burnt Sienna and a little Carbon Black and use the ¼-inch (6mm) rake to begin painting the base of the tail. Lay in this underpaint using long strokes, angling away from the center and leaving the outer edges white all the way around. Lay in more Carbon Black and Burnt Umber down the middle of the tail.

3 Add Depth to the Tail Hairs

Mix a little Carbon Black with Nimbus Grey and, using the no. 6/0 liner, lay in an edge all the way down and around over the white, starting at the Burnt Umber and ending right at the edge of the white. Staying with the same mixture and brush, use long strokes to lay in hairs down the tail.

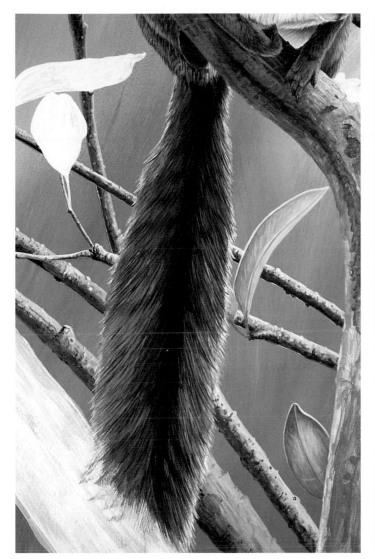

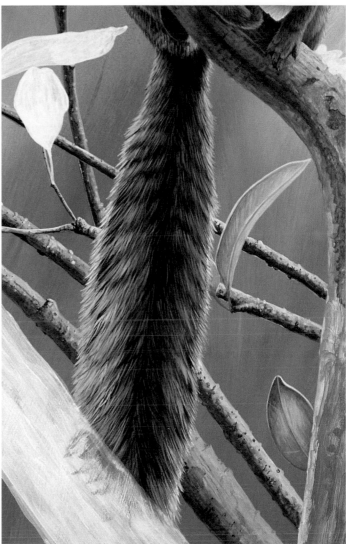

4 Continue Building Depth

Now for a brush trick: Use the ¼-inch (6mm) rake and load it with a mixture of water, Burnt Umber and a little Burnt Sienna. Start just below where the tail begins and turn your brush sideways, so that only the edge hits the painting. Begin laying in the wash over the entire tail using this sideways method. Continue this technique down to the bottom of the tail. Let dry, then use the no. 6/0 liner and Carbon Black to lay in random hairs, remembering in which direction the hair flows. Make these strokes random, working all the way down the tail. Leave enough space between these hairs to suggest depth.

5 Lay in More Individual Hairs

Take your time on this step. Use the no. 6/0 liner and a mixture of Nimbus Grey and a little Warm White. Start at the top of the tail and lay in hairs on the edges of the tail on both sides. Work your way down and carry the hairs into the tail toward the center. Spread your strokes out, allowing the undercolor to show through. Carry these strokes closer to the center on the left side of the tail but stay closer to the outer edge on the right side. This will take several washes. Next, mix Provincial Beige with a little Gold Oxide and lay in random hairs down both sides of the center of the tail.

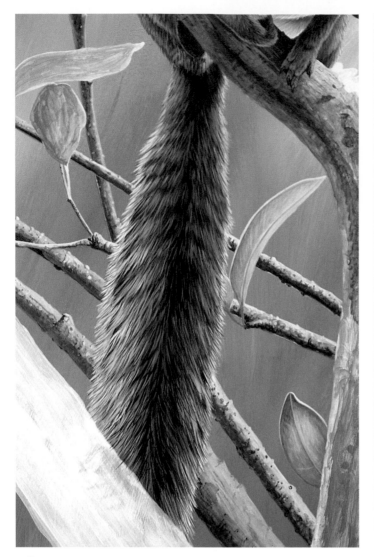

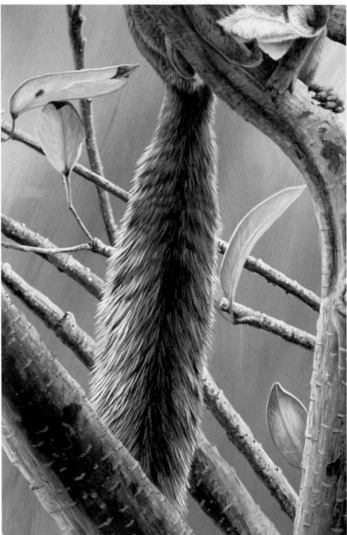

6 Build More Individual Hairs

Now mix Carbon Black with a little Burnt Umber and using the no. 6/0 liner, lay in random hairs starting at the center of the tail and working down and away. Carry some of these hairs into the white on the edges of the tail, shortening your strokes and starting just into the darker area. These final strokes should be widely spaced and will serve to deepen the tail hair.

7 Add Final Layer of Hairs

Use Warm White thinned with water and the no. 6/0 liner to lay in random hairs, starting again at the outer edges and working down the left side. Do the same on the right side and randomly work your way down. This will take a couple of washes. Notice how the left side of the tail becomes more light than the right. Keep this in mind while applying the lighter hairs. When this is completed it should look like a corona around the edges of the tail.

Brush Tip

When using the 6/0 liner, load your brush and then try to apply the paint that will simulate hairs by moving only the fingers that hold the brush, keeping the movement as smooth and subtle as possible. Lay the very tip of the loaded brush on the painting and pull it across the surface in the direction the hair grows. When the brush begins to run out of paint, reload; don't wait for it to run out in the middle of a stroke.

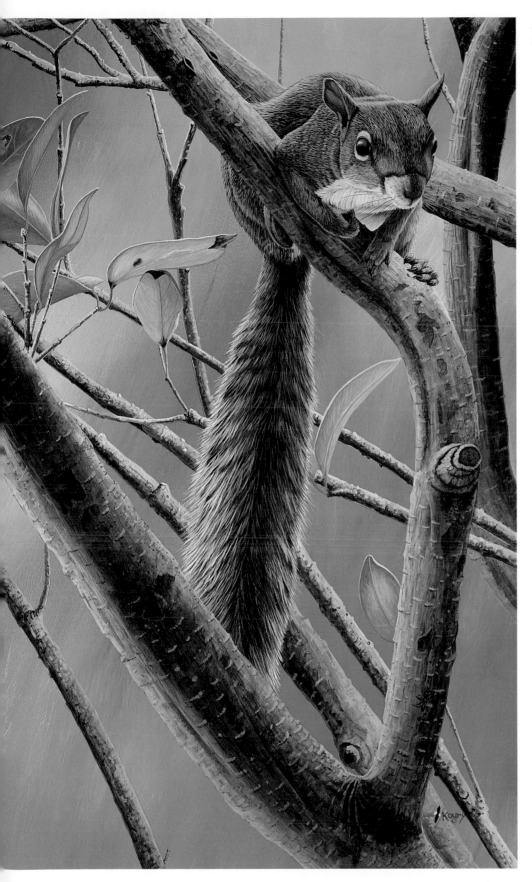

Things to Remember When Painting Fur

- You don't need to paint every hair. Bright highlights and shadows eliminate the need to do this.
- Blend your color changes, especially when there is a strong contrast between colors. Let these colors just barely flow into each other.
- Use thin washes of color to soften or change the hue of the fur.
- Contour the body by shading when you underpaint, then use gradual color shifts on top of these shadows when defining the hairs.

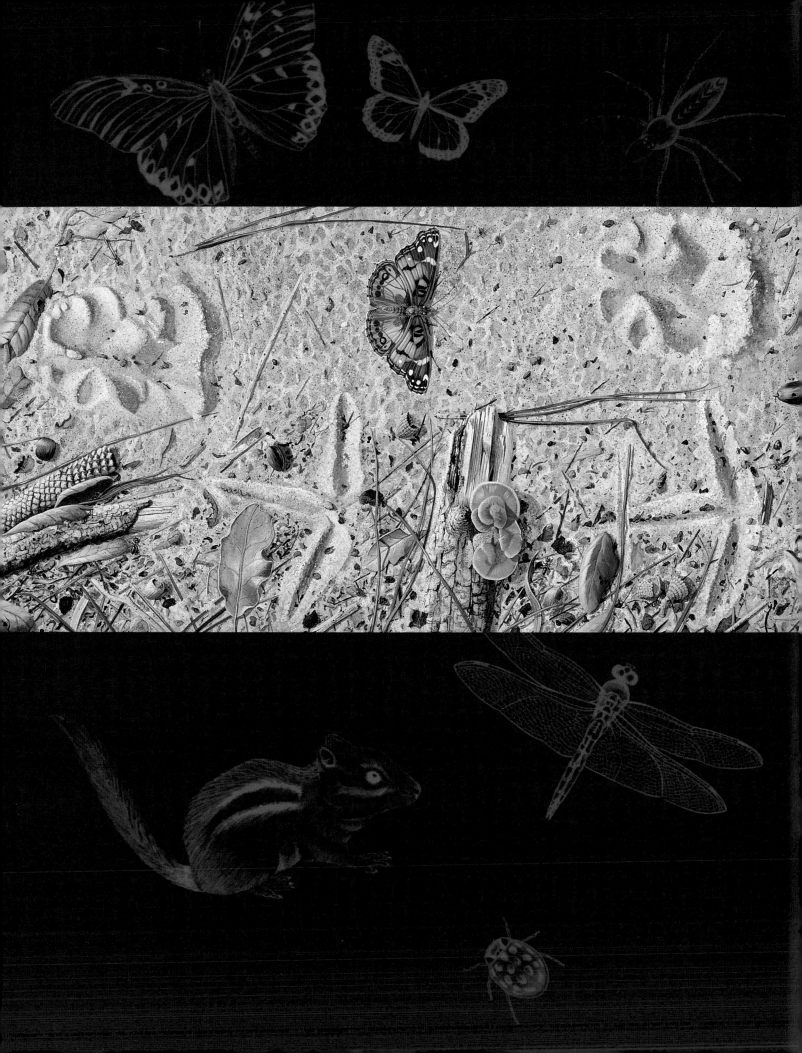

COMPOSITION

*I*n this chapter we will explore composition and what it takes to create a good painting. Not surprisingly, many of the points and elements we will be covering apply to all forms of art from wildlife portraits to impressionistic landscapes.

There are many theories about the elements of a painting and just what makes it good. Read them, understand them, file them upstairs—then just paint! The best advice I ever received was: "Paint a thousand paintings." A little extreme and time-consuming, granted, but the idea was that the more you paint the better you get! Really good paintings are born spontaneously; they must come from somewhere inside you, sparked by a combination of something you've witnessed, your imagination, the accumulated knowledge that you possess, and the ability level that you've reached. So far we have worked on how to paint, hopefully giving you some tools to increase your ability. Now let me give you some ideas about how to compose a good painting.

In *Story in the Sand* the elements combine to tell the story of a possible meeting between a turkey and a bobcat. I found this story at Lake Kissimmee State Park in Florida. I was following a set of turkey tracks early in the morning; it had rained the night before and the sand had that wonderful pocked texture. After a short time I noticed that a set of bobcat tracks had appeared, following the turkey tracks. My imagination began playing out the possible drama, and I realized—here's a great story. At that moment I began working out the composition for a painting drawing elements from the surrounding area that would help create this piece. This composition flows as I witnessed it, from right to left,

and is obviously carried off by the tracks with their interesting contrasts of light, raised edges and darker shadowed valleys. The position of the bobcat print in the top left of the piece carries the viewer's eye out of the painting and raises the question of what finally happened. The orange lichen interrupts this right-to-left flow, as does the American painted lady butterfly, which has positioned itself to catch as much warmth from the morning sun as possible. These two elements serve more than one function: they slow the viewer's eye once the tracks have become obvious, they add interest in the center of the painting, and balance the composition.

Story in the Sand
American Painted Lady Butterfly
9" × 18" (23cm × 46cm)

Find an Interesting Story for Your Art

A large part of painting is communicating what you are trying to say. Nature provides an endless array of stories, and these will become more evident to you as you immerse yourself in the activities of nature and all the little characters that live there. Begin by reading and learning all you can from various sources: field guides, periodicals and the Internet, to name just a few. Prepare yourself with a knowledge of your chosen environment and its resident critters. Some field guides contain tidbits about the best times to see them, their habitats, behavior and idiosyncrasies. Spend time in nature, slow down and really look. Your imagination and observations will become a great source for an endless number of paintings. Next step: how to convey the story in an intriguing and believable way. For me, this is done with color, contrast, texture, light and interesting items such as fallen leaves, lichens, grasses, flowers: in short, the ordinary objects that abound in nature—and, oh yeah, the critters! What do *you* find exciting and interesting? The desire to tell a story through painting a particular subject or scene must come from inside you.

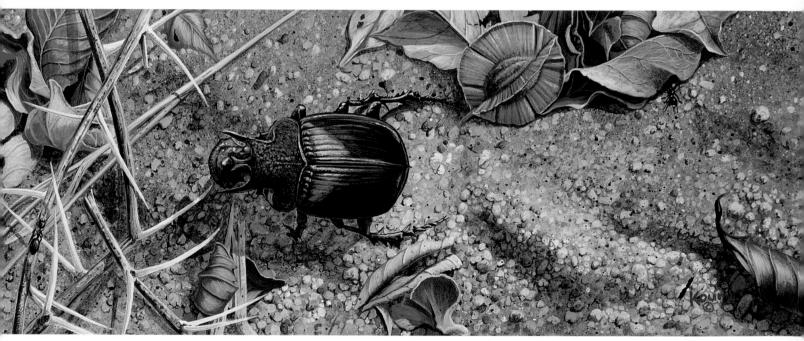

In *Roadblock*, an African dung beetle encounters a spiky obstacle in its path in the form of fallen acacia thorns. As I thought about this situation, I knew the beetle would just scramble up and over the thorns without any trouble, but the thought of him actually being held up by this imposing barricade, even for a few seconds, was the story for me. By placing a few thorns pointing directly at the beetle, the tension is heightened and the obstacle seems more threatening. The open area behind the beetle serves to balance this piece, and by placing fallen mopani leaves along the top and bottom edges of the painting, I've funneled this guy into a dead end street, again increasing the effect of the barricade.

Roadblock
African Dung Beetle
4" × 9" (10cm × 23cm)

ACCURACY

Your renderings of nature's critters must be accurate if you expect to achieve a realistic effect. Our audiences are the toughest critics in the world. They have an advantage; prior experience and an innate knowledge of how things should look like. If your painting bothers you, then you can bet it won't sit right with the viewer. Take the time to get the anatomy and proportions right so you can feel confident about your work. Be patient. This has been an underlying and recurring theme throughout this book. Patience allows a scene to unfold and a story to be told. It allows a dramatic composition to play out in your mind and on your painting surface.

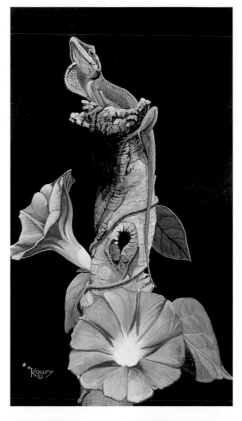

Showing His Money is a term used in the southern United States when referring to these lizards and their habit of finding a high spot and extending the flap of skin under the chin. This green anole is flashing his throat flap atop a gnarled old limb. In doing so he is announcing "This is my territory, and yes, I'm looking good!" The composition has a much deeper story. The dark background forces the subject into the foreground. A compositional triangle is created by using objects and the repetition of colors. The morning glory blooms form two of the three points of the triangle, while the anole's similarly colored throat flap forms the third point. This triangular effect leads the viewer's eye around the painting, creating a balance within the piece. Balance is also accomplished by adding highlights to the leaf surface in the lower right corner.

Showing His Money
Green Anole Lizard
8" × 4½" (20cm × 11cm)

In this painting the frog almost disappears against the sand hill background. The dayflower and fallen leaves are a big part of this story. I would not have seen this frog if he had not moved when I went to inspect the flower. Placing the frog away from the center and letting the painting be dominated by the flower, helps convey the title.

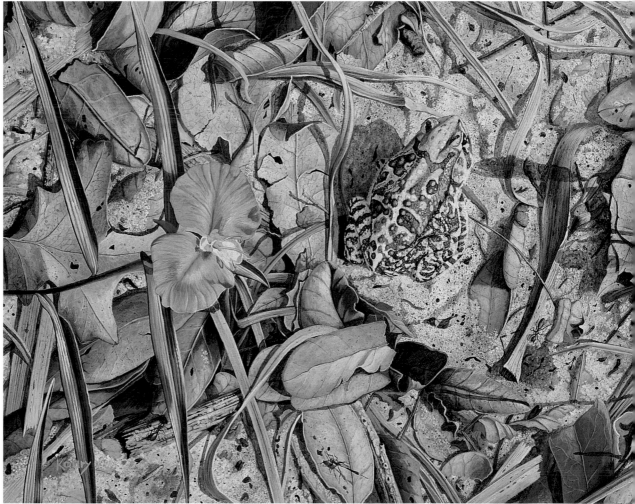

Natural Camo
Florida Gopher Frog
7" × 9" (18cm × 23cm)

Using Shadow to Create Depth and Dimension

Shadows can refine a painting by adding contour and shape to the composition. They can direct the eye toward objects outside the painting or lead it back to the image within. Shadows add dimension, create depth and help distinguish the most important components of a painting.

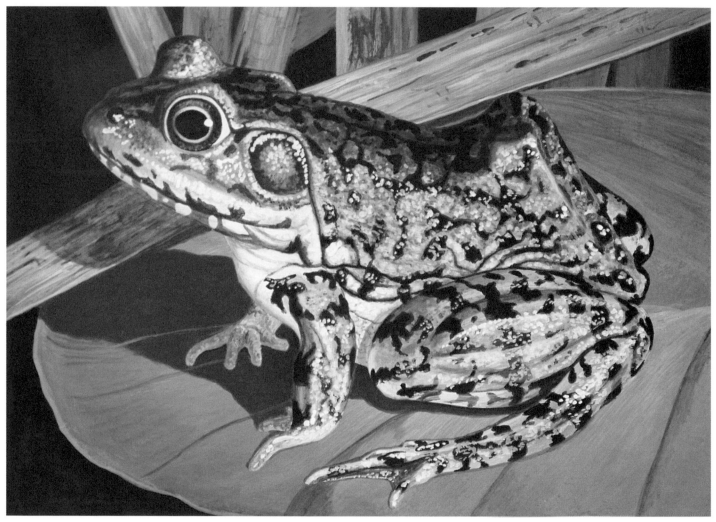

In *Riverfrog*, the development of the shadow has served to push the frog up and away from the pad that he's sitting on. Notice here that the shadow on the pad is a different color from the shadow on the reed, even though both are part of the same shadow. Keep this in mind when shading.

Riverfrog (detail)
Riverfrog
6" x 12½" (15cm x 32cm)

Tip

Use a shadow value that complements the subject. If a dark shadow with no detail will work, use it; if the shadow needs detail inside it, add the detail.

The Shadow
Eastern Pondhawk Dragonfly
9" × 5" (23cm × 13cm)

The Shadow was painted simply because I had to paint that shadow! I remember being so wrapped up in looking at the dragonfly that it was only after a minute or so that I noticed the shadow and thought, Wow! This is how shadows can be used to tell a little story while also conveying depth. Your mind knows that in order for an insect to cast such a shadow, it must be *dimensional*, or round.

In this painting the shadow of the dragonfly and the shading on the pickerelweed were done using very thin applications. Establish the shadow's parameters with the first light application. Then when you are satisfied with the placement and size, lay on successive washes until you get the color and contrast that you want.

Tip

When determining where a shadow should be, lay down a very thin, barely visible wash defining the shadow's edges. Once you are comfortable with the size and shape of the shadow, lay in successive washes until you get the value you want.

In *Follow the Sign*, shadows completely yet subtly dominate the painting, and are the reason it works. The turkey track below the Gulf fritillary butterfly and the ridge running through the middle of the piece are examples of obvious shadows, yet they create a depth to the sand. These shadows were built up using successive washes until the contrast was just right. The shadow through the middle of the piece, running vertically, separates the butterfly and the tracks from the fallen leaf clutter, in essence, placing them on an island. The next most obvious examples of shading and shadows are the fallen turkey oak leaves, meant to mirror the turkey tracks and the butterfly's shape. The shadows on these act to raise and lower the surfaces, provide contrast and, again, portray depth. Finally, the subtle shadows (the faint shadows across the white sand, running from right to left) add a bit of reality and create a curiosity in the viewer, implying that there is something out there to the right. These shadows also serve to flatten the sand and more importantly move the viewer's eye to the center of the painting. These shadows also were laid in very lightly and built upon with successive washes.

Follow the Sign
Turkey Track and Gulf Fritillary
8" × 12" (20cm × 30cm)

Tip

All the shadows in a single painting do not necessarily have the same value; some may be darker than others. Be aware of this when you are building up the value of shadow.

Making a Critter Into a Work of Art

This is without a doubt the most diffi-cult and complicated topic yet, but it is not impossible. Theories and defini-tions of what makes a *good* painting abound.

Throughout this book we have dis-cussed some essential elements of painting: light, color, texture, shape, placement and balance. When I paint, I am not consciously aware of these ele-ments , yet they are a vital part of my work. The synthesis of the way I use these elements is my *style*. As you work and become more confident, you too will develop your own style.

The most important advice I can give you is to follow you heart. If you *want* to paint it, that desire will show. Remem-ber, if your heart is in the piece, the only critique that matters is your own.

Avoiding the Bull's Eye Effect

By placing just part of the subject in the center area, you can avoid the bull's eye effect and create a more interesting composi-tion—but if you want to paint it in the cen-ter, do it! Don't be afraid to break this rule. Let the story determine the position.

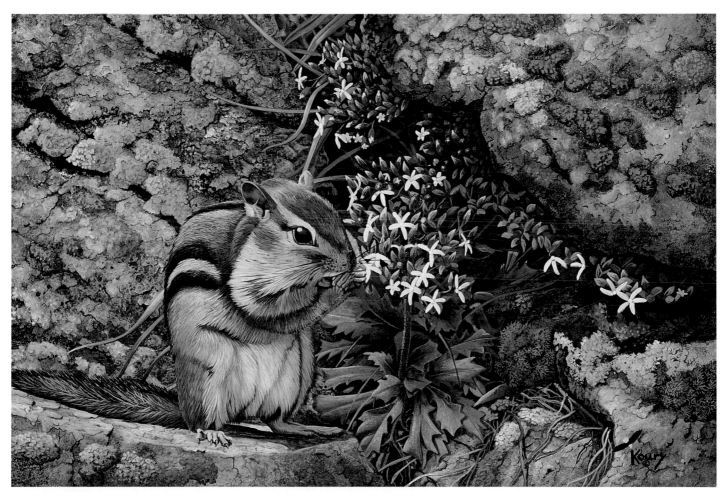

One More Bite is an example of a creature in his environment, but again this is not the whole story. This weathered rock is Grand Father Mountain, North Carolina. This chip-munk and his buddies run all over these rocks. This story is about the rocks and plants of this ecosystem, not the chipmunk. But this example is meant to show you that you can place your subject front and center, or in the spotlight, so to speak. The rock shelf that the chipmunk is standing on is almost like a stage; by strategically moving to the edge of the stage so the audience can watch him eat. Actually, this is a good vantage point for the chip-munk, affording a good view of the area while eating.

One More Bite
Eastern Chipmunk
8" × 11" (20cm × 28cm)

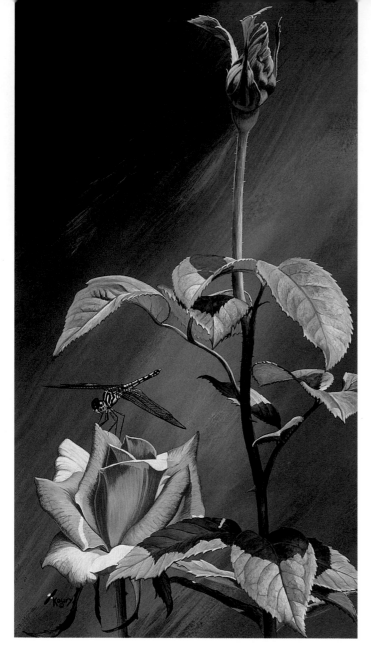

Situating your creature away from the center is also fine and should be determined by how you feel about your composition and what works. In *Dragon Rose* color and light combine with placement to create a good composition. The contrasts on the leaves draw the eye and deepen the painting while the rose below and the bud above move the eye from bottom to top. The contrast between colors is important in conveying a sense of reality here. Note the highly reflective surfaces of the leaves and the subsequent shadows as well as the undersides of the leaves where the light from above shows through. The color under the leaves also closely follows the color on the body of the dragonfly and helps draw him into the piece. The dragonfly is overpowered by the color and light on the rose that he's resting on, yet he is featured and almost held in place by the rose below and the leaf above, cupping him as if it were a hand held above to keep him from flying away. This is a very uplifting piece to me. The background flows upward diagonally and the rose builds to a single bud atop the stem.

Dragon Rose
Dragonfly
12" × 6½" (30cm × 17cm)

Rule of Thirds

The Rule of Thirds is simply a compositional guide. Your intentions and personal judgment will determine where you decide to place the subject

Divide your painting using three equally-spaced lines along the horizontal axis, and three equally-spaced lines along the vertical axis. Place your focal point on or near the outermost lines.

Islands is a very busy piece by most standards, yet it's a piece full of color, shape, texture and light. The basis for this piece is my love of streambeds and the chance viewing of a swallowtail resting on a stone in a riverbed. This work is made of many colors, yet none of the stones carry the vibrancy of the leaf or the swallowtail. Their color alone lifts them above the streambed and draws the viewer's eye. With so much going on below the butterfly, it would be easy for him to get lost. To avoid this, a majority of the stones below the butterfly are submerged and therefore are darker. This further highlights the butterfly while the stone directly below him, the one he's resting on, is lighter, allowing the front half of the butterfly to be well defined.

The flow of this piece is primarily from the bottom center up to the top left corner. By placing the butterfly where he is and the yellow leaf where it is, the flow is momentarily interrupted. The yellow leaf points the viewer's eye diagonally away from the center, toward the top right corner. The butterfly's right wings move the eye toward the bottom right corner.

The contrasts between the stones in the lower right and the stones in the top left help balance this piece. Finally another element carries the eyes back toward the center: the water-soaked twigs on the left side. The result of all this color, shape and texture is a piece that keeps the eyes absorbed in exploring from corner to corner the wonderful shapes and beautiful colors.

Islands
Tiger Swallowtail
12" × 8" (30cm × 20cm)

Balancing Elements

What to put in, what to take out. This is really a "feel" for the sense of balance created by the painting. In *Islands* there are quite a few rocks, yet only a few demand the viewer's attention with their color, texture or shape.

Try to move the viewer's eye around the painting by using objects, shapes and colors that are intrinsically interesting.

CONCLUSION

*W*hen North Light approached me about doing *Painting Nature's Little Creatures*, I was honored to have the opportunity, but concerned about how I could possibly convey all the information that I wanted to share. I have tried to cover techniques and methods that would have the greatest transference effect, meaning that they could be used on a wider variety of critters than just the ones in this book. Techniques for painting the wings of butterflies, dragonflies and bees can be used on an infinite number of other creatures, as can those for beetle shells, amphibian and reptile skins, and the fur of small mammals.

Explore the techniques and ideas illustrated in this book and incorporate them into what you do, but allow your own style to unfold. Be true to your heart and paint what's there.

I sincerely hope *Painting Nature's Little Creatures* has helped each and every one of you. Paint a thousand paintings!

Landing Pad
Bumblebee
5½" × 8½" (14cm × 22cm)

Index

Create extraordinary wildlife art with North Light Books!

Learn how to create mysterious, atmospheric nature paintings! Whether rendering scales, feathers, sand or fog, dozens of mini-demos and step-by-step guidelines make each step easy. You'll learn to paint the trickiest of details with skill and style. A final, full-size demonstration, combining animals with their environment, focuses all of these lessons into one dynamic painting.
1-58180-050-9, hardcover, 128 pages, #31842-K

Make your wildlife paintings stand apart from the herd by capturing the fine details that give your subjects that certain "spark" they need to come to life. Fifty step-by-step demonstrations show you how to make fur look thick, give feathers sheen, create the roughness of antlers and more!
1-58180-177-7, paperback, 144 pages, #31191-K

Capture your favorite animals up close and personal—including bears, wolves, jaguar, elk, white-tailed deer, foxes, chipmunks, eagles and more! Kalon Baughan and Bart Rulon show you how, providing invaluable advice for painting realistic anatomies, colors, and textures in 18 step-by-step demos.
0-89134-962-6, hardcover, 128 pages, #31523-K

Through step-by-step demonstrations and magnificent paintings, Patrick Seslar reveals how to turn oils, watercolors, acrylics or pastels into creatures with fur, feathers or scales. You'll find instructions for researching your subjects and their natural habitat, using light and color and capturing realistic animal textures.
1-58180-086-X, paperback, 144 pages, #31686-K

Discover a wealth of crisp, gorgeous photos that you'll refer to for years to come. Finding the right image is easy—each bird is shown from a variety of perspectives, revealing their unique forms and characteristics, including wing, feather, claw and beak details. Four painting demos illustrate how to use these photos to create your own compositions.
0-89134-859-X, hardcover, 144 pages, #31352-K